ALWAYS
A
SONG

ALWAYS A SONG

SINGERS, SONGWRITERS, SINNERS & SAINTS

MY STORY OF THE FOLK MUSIC REVIVAL

ELLEN HARPER

WITH SAM BARRY

FOREWORD BY
BEN HARPER

CHRONICLE PRISM

Library of Congress Cataloging-in-Publication Data
Names: Harper, Ellen, author. | Barry, Sam, author. | Harper, Ben, 1969-
writer of foreword.
Title: Always a song : singers, songwriters, sinners, and saints : my story
of the folk music revival / Ellen Harper with Sam Barry ; foreword by
Ben Harper.
Description: [1st.] | San Francisco : Chronicle Prism, 2021. |
Identifiers: LCCN 2020034418 | ISBN 9781452184241 (hardcover) | ISBN
9781797201603 (paperback) | ISBN 9781797201580 (ebook)
Subjects: LCSH: Harper, Ellen. | Folk singers--United States--Biography. |
Folk Music Center (Claremont, Calif.)
Classification: LCC ML420.H1616 A3 2021 | DDC 782.42162130092
[B]--dc23
LC record available at https://lccn.loc.gov/2020034418

Manufactured in the United States of America.

Typesetting by Maureen Forys, Happenstance Type-O-Rama.
Typeset in Baskerville Pro, Acre, Omnibus, and Benguiat Caslon.
Cover design by Sara Schneider.

Some names in this book have been changed
to ensure privacy and confidentiality.

10 9 8 7 6 5 4 3 2 1

Chronicle books and gifts are available at special quantity discounts to corpora-
tions, professional associations, literacy programs, and other organizations. For
details and discount information, please contact our premiums department at
corporatesales@chroniclebooks.com or at 1-800-759-0190.

CHRONICLE PRISM

Chronicle Prism is an imprint of Chronicle Books LLC,
680 Second Street, San Francisco, California 94107
www.chronicleprism.com

For Judy Ritchie, who has been a friend, confidant, and kindred spirit through husbands, kids, grandkids, dogs, cats, jobs, and fifty years of sharing books

CONTENTS

FOREWORD

BY BEN HARPER

My mom's life has been as deep and vast as the many names and roles she has carried: daughter, sister, mother, friend, wife, mother-in-law, grandmother, Chase, Harper, Verdries, Ms., Mrs., Dr., teacher, musician, and my personal favorite, Ma.

Ma's rules were tough and not always appreciated, but looking back, I recognize how difficult it must have been to be a single mother raising three Black, nappy-headed boys on a shoestring budget in a white town. Sometimes this meant pancakes for breakfast *and* for dinner. Our pants received knee patches and our sneakers got Shoe Goo. Our family stood out in the neighborhood; even as children my brothers, Joel and Peter, and I knew we were different. We felt it. Ma always found a way to protect us from semi-concealed vitriol, to lead the way for three half-Black, half-Jewish boys to take our unique heritage and transform it into uncompromising strength, clarity, and fortitude. In other words, my mom took no shit from anyone ever. Full stop.

My mother always spoke truth to power. In sixth grade I was excited to embark on my graduation field trip. The whole class

was in line, ready to get on the bus, when the school librarian and principal pulled me out of line and informed me that, because of an overdue book, I would not be allowed to go on the trip.

I was crushed. However, being the product of political dissidents proved to have an upside. This injustice would not stand. I insisted that they call my mom immediately. Within what felt like one minute my mother was in the face of the school librarian, the principal, and every teacher, staff member, parent, and janitor within earshot. Ma demanded to see the library's checkout ledger, firmly stating that if she found one white kid in my class with an overdue book who wasn't also getting pulled from the field trip, she would immediately call the ACLU. I went on the field trip.

Our home was on Eleventh Street but I grew up in the Folk Music Center. I learned to crawl on the ugly yellow carpet my grandfather chose to brighten up what used to be a hardware store, and learned to walk by tentatively holding on to the guitars on the guitar wall, inching my way one hesitant step at a time from guitar to guitar. Very soon I walked, then ran, along the path of guitars, strumming each one as I zoomed past and backing up to catch the ones I missed. I was never told no, or stop, or don't touch. The Folk Music Center was where my brothers and I went after school, where we played and squabbled, snacked, and grew up. The Folk Music Center was Mom. It was my grandfather Charles. It was my grandmother Dot. It was family.

My grandmother taught guitar (and banjo, dulcimer, and autoharp) at the music center in the evenings, and when I was a young teen I helped her set up chairs and a chalkboard and watched the front of the store while she taught. Rather than doing homework I'd sneak a "thumb brush" or two in along with the group of guitar students. Not eagerly, though, because the music my mother and grandmother were playing wasn't what my peers and I were listening to.

After I graduated high school, I went to work for my grandfather in the repair shop and studied guitar repair with Jack Willock in Glendale. My world was guitars and guitar players, and it was impossible for me not to pick up every guitar I encountered and test it out. The Folk Music Center was my real education. It was where I heard Clabe Hangan's gospel-rich baritone, John Harrelson's blues, David Lindley's exquisite slide guitar, and Frizz Fuller's eccentric lyrics. I was hooked. The first shows I played were at Cal Poly, Nicks Caffé Trevi, the Starvation Café, the Claremont Folk Festival, and the Grove House.

Even as the gigs rolled in, I tried to keep up with the ever-growing demands of instrument repair/restoration and helping my grandma Dot behind the register. To this day I love repairing and restoring guitars, and there was a moment in my early twenties where it could have gone either way—luthier or musician. That was when my grandfather Charles, my central male role model and father figure, walked into the workshop and said, "It looks to me like you're spending more time playing the instruments than repairing them."

My grandpa had an inherent distrust of big cities, big-city thinking, big egos, and big business, especially in the music business. His interactions with professional musicians were often cantankerous. As a lifelong advocate of working-class folks, Grandpa Charles grew impatient with entitled musicians haggling with him over the price of an instrument. My grandpa and grandma were not about fame. But if you were a musician who loved music and played for family, friends, and community, they supported you.

I had a gig booked with Pat Brayer's Starvation Café concert series in San Bernardino, having just come off of the road touring as a member of Taj Mahal's "International Rhythm Band." By this time I had built a significant local following, and the place was packed. My grandmother Dot loved live music and I often

accompanied her to concerts featuring the likes of Allen Ginsberg, Sweet Honey in the Rock, and Pete and Peggy and Mike on their Seeger Family tour. And Grandma Dot never, ever missed a show of mine. Even after I had "made it," she would show up at my gigs with a quart of orange juice to be sure I was getting my vitamin C!

To my surprise, on this particular night, she arrived with my grandpa in tow, who never attended shows. The remarkable thing about my grandparents and the Folk Music Center they started is that every day, at any moment, someone might walk in, pull an instrument off the wall, and give them the best private show. My grandpa wasn't interested in concert performances, but on this night there he was, hard of hearing, and deeply concerned about losing his ace guitar repair grandson to the evil empire that was the music industry.

The next morning I arrived at my workbench, 7:30 a.m. sharp. My grandpa usually got to the shop before I did, but as a message to him that I had no intention of letting him down, I was crouched over an instrument when he came in, doing my best impression of a musician who wasn't in a post-gig haze. He walked to my workbench and pulled up a work stool. "How did you feel about the show last night?" he asked. "Do you think it's something you would want to do more of?"

I didn't want to let down the one man who had ever extended himself to help me, who had unconditionally loved me in spite of myself. "It was really hard on the nerves," I mumbled, "and I'm not sure if I'll do it again."

This comment hung in the air for what felt like an eternity. Finally, Grandpa Charles took a deep breath, looked me straight in the eye, and said, "Well, that's a shame, because I think you have a calling." That may have been the most important thing anyone ever said to me.

I was twenty-three when Jeff Ayeroff signed me to Virgin Records and twenty-four when my first album, *Welcome to the Cruel*

World, was released and I began crisscrossing the country on tour in a van with my band, gigging nine months out of the year. The impossible dream was close at hand. I was a young musician on the road. This was not a time in my life when I thought about singing with my mother. In fact, nothing could have been further from my mind. But deep inside I knew the early influence of my family's musical traditions was a major source of my creativity.

As long as the Folk Music Center exists I will call it home. It has traveled with me across the world and back too many times to count. During my journey I have learned that home is where you run from, and then run to. The idea of recording an album with my mother began brewing in the back of my brain, and over time I wrote a few songs and tucked them away for this very purpose. In August 2013, we recorded the collaborative mother-son album *Childhood Home*. I'm as proud of this album as I am of any of my other studio albums.

The struggles my family endured, the brave and unwavering stances they took in the face of bigotry, injustice, and the blacklist, and the extraordinary life I had growing up in the Folk Music Center all shaped my life and infused my music, politics, values, and perspective. However, it is my mom's music, the sound of her voice and guitar, along with her eclectic record collection (which she gave me immediate access to the day I was tall enough to reach the turntable), that played the pivotal role in shaping my musical path.

My mom has lived and is living an extraordinary life. In reading this memoir, I have come to understand and appreciate the many sides of Ma. It's given me the opportunity to bond with mom the child, and it is a special moment when the child and the parent are able to truly see one another as both. I am deeply touched by her story, and I can't wait to see what she sets out to accomplish next.

VOICES OF THE PEOPLE

My life has seen an endless flow of musicians, activists, and artists eddying through my home and the Folk Music Center my parents founded and I maintain today. Some were musicians who played and sang for a living. Others played and sang for the sheer joy of it. They were working people, union people, family people, and traveling people. Some had money and some were broke. Some had recognizable names—Doc Watson, Jean Ritchie, Hedy West, Sonny Terry and Brownie McGhee, Pete and Mike Seeger, Joan Baez—but most did not. What all these musicians, music lovers, pickers and players, songwriters, painters, poets, dancers, political activists, and their husbands, wives, and children had in common was singing. Singing was essential. Everyone's voice mattered, regardless of fame, or skill, or any other label. Community mattered. We were all singers, and singing could change the world.

My mother, Dorothy Udin, gave me a great gift: the world of folk music and folk musicians. She sang me to sleep with mournful lullabies from Eastern Europe, the British Isles, and the American South. She taught me the power of music through the work of great folk singers and musical ambassadors such as

Pete Seeger and his *American Folk Songs for Children* and Woody Guthrie's *Songs to Grow on for Mother and Child*—the joyous, raucous albums that inspired and empowered me. I grew up listening to her giving music lessons. My ears were filled with the music of hootenannies and song circles; the glorious sing-along music of the union, civil rights, and antiwar movement songs; along with the blues, hymns, and gospel tunes that undergirded them. I took up the guitar and learned to play the songs I had been singing my whole life, including the beloved folk classics "Gold Watch and Chain," "Goodnight, Irene," "So Long, It's Been Good to Know Yuh," "Single Girl, Married Girl," "Midnight Special," and dozens more.

I developed my own musical passions. I embraced the music of my generation—folk rock, rock and roll, and psychedelic rock. I joined my fellow musicians and explored the sources of our music, such as Delta blues and country music. I discovered that all these genres grew from the same roots, the music of generations of anonymous musicians who made music for their lives and communities, the music that we call folk. Not the commercial-variety folk music that bloomed and faded in the 1950s and 1960s, but the legacy of the *voices of the people* expressed in poetry and lyrics that shaped my life, my musical taste, my style, and ultimately the music of my children. Throughout my life the traditional folk songs I learned at my mother's knee have always been in me, old friends that speak the wisdom of the ages as I faced new challenges.

Folk music is a living art form that tells and retells its history, even as it creates it. As with any vital art form, there are passionate debates. The very term *folk song* is contentious. Blues musician Big Bill Broonzy, upon being asked "What is folk music?" is purported to have answered, "All music is folk music. I ain't ever heard a horse sing," a comment that unleashed a decades-long feud among musicologists about the origins and definition of folk music.

Ultimately what matters is that the music lives on, enriching our lives. We know enough. We know that American folk music originated in the oud strummers of the Middle East; the lute pickers of Europe; the balladeers and bawdy pub singers of England, Scotland, Ireland, and Brittany; the fiddle bowers of eastern Europe; the *n'goni* pluckers of Africa; the chants, plaints, calls, and hollers that came from everywhere to the New World, bringing lyrics, melodies, marches, and polyrhythms that invented and expanded the American musical horizon forevermore. No matter how much Americans tried to segregate themselves, the music ignored boundaries and slipped in and out of parochial communities, creating something bigger than the sum of its parts: American music. The folks who created folk music borrowed, stole, shared, and learned from each other until the music became something distinctly American, something that went on to influence world music, which in turn influenced American music.

For me, a good song is a good song. Defining folk music is best left to the experts. What matters are the songs, which connect us across generations and cultures. What matters is the singing.

The community and the social and political activism that are as integral to folk music as the music itself are woven throughout my story—our story. It begins in New England during the early days of the folk music revival and travels through the fear and hatred of the McCarthy-era blacklist that drove so many nonconformists, bohemians, leftists, and ordinary people who believed in a better world—including my father—out of their jobs and underground. Forced to leave our home, we moved to the West Coast, and my parents founded the Folk Music Center and went on to play a vital role in the 1960s folk boom that impacted the counterculture and its music—influence that reverberates to this day.

Always a Song is the story of the challenging, transformational times in which I have lived, loved, and sung, from the dawn of the age of the singer/songwriter as the premier artist and the guitar as Western music's dominant instrument, accompanied by the popularization of new, "exotic" instruments such as the sitar and the ukulele, and the legacy of love-ins and decades of protest movements. *Always a Song* is my witness of the world of folk music that is the fuel and inspiration of American music. It is the story of the extraordinary times in which I have lived and the people who have flowed through my world with a song for every reason—songs about hardship and good times, songs of love and loss, songs of hope and hurt, songs of endurance and solidarity, and some songs just for fun—but always a song.

PEACE THROUGH MUSIC

"I had a crush on Charles from the moment I saw him. He was tall and handsome, with hazel eyes that drew me to him."

My mother tells me stories about her youth, reminiscing as she brushes and braids my hair. "The first time we went out together he took me for a walk through the sugar maples. He held my hand and it was a magical moment. I was a short, olive-skinned, black-haired, brown-eyed Jewish girl, not glamorous or tall like some of the girls that visited his farm. I couldn't believe someone like Charles would take an interest in someone like me. The second time we were out walking together, I twisted my ankle. He carried me back to the farm, brought buckets with warm and cold water for soaking, and gently massaged my ankle until it felt better. I was madly in love. But then Charles said, 'You have the funniest-looking feet I've ever seen. They're square. I could never marry anybody with such funny-looking feet.'"

Never say never.

In 1938 my father, Charles Chase, asked my mother, Dorothy Udin, to marry him. He was twenty-four, and she a tender

eighteen. Dot, as she was known, was studying art at Boston University, but as soon as she accepted Charles's proposal, she quit school. She went from being a city girl studying art to helping her future mother-in-law, Elba, on the Chase family farm in Washington, New Hampshire.

My paternal grandfather Fred Chase's ancestors arrived in the New World in 1636. His mother, Elba, a first-generation Jewish immigrant from Tukums, Latvia, arrived in 1903. She met Fred in the Socialist Party in Boston. Elba spoke Yiddish, German, Russian, and Lettish and learned to speak impeccable English. The unlikely couple fell in love, engendering disapproval from family members on both sides but especially the Chase side. Bad enough that Fred became a socialist. But marrying a Jew? Unforgivable. Fred and Elba purchased a small farm in Washington, New Hampshire, and subsequently had four sons and a daughter.

During the Depression, Fred took work building a dam across the Ashuelot River for the Works Progress Administration to bring in some money for his cash-strapped family. Not long after, his rheumatic heart gave out and he died in 1933, leaving my grandmother with the two younger children still at home. In dire need of income, Elba took in well-heeled but progressive-thinking boarders from New York and Boston to help make ends meet. My father stayed on at the farm to help his mother with the rigorous chores and obligations of subsistence farming, and my mother, taught by her mother-in-law, learned to prepare huge and delicious meals from sparse resources to feed the guests vacationing in the picturesque setting and enjoying a taste of country living.

"Couldn't you have done art school first?" I ask her, knowing how much she enjoys sketching and painting.

"I loved art school, but I didn't have any choice," she tells me. "I loved your father more." My mother—as did most women of her era—set aside her own dreams to follow her man. But it is a

love story just the same. It was the last years of the Depression. Charles and Dot couldn't afford a wedding and went to a justice of the peace for their ceremony. In their wedding photo Dot wears a belted shirtwaist dress with a white scarf and saddle shoes. Charles looks handsome and debonair in a blazer and tie. He gazes out past the camera, his arm around my mother's shoulders as she looks adoringly up at him. After the wedding, my parents packed a tent and supplies and headed out in their Model A to camp on the shores of Umbagog Lake in the wilderness between New Hampshire and Maine. Unfortunately, their timing was terrible, because they arrived at the lake just as the Hurricane of 1938 was poised to strike New England. Weather predictions were unreliable, and the newlyweds had no idea what was about to dash their hopes for a romantic honeymoon: One of the deadliest natural disasters in American history was headed straight for them.

They were rowing on the lake when the storm hit. My father fought the roiling waters and raging winds for all he was worth, his entire being focused on getting safely to an island in the middle of the lake. Finally, exhausted, wet, and miserable, they stumbled ashore. Once landed, they needed a place to wait out the storm, and the first shelter they came upon was a big, empty vacation home. Without a second to spare they broke into the house and felt their way to the kitchen, where they lit candles, gathered blankets, and settled in for the night.

Outside, the hurricane raged. Search parties combed the campground and surrounding wilderness for signs of my parents. When none were found, they were presumed to be dead—among the more than seven hundred who would, in fact, die in that cataclysm. After the worst of the storm passed, my parents made their way back to the campground where they had intended to stay. It was obliterated. Not one shred of clothing, not one bit of camping gear, not even a fender from the Model A remained, just a tangle

of downed trees and windswept riverbanks. It was then that they began to grasp the magnitude of the storm and the tragedy they'd barely escaped. But gratitude and rejoicing had to wait; the first order of business was to find the road home.

My life begins in a small hospital in Exeter, New Hampshire, on February 19, 1947. It is an ordinary winter day in the Granite State; in other words, we are in the middle of a snowstorm. I am the third child to join the family; my sisters, Susan and Joanne, are quickly deposited at the neighbors' as my parents navigate their way through the blustering wind to the hospital. Having given birth twice before, my mother has ideas of her own about how she wants to bring her third baby into the world. She is very fortunate to have found a progressive doctor, Dr. McGregor, who has delivered many postwar babies to mothers who had worked in factories, managed farms and families, and worked ad hoc jobs contributing to the war effort all on their own while their men were overseas. My mother is among a small group of women in the graduate student dorms at the University of New Hampshire who challenge the status quo of labor and delivery.

"No drugs," she tells the doctor. "I want to be awake. I want to be the first one to hold my baby, and I can't do that if I'm drugged and asleep." This is highly unusual for the 1940s. It is a time when doctors, who are almost all male, routinely drug laboring mothers into a "twilight sleep." Even if a woman protests, a doctor and the nurses are likely to insist. "Doctor knows best," they condescend. But my mother is insistent, and Dr. McGregor knows better than to argue.

"Have it your way," Dr. McGregor says, chuckling. On the day of my birth, he shows up, meerschaum cigar holder clamped in his teeth, looking for all the world like President Franklin Delano

Roosevelt. He is a cheerleader, encouraging my mother to breathe through the pain. Squinting his eyes to avoid the cigar smoke spiraling to the ceiling, he catches me as I slip into the world, spanks me, and puts me to my mother's breast. He then finds my father pacing in the waiting room with several other anxious fathers-to-be, beckons to him, and allows him to visit my mother and me for the moments before the nurse whisks me away to the nursery.

The very next day my mother heads home, marveling at her energy and her wide-awake, undrugged baby. My father is also happy, and claims—as he will for years to come—not to care that I wasn't the hoped-for boy.

My birth is unusual for the time but not exceptional for my family, which is predisposed to making unconventional choices. Not only does my mother want a natural birth when drugs are routinely administered, and to breastfeed during a time when man-made formula is touted as the best food for a baby, but she also isn't inclined to prioritize housekeeping over creativity. While other young wives and mothers in the neighborhood are trading recipes and comparing brands of detergent, my mother paints and sketches and plays the banjo.

My mother encourages my sisters and me to follow our own pursuits, managing to keep us busy so she can pursue her own. We girls are always well supplied with paints, crayons, colored pencils, drawing paper, yarn, knitting needles, shelves of books, and board and card games to keep us occupied inside during the long winters. My mother, a speed skater in high school, loves to skate. She puts me on double runners and takes me out on the ice as soon as I can walk. In the winter we ride sleds and flying saucers; in other seasons the yard is littered with tetherball, croquet, and badminton equipment. In my mother's never-ending quest to burn up some of my energy, she also provides me with multicolored bouncing balls, jump ropes, and chalk for hopscotch.

My mother sets a good example for keeping oneself entertained. With all her artistic pursuits, social life, and family responsibilities, sometimes it's difficult to get her attention. I have an annoying habit of sneaking up on her while she's playing the banjo and dampening the strings with my sticky little hand. In the second between her surprise and shooing me away, I list my current demands.

Our record player is working seven days a week. My mother is either listening to her records for pleasure or to learn new tunes and accompaniments on the banjo. Joanne and I are addicted to *The Lone Ranger*, and every evening we tune in to the radio broadcast no matter what else is going on. I have also become enamored by my parents' album set *The Lonesome Train*, originally a radio play—or ballad opera—from the '40s written by Earl Robinson and Millard Lampell, and request it constantly, ignoring my sisters' "Ma, not again!" It takes three albums to tell the story of the train carrying Lincoln's body from Washington to Springfield. It's a dramatic story of all the different kinds of people from each city along the tracks who have come to mourn a beloved president and say goodbye. I especially love the refrain backed by the muffled *chug, chug* of the sad train rolling along:

> *It's a lonesome train on a lonesome track*
> *Seven coaches painted black*
> *It's a slow train, a quiet train*
> *Carrying Lincoln home again*

My mother learned to play banjo and guitar from Bess Lomax Hawes—daughter of John Lomax and sister of Alan Lomax, who rank among the world's great folklorists. A renowned folk singer and folklorist in her own right, Bess had sung with the pro-union, antifascist folk music group the Almanac Singers, which included the folk luminaries Millard Lampell, Lee Hays, Pete Seeger, and Woody Guthrie.

Bess teaches guitar and banjo classes at the Hecht House in Boston, and my mother is one of her first students. My mom is a quick study, and it isn't long before she transitions from student to teacher, and Bess comes to rely on her to meet the overflow of students. When Bess leaves Boston for California in 1951, she entrusts my mother with all of her guitar and banjo classes. My mother now teaches two nights a week: two banjo classes one evening, two guitar classes on the other. When I see my mother gathering up her instruments and folders of song sheets, I beg her to bring me along. Since she is now in charge, she sometimes relents, sitting me in the back of the room with colored pencils, paper, and a snack. My mother loves teaching, and I like seeing her in charge. I also like when she begins each banjo class with the traditional square dance song "Skip to My Lou." I sing along under my breath:

Fly's in the buttermilk, shoo fly shoo
Skip to my lou, my darlin'

Just as he used to visit the classes of his old singing partner, Bess, Pete Seeger shows up unannounced to my mother's classes from time to time when he is in the Boston area. Pete, who can't resist a crowd or an opportunity to teach, stops by Hecht House with his long-neck banjo to contribute his considerable talent for getting everyone singing and to help Dot with the large classes. Pete always takes a minute to say hi to me and asks about my drawing. I have no idea that he is famous, but it doesn't matter. All I know is that he is the tallest person I have ever seen. I have to crane my neck to see his face when he stands over me.

Most of the students in Mom's banjo and guitar classes are young adults, but many students are starting music lessons in middle age or older. Many of them had been told as children that they didn't have good singing voices or were tone-deaf. The voice

is an integral part of human identity, and one negative comment can damage a person's musical self-confidence forever. Dot understands this very important aspect of teaching music, which is why Bess is comfortable putting Dot in charge of her classes.

Dot gets her students playing and singing within the first five to ten minutes of class. Her students' faces brighten and their bodies relax the moment their fingers are on the strings and strumming with the group, making real music. Immediately they know they can be musical, too, and they come back to learn more, week after week. The school blossoms into a community. The Hecht House teachers gather their students regularly to perform at hootenannies and open mics and bring folk musicians to town for everyone's enjoyment.

Folk music events are a constant in our lives. They are also family affairs. At an outdoor concert in a park one warm summer evening, my mother insists that I sit on her lap, but sitting still and listening quietly are not exciting for a small child. I wait for her attention to be diverted, and then I wiggle away and run in the aisles with other small children—that is, until she captures me and tells me to quiet down. We are about to hear the singer Paul Robeson, and she wants me to pay attention.

My parents are pleased when Pete Seeger introduces them to Robeson—not only because he is a famous actor and singer but also because of his efforts on behalf of civil rights. We feel in his music the promise of a better way for everyone.

"Even if you don't remember it when you grow up," my mother says to me, "you met Paul Robeson."

During my childhood years, Boston is growing as a vibrant hub for all the wonderful community and culture that is possible in a fascism-free postwar world. Boston is fertile ground for the intertwining of politics and folk music. Politics lends folk music gravitas, and the music gives the politics heart and joy. My artist and musician mother, with her politics of peace, finds a natural

home there. Guitars, banjos, and singing are the glue of our life. Folk songs and food, folk songs and politics, folk songs and picnics, folk songs and friendship—they all fit together.

My mother's friends like to gather in each other's homes, with families in tow. They hold dinners and songfests, talking about music, politics, social unrest, and the news of the day, while sipping wine or coffee. At some point in the evening, in response to some mysterious signal, they retrieve their guitars, banjos, mandolins, and maybe harmonicas or musical spoons, and start playing—each voice and instrument finding its place in the spontaneous folk choir, the sounds lilting throughout the house and yard where we kids are playing games like tag and hide-and-seek. We run around like banshees, shouting as we go, eliciting occasional admonishments from our parents, who want us to *calm down*.

My mother, with her banjo or a guitar in hand, is always in the thick of these gatherings. She favors laments like "Careless Love" and "Down in the Valley" and Woody Guthrie's "Union Maid." "This Land Is Your Land" and "So Long, It's Been Good to Know Yuh" are also favorites, as is Joe Hill's "The Preacher and the Slave." My own favorites are Pete's songs "Banks of Marble" and "If I Had a Hammer," songs that are catalysts for social change, although I'm not aware of those nuances yet—I just know I like the catchy tunes, and the words. *If I had a hammer . . . If I had a bell . . .*

One evening we are gathered at Bess and her husband Butch Hawes's house when Pete Seeger arrives. We kids are playing a thunderous upstairs-downstairs game of tag when Pete shouts for us to come to the living room.

"Kids! Kids! Come on and gather 'round," he yells in his swingy cadence. "Everybody come gather 'round!"

One by one, we kids filter out of the shadows, surprised. We look at each other and shrug our shoulders, and gamely head toward Pete and the other adults, still trying to avoid the "it" person.

Pete has done as much as anyone to spearhead the folk music revival. His influence is global: He is a members of the Weavers, far more commercially successful than the Almanac Singers but equally political in outlook. Pete sings and writes songs and anthems for the labor movement, civil rights marches, environmentalism, and antiwar causes. The adults know his legacy is large and not yet complete.

But to us kids, he is just our pal. We traipse into the living room, and Pete has us sit in a circle, quickly soothing our wound-up energy so we can sit quietly cross-legged on the hardwood floor. Pete is a tall, wiry man, dressed in a comfortable flannel shirt and sweater, and it seems to me that he is always ready for anything—from leading a spontaneous rally to sitting on the floor with children. In what feels like slow motion, he folds up his long body like the jointed yardstick in my father's toolbox and lowers himself to the floor, all knees and elbows.

"I've just returned from a place I've never been to before, a place across the ocean," Pete says in his storytelling voice, and I know we are in for a lengthy disquisition.

Pete has just returned from a trip to the Caribbean islands, where he became intrigued by the musical steelpans, or steel drums. One of the very few new acoustic instruments invented in the twentieth century, steelpans are made from empty fifty-gallon oil drums left behind in Trinidad by tankers from the Caribbean oil ports, he explains. The bottom of the oil drum is hammered into a convex shape, and then small dents are made to create notes. There are all kinds of steelpans, he says, all with different note ranges, from the bass to soprano line. Pete has some pans with him, and he demonstrates their sounds for us. Then he lets us each take a turn playing with the rubber-tipped mallets, which we do while surreptitiously tagging the new "it" person from our game of tag.

By the time Pete finishes his demonstration, and we've all had our turns with the pans and mallets, the night has grown late. Still, my father wants to know more about the pans—he is fascinated by how things are made and has a passion for making things from found objects. So he and Pete discuss steel drums while the other parents gather kids and coats and baking dishes.

When we are finally in the car, I collapse dramatically in the back seat, groaning and rolling my eyes.

"Aaghh. That was *soooo borrrrring.*"

My sisters laugh, but my mother isn't amused. "You don't know how lucky you are to learn from Pete," she says.

She is right, of course.

My parents move five times in as many years after my father's graduation from the University of New Hampshire, which was paid for by the GI Bill. First stop is a year with my mother's parents in their large house in Newtonville, Massachusetts, while he attains a credential from Boston University for teaching high school math and English. His first job is in Vermont. Then we move back to Massachusetts. With some teaching experience under his belt, my parents are ready to choose a place to settle down.

When I am six years old, Dad accepts a teaching job in Quincy, Massachusetts, not far from Boston. We move into the home at 189 Sea Street in North Weymouth, a neighboring town of Quincy. The house was built by a sea captain in the 1790s, and the previous owner, the last in the long line of a distinguished seafaring family, had lived there her entire ninety-some years. With the exception of installing electricity and an indoor sink and toilet, she had made no significant changes to the house. Then, after her death, some roughneck neighborhood boys broke in and trashed the place,

leaving a mess of torn-up ancient magazines and newspapers, knee-deep piles of feathers from shredded pillows, ripped-out brickwork, and broken glass. They topped off their work by urinating on the entire mess.

My father looks past all the problems and sees the bones of a wonderful old house—one that looks like shambles but had been built to last. My parents see value in preserving and bringing to life the historic beauty of the house. Full of optimism, they get to work on creating a home.

My father attacks the kitchen first. Once cleared of debris, it turns out to be mostly intact and functional. Iron bars for holding kettles and soup pots swing out of the brick fireplace, a contraption my father calls "the crane." His devotion to craft blossoms and he spends hours on his hands and knees reconstructing the original pattern of bricks for the hearth. We live in the kitchen while the rest of the house is slowly restored.

There are two staircases. The large staircase in the entryway leads to the upstairs gallery. It features a newel post and a landing by the big front door, which traditionally would have been used only for dignitaries, such as a visit from the minister, or events such as weddings and funerals. Over the door is a classic sunburst with the original leaded glass. The other staircase tucked away by the kitchen was for the maid, whose room would have been in the attic. The only thing in the attic now is a large trunk with some old relics in it: a tool for making bullets out of molten lead from the Revolutionary War, a powder box, a framed needlework piece that reads THE LORD WILL PROVIDE, and some ancient rolled-up pieces of cloth-like paper that my father identifies as wallpaper remnants. It is from these pieces that my parents design the rooms in the house, staying as close to the original as possible.

They decide to keep some of the furniture that was left behind in the living room. The Victorian sofa and chairs have the original

horsehair stuffing and velvet upholstery. They look grand but are a menace to sit on, especially when wearing shorts in the summer. When we aren't reading, our indoor activities take place on the living room's carpeted floor.

The blue room is Sue's bedroom; the captain's room, built like a ship's cabin, goes to Joanne; the green room is my parents' bedroom; and the rose room is mine. One of my walls has a fireplace and my windows face the front of the house, providing a view across the sweep of lawn and the twin Dutch elms near the street.

My parents restore the entire house with such loving care and attention to detail that it is designated a historical monument by the state.

THE BLACKLIST

My first-grade teacher literally ruled her classroom with a ruler, which she brought down frequently and painfully on the back of my hand whenever my finger pointed to the words on the page as I read. So second grade is a considerable improvement. My second-grade teacher is a soft-spoken young woman who wears her light brown hair in a loose bun and dresses in tweed skirts, prim blouses, and cardigans in shades of beige, like her hair. I like her. I have friends, and I belong. As far as I'm concerned, we should stay in Weymouth forever.

We visit my grandma Elba, my father's mother, in New Hampshire. She makes me hot chocolate and biscuits when I visit and tells me I'm too skinny. She lets me help tend her birdfeeders, saying "The birds need fat to get through the winter," as we stick a piece of suet in each feeder. In the hottest days of summer, Elba fires up her wood stove to cook and can the gallons of blueberries my cousins and I pick, canning enough to get us through winter. She is a midwife and nurse and delivers most of her neighbors' babies. She knows how to braid rugs into works of art, organizes the first

birth control clinic in New Hampshire, and runs for governor of New Hampshire (and loses) three times! She is one of my heroes.

That spring an article appears in the right-wing newspaper the *Manchester Union-Leader* naming Elba as a communist and accusing her of fomenting revolution. Young as I am, I understand what this means. My grandma Elba is being accused of being disloyal to the nation.

Now my amazing grandmother is in a jail cell, arrested for being a communist. I am shocked and confused and frightened for her. "Don't worry," my parents tell me. "She'll think of something. She'll be fine."

Three days later she is released from jail. The head of the Lawyers Guild of New Hampshire argues that she had not broken any law, and the court is forced to let her go. Still, she is called before the House Un-American Activities Committee of New Hampshire—a state version of the United States HUAC, which is terrorizing people with leftist connections who are (as they see it) fomenting revolution.

My grandmother is undaunted. She appears before the committee and declares that the New Hampshire State Constitution codifies her right of revolution under article 10, which is conveniently titled "Right of Revolution":

> Government being instituted for the common benefit, protection, and security, of the whole community, and not for the private interest . . . whenever the ends of government are perverted, and public liberty manifestly endangered, and all other means of redress are ineffectual, the people may, and of right ought to reform the old, or establish a new government. The doctrine of nonresistance against arbitrary power, and oppression, is absurd, slavish, and destructive of the good and happiness of mankind.

After the hearings, the FBI track Grandma Elba's every move. Agents listen to her phone calls and intercept her mail. Most of the letters are to and from her sons and detail the workings of the farm. They arrive with words like *cow* and *baby* flagged and *Khrushchev* and *communist cell* scrawled on the page, which are the FBI's clumsy attempts to decode what they think are secret, subversive messages. Ultimately the FBI is forced to admit that my grandmother is simply asking her sons for help on the farm.

Grandma Elba waves the episode away, but the saga doesn't end there. The *Manchester Union-Leader* continues its campaign of intimidation, publishing an article that names her four sons and identifies my father's place of employment.

It is 1954, and the United States and the Soviet Union are locked in a competition that is defining world and local politics. It is the beginning of the Cold War, and the United States is gripped by anti-communist hysteria. Hyper-conformism is the order of the day. Communists, socialists, civil libertarians, activists, musicians, artists, homosexuals, academics, union organizers—anyone perceived as different—are painted with the same broad brush and condemned as unpatriotic, subversive, and worse.

Famous artists, Hollywood directors and writers, composers, and political figures are called before HUAC in Washington, DC, to confess their allegiance to the Communist Party and name names. Those who refuse to cooperate are blacklisted. Many lose their livelihoods. Some go underground; some leave the country. Everyone is on edge.

My father joined the Communist Party in 1933, during the depths of the Great Depression. He was eighteen years old and, like millions of other Americans, in need of work. The party offered my father hope and meaningful work, sending him to rural Pennsylvania to help a farmer named Bentzley.

Comrade Bentzley was married and had three children. He was suffering from ulcers and needed help on his farm. He also needed help with the penny auctions he organized throughout Pennsylvania to save farms from the flood of bank foreclosures caused by the Depression. He taught my father how to organize the neighboring farmers. On the day of a bank auction my father and Bentzley spread the word among the farmers to make low bids—a penny for this, a nickel for that, bidding on tractors, cows, horses, farmhouses, and land, spending as little as twenty or twenty-five dollars for entire farms. After the auction, they would give it all back to the original farmer.

The banks called in law enforcement to put a stop to this practice, but by the time the sheriff and his deputy arrived, word had spread among the farmers. Most supported my father and Bentzley's efforts, well aware that it could be their farm on the auction block next. At one auction my father and some of Bentzley's friends found it necessary to confiscate the sheriff's and deputy's guns.

"While the sheriffs were threatening the farmers, Bentzley and I quietly organized a group of men that circled the officers and suggested they walk behind the barn, where we encouraged them to surrender their firearms," explains my father. "No one knew what to do with the guns. Bentzley was afraid to keep them and convinced me to take them back to New Hampshire. I was scared the whole time. I traveled home with two Colt .38 Police Specials in my suitcase. I hid them in the hayloft."

By the time World War II came along, my father had separated from the Communist Party. He believed in the fight against fascism and supported the causes the Party fought for—free speech, higher wages, better working conditions, labor unions, civil rights—but he thought it was a mistake for American communists to affiliate with the Soviet Union. He believed that the Communist Party in America should be a party of resistance and protest, not

revolution. Because of these views, in 1946 the party leadership deemed him an "inadequate member."

These subtleties mean nothing in the McCarthy Era. A communist is a communist. We've been living in North Weymouth for nearly a year when my father is notified that he is suspended from his teaching job. The State of Massachusetts Special Commission to Study and Investigate Communism, Subversive Activities, and Related Matters investigates his "communist connections," and until further notice he may not return to work. Undaunted, my father goes on the radio to argue his case. He is dismayed at how unfriendly they are at the station, but he perseveres, telling anyone who will listen that the American Communist Party poses no serious threat to the United States and emphasizing how important it is to be true to America's highest values in the face of the current "popular excitement."

His radio appearance doesn't help. One day two men in dark suits arrive at our house and pound on the front door. My mother steps outside and shuts the door behind her, not wanting her children to witness the conversation she fears is coming.

"FBI," they say. "We're here to investigate Charles Chase for communist activity."

My father is repairing the old shed behind our house. My mother hopes he'll stay put, but when he hears the ruckus, he comes around the corner with a hammer in his hand.

"I suppose you've come to help me get my job back," he quips to the agents.

The agents leave, but my parents know the scrutiny won't end there. Before long, my father is summoned to appear before the Special Commission. He appears as commanded, but refuses to repudiate the Communist Party. He reiterates that he is not a

member but insists that the party's principles and goals are not a threat to the nation. We are proud of him for his principled stand, but as soon becomes clear, the result is his teaching career in New England is over. On July 5, 1954, the school board holds a closed-door meeting. My father is not present. The board determines that my father's refusal to renounce the party and name names before the Special Commission should result in his permanent dismissal.

My father is outraged. In a letter to the School Committee of Quincy, he writes,

> I have risked my life for my country and seen others give their lives. I have prayed for a peaceful world and seen whole countries ravaged and ruined. These things I have seen and these things raise questions in my mind . . . I have sought the answer in many political parties: Communist, Republican, Progressive, Democratic, Farm Labor. Each has had part of the answer but no party has had all the answers . . . My way of life has taught me above all else to put my faith and my belief in the growth and development of young people.

A small group of parents come to his defense, hoping to reverse the situation. One mother writes a letter to the *Quincy Patriot Ledger,* declaring that she is "heartsick" over his suspension, adding that two other mothers she spoke with said "he is a high grade gentleman and wonderful to the children . . . the children are crazy about him."

None of this matters. The job is gone, and we are bereft.

Life in North Weymouth becomes painful and bewildering.

"Go back where you came from, commie Jews!" the townsfolk yell. These are our neighbors, people who had been our friends.

On the playground during recess, children grab my head to see if they can feel my "Jew horns."

One morning, I am walking to school when I feel a sharp pain in my back. I look up to see a Coke bottle rolling on the sidewalk and a carful of boys passing by. I run home, crying.

"Lucky it wasn't your head," says my father, unflustered. "You're smarter than any of them. You'll be fine." He sends me off to school again.

Staying home is also a risk; the FBI has threatened to take my sisters and me away if we miss too many days of school. Heartless as it may seem, my father's flinty "Rise above it" attitude is the antidote for me. He is encouraging me to tough it out, and in truth I have very few options. The men of his generation are required to be strong, silent protectors and providers—the paterfamilias. Feeling helpless nearly destroys him, but if he can keep going, so can I.

I return to school with spine straight and chin up, but I spend all day, every day, with a constant, overwhelming fear that one day I'll come home from school and my father will be gone, sent to prison. After all, my grandmother had been jailed. Communists Julius and Ethel Rosenberg were arrested for spying on behalf of the Soviet Union. They were taken from their home and executed in 1953. The Rosenbergs had children. My father isn't the only one who feels helpless.

The popularity and confidence I felt before my father was blacklisted vanishes. Suddenly no one will talk to or be seen with me. My parents explain that the ostracizing isn't my fault and has nothing to do with me, but my seven-year-old mind comprehends only one thing: Suddenly people don't like me. I have no friends; I am alone.

I learn to be tough and to run fast. I yell "You're a dumb jerk" at a kid who threatens to punch me. I shove a girl twice my size to the ground.

These tactics don't win me back my friends, but they work—eventually, everyone steers clear of me. Being lonely is better than being under siege.

I learn lessons in the crucible of the McCarthy era that stay with me for a lifetime. Nothing is constant. Security is ephemeral. Control is an illusion. I am left with a nebulous yet perpetual fear that at any time a nameless force will sweep in and dismantle my life for good.

Home is no refuge. We are pariahs in North Weymouth, the town where I once had endless places to play. Bricks crash through our windows. One brick has a note tied to it that says, "Commie Jews, go back to Russia."

My mother, wanting to spare her children the grief of alienation, tries to find us new friends. My sister Sue, six years older than me, is an excellent student. She is pretty, with sky-blue eyes, clear skin, and a slight, endearing overbite. Sue finds sanctuary among the Society of Friends in nearby Quincy, Massachusetts, where her musical gifts are appreciated and she can escape the oppressive alienation of North Weymouth. When she is home, she accompanies herself on her favorite songs with an old Kay archtop guitar my father finds for her in an antique shop. I like it when she sings "Old Blue" because I like dogs, but I wish Blue wouldn't die in the last verse.

My sister Joanne wants to be the opposite of Sue. Four years older than me, Joanne is cute, short, and round, with brown eyes, curly brown hair, and a face full of freckles. In her estimation, Sue is "prissy," while Joanne herself is a "tomboy." Sue obeys the rules; Joanne makes her own. Her active imagination is compelling, and she often tries to recruit me into her wild schemes. One day, while climbing in the woods, she decides to play Tarzan, wrapping herself in what turn out to be poison ivy vines and leaping from

a tree. She urges me to join her, but I—luckily—choose to watch from a safe distance.

Joanne is more pained than any of us by the alienation and humiliation of the blacklist. Her feelings of self-worth plummet, and she interprets my father's instructions to be "tough" and "above the fray" to mean she should reject all of her former friends and find a new set of allies. She takes up with a group of outsiders, kids who are seen as "hoodlums" and "juvenile delinquents." Her new friends flaunt rules and are always in trouble. When my parents protest, Joanne shuts them out for creating this terrible situation. She refuses all solace and advice.

When she is home Joanne spends most of her time listening to rock and roll on her pink plastic AM radio. She likes Fats Domino, Chuck Berry, Elvis, and Bo Diddley and derides our mother's attempts to bring her back to the family by explaining that these rock and roll musicians are playing a form of folk music. Joanne scorns my father's suggestion that Bo Diddley's name is a play on the diddley bow, a single-stringed, homemade instrument originating in West Africa, one of many links from Africa to American blues and rock.

"You don't know anything!" she shouts, slamming a door in their faces.

I don't understand Joanne, and my parents can't explain her to me. I just want to be invited into her room to listen to rock and roll with her on the pink plastic radio. When she allows me in, it is the highlight of my day. I love Joanne's favorites as much as she does, but for me, listening to them is not an act of defiance. The driving rhythms and addictive melodies make me feel on top of the world, but I also like the ballads, tunes, ditties, sing-alongs, and activity songs my mother sings. I am torn between them: my mother pumping me for information about Joanne and Joanne rejecting me for being a tattletale.

After the Coke bottle incident, my mother, desperate for me to have friends, sends me to Sunday school at the local Congregational church. Intimidated by the mob-rule mentality of the blacklist, she reasons that everyone goes to church in North Weymouth, and a little conformity might help my situation. At least the church is Protestant, she says to my father, so it might be a little more open-minded than our Catholic neighbors. And so I, the seven-year-old daughter of an atheist father and secular Jewish mother, begin my religious education in an institution that my parents neither approve of nor participate in.

I take to church well enough. Sunday school is easy, and there are prizes to be earned. One contest offers a beautiful satin ribbon as a reward for memorizing a Bible passage, with the possibility of earning ten ribbons in every color of the rainbow. I covet the ribbons and enthusiastically participate in the contest. Each week I memorize and recite.

My father wants to question me about the Bible passages, but my mother won't allow it.

"Leave her alone, Charles," she says. My mother is happy that I am attending church each week, and is worried that my father's skeptical questions might deter me. "She's fine," she says. "Obviously she's taking this very seriously."

To all appearances, my mother's plan is working. Every week I go happily to church, where she imagines I am enjoying the camaraderie of my Sunday school classmates and the benevolent tutelage of my teacher. I come home content and motivated to learn. Finally, the week arrives when I recite my last verse and receive the last ribbon. I run home, triumphantly waving all the ribbons. `

"I won! I won all the ribbons!" I shout, proudly showing them off to my family, whose tepid response does nothing to diminish my joy.

The following Sunday I make no move to leave for church. My mother asks me why I'm not getting ready.

"Why?" I ask. "I have all the ribbons!"

My father laughs. My mother groans.

Beribboned, I am done with church.

That winter my mother discovers she is pregnant. She is thirty-five, which at the time is considered a late-in-life pregnancy, a high risk for complications for mother and child. At first she isn't worried, but early in her pregnancy my mother develops hepatitis from her doctor's contaminated needle when he is administering a blood test. (My mother isn't the only one. The doctor ultimately loses his medical license.)

We are all given gamma globulin shots and are fine, but my mother grows sicker and yellower by the day. My aunt Miriam, who is a doctor, is worried. She says nobody knows what hepatitis does to a fetus and sends my mother to a hospital in Boston, where the doctors agree that no one knows if hepatitis crosses the placental barrier. Their best guess is that it does not, but that is just a guess.

I am worried about my mother and the unborn baby and I'm worried that my father will go to jail. I voice my concerns to my father and sisters, but they tell me to stop whining. No one reassures me that everything will be okay. That is not the way of our family.

The truth is that none of us knows if *anything* is going to be okay.

From then on, I keep a stiff upper lip and do my best. My mother is sick in bed for what seems like forever, so I learn how to get myself ready for school. One morning as I am leaving, with my ponytail tangled and askew, our neighbor June Wright waves me over from her back stoop. Her husband, Herbie, has forbidden

her and their daughter, Carol, my best friend before the blacklist, to talk to me. He says it is dangerous for his job and the family's well-being to have anything to do with us—it would only bring them trouble. My father is blacklisted and I am banned.

But June beckons to me anyway.

"Don't tell a soul," she hisses as she ushers me into her kitchen. "Herbie'll kill me if he finds out you were here."

June pulls the elastic band out of my hair, sticks my head under the faucet, and gives me a shampoo. She combs out my snarls and brushes my hair into a smooth, bouncy, perfect ponytail. Then she sits me at her chrome-and-egg-colored Formica kitchen table and gives me a peanut butter and marshmallow fluff sandwich on Wonder Bread with a big glass of milk. We talk while I blissfully eat my sandwich and she blissfully drinks her first beer of the day. After we finish, I run to school so I won't be late.

This becomes our morning routine. After Herbie leaves for work at the shipyards and Carol leaves for school, I sneak over to the Wrights' house. June brushes my hair into a fashionable ponytail, feeds me a sandwich and milk, opens herself a can of beer with a gadget she calls a church key, and tells me stories about when she and Herbie were courting. She shows me a photograph of a much younger Herbie—he still had hair—standing beside June at Coney Island. In the photo, June, wearing a smart suit and a small hat perched on her finger-waved hair, looks boldly at the camera while Herbie's hands circle her slender waist. It is hard to believe this was the same person as the woman sitting across from me, with her ruffled apron and frizzy orange hair.

In a world turned upside down—where my father is being treated like a criminal and we are pariahs, where my mother is sick and the baby inside her might be, too—I have found a friend. Each morning June shows me her good-luck mustard seed pendant, her blue St. Christopher medal, and her gold cross with the entire

Lord's Prayer inside an itty-bitty magnifying bubble. It amazes me that I can read the whole prayer through that little bubble. I look forward to holding it in my fingertips. These morning meetings with June make a hostile world seem safer.

When my mother recovers from the hepatitis, she puts a stop to my visits with June and a quicker stop to my demands for sandwiches of peanut butter and marshmallow fluff on Wonder Bread. June goes back to drinking her first beer of the day alone, while I eat eggs and rye toast and keep an eye on my new sister, Sally, as our mother showers.

My father finds a part-time job at Grossman's gardening shop. He isn't shy about expressing his views on the injustices of being blacklisted, and one day one of the men he works with says, "Charles, why don't you give up talking about this firing business? Seems like we've heard enough of it. You're not getting your job back, so drop it."

My father thinks about this and decides it is good advice. From then on, we rarely talk about the blacklisting, or his job. But it still lives with us, ever-present, influencing every aspect of our lives.

When my mother is well enough, she returns to teaching music at Hecht House, organizing concerts, hootenannies, and workshops and designing posters and flyers to promote all the goings-on at the center. Much of our social life revolves around the Boston and Cambridge activists and artists who are connected through the Hecht House's activities and events. Some people come to the Hecht House through their left-wing politics and discover the music, while some come for the music and discover left-wing politics.

My mother's friends—including Manny and Leona Greenhill, Tony Saletan, the Afro–Puerto Rican folk singer Jackie Washington, and Irene Kossoy of the Kossoy Sisters—are unsung powers at

the heart of the early folk music revival. Manny Greenhill is the founder of Folklore Productions, the management and booking agency behind seminal folk and blues artists such as Pete Seeger, Bob Dylan, Joan Baez, Doc Watson, Taj Mahal, Reverend Gary Davis, and John Renbourn. Tony Saletan is a founding member along with Jackie Washington and Irene Kossoy of the Boston Folk Trio that the Kingston Trio will pattern themselves after. Irene and her twin sister Ellen's album *Bowling Green* ultimately influences folk singers around the world. (Their version of "I'll Fly Away" will be used on the *O Brother, Where Art Thou?* soundtrack.)

One afternoon at a picnic and folk concert in a beautiful tree-ringed park, a large group of friends and family from the Hecht House gather to sit on blankets and enjoy sandwiches, fruit, home-made cookies and brownies, wine and coffee, and lemonade for the kids. The Boston Folk Trio plays a set, and then a few people wander off to stroll along the river and soak up the sunshine. The kids play on swings and slides. I prefer to sit at the table and listen to an impromptu version of "Down by the Riverside."

Suddenly I feel a fierce pain in my thigh, like a burning stake driven deep into muscle. While the musicians continue their jamming, I scream and slap at the yellow jacket still stuck in my leg, forcing the stinger deeper. A woman in a flowing skirt and flowered shawl sees me flailing in pain.

"Hold still!" she commands, flicking the stunned insect away. She runs to the riverbank and back, slapping a handful of mud on my thigh, which is swelling and turning an angry red. Soon my thigh doubles in size and is hot and hard to the touch. I can't stop crying, so my parents pack up and we leave.

"You ruined everything!" says Joanne.

"It wasn't my fault!" I protest.

"You kind of did ruin the day," says my mother. She is reluctant to leave the fun for what appears to be an innocuous bee sting.

But as my leg becomes more inflamed and painful, my parents decide to take me to a doctor, who prescribes aspirin and Benadryl.

"And for God's sake, wash that filthy mud off of her!" the doctor says. "Do you want her to die of an infection?"

My parents are unmoved by the doctor's criticism, and I'm unmoved as well. Who cares if I'm clean or dirty? I have one thing I want him to know, the most important thing of all. I look into the doctor's eyes with all the pathos I can muster and declare, *"It wasn't my fault."*

One night, Pete Seeger comes to our house for dinner. He is so tall he has to duck under the lintel of the kitchen doorframe. He enters with a wide smile and greets each of us warmly, but my mother's overly buoyant manner piques my curiosity. She has something on her mind, and she must have invited Pete for a reason—something serious. My sisters disperse, but I hang around because my intuition tells me there will be important information exchanged this evening.

Over coffee and dessert, my mother takes a deep breath and brings up our struggle with the blacklist. We have been coping with it for more than two years by now, but it is rare that we talk about it. *So this is what my mother is up to,* I think. She wants Pete's help with my father's situation, and her idea pays off. Not only is Pete open with my father about his own experience with HUAC and the blacklist, but he honors my father for taking a stand against McCarthyism and the Massachusetts Special Commission. Neither Pete nor my father allowed themselves to be intimidated into giving names, and Pete feels triumphant about this.

Soon the two men are huddled together discussing politics and the impact of the blacklist on their lives, their friends, and the nation. Eventually, though—as often happens in my house—the

conversation turns to music. Before long, Pete and my dad are engaged in an intense discussion of banjos.

A few years earlier, my parents met an Episcopalian minister while protesting the Korean War at a peace rally on the Boston Common. The minister gave them an old Dobson banjo, and my father took it to the Vega Company in Boston to be repaired. They charged him seven dollars. (Today it would cost about two hundred dollars for the same job.) My father, always a frugal New Englander, decided he'd learn to fix banjos himself. He placed ads in Boston-area newspapers saying he would buy old banjos for five dollars apiece. He compared the old and damaged banjos he bought to the repaired Dobson, taught himself to repair them, and sold them to my mother's students for twenty dollars. At that time my mother was charging one dollar per lesson.

Pete is impressed with the story and Dad's repairs. He advises my father to stay with it, saying there is always a need for instrument repair and restoration, and that it's work my father can do for himself, without needing someone to hire him. Since no one knows how long the blacklisting—the dark ages, as my father calls it—will last, having an independent trade is a safer prospect than job hunting. So Dad learns as much as he can about banjo and guitar repair and construction. He loves the work, but most of all, he loves that it is immune to the blacklist.

His only reservation is Weymouth. The more he learns about repairing instruments, the more he broods about his future. Can he really make a success of an instrument-repair business in a provincial town that refuses to let go of the past? Something tells me my father thinks the answer is no.

SWEET HOME CALIFORNIA

My mother doesn't want to leave Massachusetts.

I think it's easier for her here than for the rest of us. She has her family, her friends, her music. The Boston folk-music community, full of mavericks and dissidents, is a safe harbor in which she thrives. She doesn't feel the same pressures of living in the black-listed world as Dad and my sisters and I do at work and school. But once my father makes up his mind that California is meant to be his utopia, there is no going back. My mother's pleas fall on deaf ears, and in the summer of 1957, he hitches a ride with friends and heads west, leaving my mother behind to sell our house. Selling the house is hard on all of us; with all the care my parents put into restoring it, it means more to us than mere shelter. Nonetheless, the house goes on the market and three months after my father's departure we follow him to California, driving in our two-toned blue 1955 Ford Fairlane V8. Very few mementos of our life in Weymouth make the cross-country passage, but one that does is my mother's banjo, packed carefully into the trunk alongside Sue's archtop guitar and Joanne's pink plastic radio.

My mother, her friend Sally Walker, and Sue sit in the front seat. In the back, Joanne sits by one window, sulking because she misses her boyfriend, Henry. Baby Sally naps and plays with her toys in her car bed by the other window, leaving me stuck in the middle. I have a lot of time to think. Sometimes I'm excited about being on the road, and sometimes I'm sad because I miss my cat, my dog, my stuffed animals, my room, the Atlantic Ocean. Other times I complain because I'm confined and squished and bored. When Joanne and I argue too much about space, Sue and Joanne have to swap seats. The swap is definitely not worth it for me. If I get fidgety or squirmy, or if I sing "Ninety-Nine Bottles of Beer on the Wall," or if I want something to eat, or if I say I have to go to the bathroom again, Sue pinches me—sometimes hard enough to make me cry. Finally my fussing wins me a spot in the prized front seat, where Sally Walker and I play Animal, Vegetable, or Mineral while Sue and Joanne jockey for space in the back.

We've been driving for what seems like days when we are abruptly jolted out of our road stupor as my mother spots a highway patrol car in the right-hand lane of the Ohio Turnpike. Cruising along in the middle lane, she says, "Charles is always so scared of these guys. He never has the nerve to pass them. Well, I'm not scared!"

"That's not a good idea!" cries Sally Walker, just as my mother floors it and flies past the startled cop.

"Look at that! I passed him!" she says.

In less than a heartbeat, the blinking lights and siren are behind us.

"Uh oh," says my mom. "That idiot is going to pull us over."

All of us are holding our breath as she pulls over to the shoulder and rolls down her window.

The police officer leans into the car window and says, with a Southern drawl, "Ma'am, is your speedometer workin'? . . . You just blew by me at eighty miles an hour."

"I know. I'm heading to California with my girls and I just wanted to see if I could do it. My husband is always so chicken about passing a police car."

The officer is understandably shocked. "Never in mah entire pro-fess-ion-al life has anyone *ever* done that. It won't do me no good to give you a ticket as you're just passing through Ohio. But the law says I gotta take you into the station."

"Really?" asks my mother, taken aback.

Baby Sally starts to cry. Sue keeps repeating, "You get one phone call, Ma. Don't forget you get one phone call." Joanne mutters, "I told you so, I told you so." The truth is that Sally Walker told her so, and I feel obliged to remind Joanne of this. The highway patrol officer assesses the situation and shakes his head.

"I will be the laughingstock of the whole station if I haul in this car full of all y'all . . . women. I'm going to let you go with a warning. Listen to your husband!"

My victorious mother pulls onto the highway.

"Hah! Can you picture all of us at the police station? He'd never live it down! I can't wait to tell Charles!" My mother, the daredevil.

After this the trip proceeds uneventfully until we stop at the Onondaga Cave State Park in Missouri. We haven't done any sightseeing on the trip and this is a first. When we are deep in the caves, our guide shows us absolute darkness by turning off the cave lights and his flashlight. My mother is carrying Sally in one arm and clutching my hand with the other when suddenly I feel her pull away and turn sharply. A moment later she demands that the guide turn on the lights and take us out of the cave immediately. When we are back at the surface, she marches us all to our car without a word or a how-do-you-do to anyone.

"What happened?" Sally Walker is the only one brave enough to ask. "Did you panic?"

My mother takes Sally Walker aside and whispers, "He groped me." When she pulled away from the guide, my mother felt the edge of the cliff floor with her foot and feared we were about to plunge to our deaths.

I ask Joanne what she means by "groped" because, of course, we were eavesdropping.

"Grabbed her titties," says the always-wise Joanne.

We reunite with my dad at the Continental Divide. Sally Walker catches a plane and goes back to Boston, while we drive the rest of the way to Los Angeles. As we cruise into one of America's most famous cities, I stare at the buildings and the architecture, all of it foreign to me and my eastern upbringing. There are the funny turrets on the roof of the Brew 102 brewery at the interchange of the 10 and the 101 Freeways, and a fuzzy haze that hangs in the air. I rub my eyes, thinking they're cloudy from my nap, but it's just LA pollution—smog, my father tells me. I'm disgusted.

Another feature of Southern California that captures my attention is the jade plant. It grows everywhere: in front yards, empty lots, parkways, and along the sides of the freeway. I have a jade plant with me, a gift from my nana. It's about six inches tall, including the tiny pot it is planted in. I nurtured it for two years on a kitchen windowsill in Weymouth, as precious to me as the stone it is named for. I'm stunned by this profligacy of nature.

We land in the middle of Los Angeles, where my father has found us the front half of a pink stucco duplex with red steps on Orange Grove Avenue between Pico and Olympic. It is endless blocks of small stucco houses and duplexes bordered by huge boulevards. There is no neighborhood to speak of; none of the neighbors seem to know each other. Every day everyone gets in their

car and drives somewhere else. I despise our pink stucco duplex from the minute I see it. I can't believe I have to call this home.

My father doesn't notice; he's in love with his chosen hometown. Two things immediately delight my father about California. The first is walking on the beach in shorts and barefoot on Christmas Day.

"It's Christmas! Can you believe it?" he marvels. "No shovels, no scrapers, no storm windows, no snow, no ice!"

It is pretty great. My sisters and I wade in the surf, collect small white shells, spread a blanket on the sand, and enjoy the picnic lunch my mother prepared for us. It isn't much of a lunch, because my father lost his job selling fireplace and gardening equipment. My dad is collecting unemployment, but it's hardly enough. Still, we're having fun.

The second is when my father discovers he can buy a half gallon of Gallo red, white, or rosé for next to nothing at the grocery store and can't stop marveling at how so much wine, for so little money, can be so good. He expounds on this fact to anyone who will listen. Neighbors and visitors are regaled with the fruits of his discovery until a friend explains that the wine is cheap because of the work of exploited migrant workers, many of whom are from Mexico or Mexican-American. After that the bottle disappears from our table.

My mother isn't as charmed by Los Angeles. Her initial view of LA is filtered through the melancholy of homesickness, and at night I hear her crying herself to sleep, accompanied by my father's deep rumbles as he lectures her about how much better off we will be. She does her best to make a new home for us in a house I can tell she loathes as much as I do. She hangs her banjo on the living room wall and places the ancient framed needlework piece from Weymouth above the fake fireplace: THE LORD WILL PROVIDE.

But I can tell she's overwhelmed and brokenhearted, having set out on an adventure she never wanted, torn from everything and

everybody she loved, from a life she'd built and nurtured, from all that was familiar. Thankfully, Bess Hawes is already in Los Angeles. The two women revive the New England get-togethers at Bess's house in Topanga, a haven for bohemians and creatives in the Santa Monica Mountains. Bess introduces my parents to West Coast folk musicians with like-minded views on politics, and their circle of friends begins to grow. Bess also introduces our family to the Children's Music Center on West Pico Boulevard. We all feel immediately at home in this family-oriented music store featuring more Folkways albums than we've ever imagined. This is a propitious moment, because it is this place, with its folk music books, records, musical toys, and folk instruments that will inspire the model for our family and the Folk Music Center.

My sisters and I each adjust to the situation in our own way. It's easiest for Sally. Two years old, with a puff of frizzed brown curls and Delft-blue eyes, she is good-natured and undemanding, busy with her dolls, and happy for attention when she gets it. In no time she is a real California baby, playing in the sunshine on the red postage stamp–size front porch, released from the bondage of her snowsuit, hat, and mittens.

Sue, as usual, takes her new life in stride. She makes friends with the Quakers (pacifism and folk music go hand in hand) and turns her attention to her blossoming—and increasingly complicated—love life. Her high school sweetheart, Paul, had been drafted right out of high school and left for boot camp just before we headed to California. Sue and Paul had exchanged photos and sworn to be true to each other forever. She dutifully replies to every one of Paul's letters, professing her loyalty and devotion— even as she starts dating a boy named Warren who lives across the street from us.

Then Warren gets *his* draft letter, and soon he is headed to boot camp. Before he leaves, he and Sue exchange photos and promises

of eternal love. Sue continues to write to both Paul and Warren. Sue tells our mother that she will break up with one of these two young men, but she doesn't have the heart to send either of them a Dear John letter. The situation remains unresolved until one day two letters arrive addressed to Sue, both posted from Fort Ord. One is from Paul and the other is from Warren.

"Dear Two-Timing Cheater . . ." opens one letter, while the other starts, "Dear Two-Timing Liar . . ."

It turns out Sue's two boyfriends were bunkmates, and one night, as young men will do, they started talking about how much they missed their girls at home. Coincidently, both of their girlfriends were named Sue! Coincidently, both of their girlfriends played the guitar! Paul showed Warren the photo of "his" Sue—with "Love, Sue" written across the back in even, rounded cursive. Warren pulled the same photo from his wallet, with the same declaration in the same handwriting.

Miffed at being called a liar and a cheat, Sue shows the letters to our parents.

Mom laughs, "Serves you right."

My father is more interested in the science. "What are the odds?" he asks.

"I never really liked either of them that much," replies Sue, coolly dismissing the whole debacle and acting as if she had nothing to do with it.

The moment we arrived in California, Joanne fell in love with Chicana culture, adopting it in every facet of her life. I watch her change overnight. A layer of makeup now covers her freckles; the favored pedal pushers disappear along with the tucked-in blouses, pleated skirts, and saddle shoes with ankle socks for school. The new Joanne wears flat, wide Mary Jane–type shoes, a tight straight skirt that hits just below the knee, and a small gold cross on a thin gold chain that lands in the deep V neckline of her very tight

sweaters. She outlines her lips with dark lipstick, draws surprised eyebrows in a careful arch, adds a beauty mark to the side of her mouth, and sports spit curls plastered in front of her ears and an upswept hairdo that spills curls over her forehead.

My parents worry for her and wonder why she would take on the culture of another oppressed minority when we already have our own. They assume she brought her resentments and hurts to California from the blacklist experience in New England. The overt and often violent discrimination against Latinos in Los Angeles resonates with her feelings of marginalization. In California Joanne joins a rough crowd, drinks Thunderbird wine, and smokes cigarettes and "Mary Jane." She gets into gang fights and does poorly in school. She keeps a tone bar in her purse to use as a knuckle duster and gets a prison-style ballpoint pen tattoo of a cross on the webbing between her thumb and index finger. She calls herself a "chola" and says she's living *la vida loca*. All her friends are Chicanos, all her dates are with Chicanos. She even cultivates an accent.

I'm boggled by my sister's transformation, but my parents aren't as surprised. Joanne has always been the most rebellious and contrary sister, and she isn't the only white kid rejecting the status quo. She also isn't the only white kid rejecting her racial identity. My parents explain that many children of the blacklist, sometimes called "red diaper babies," are taking all kinds of routes to figure out where they belong in the world. Some turn to great music and art, while others pursue education for the secret to personal power. Still others succumb to drug and alcohol addiction and dysfunctional relationships.

None of this matters to me. I want my sister back. "Why doesn't she act like Joanne anymore?" I ask my father.

He thinks a long time before answering. "Joanne feels connected with people who are treated badly because she knows what it feels like."

This thoughtful analysis stays with me but does little to assuage my immediate concern; I miss my sister. I miss sitting in Joanne's little ship's-cabin room in Weymouth listening to rock and roll on her pink plastic AM radio. I miss ranting with Joanne about how much we hate Pat Boone, Tab Hunter, and Ricky Nelson—the clean-cut, sterile, all-white artists who don't threaten the status quo. I feel I'm the same, but once we move to LA Joanne changes her identity and won't have anything to do with me.

I feel confined inside the small apartment. I don't have my own room anymore; I share a room with Sally. The weather is always nice but it makes no difference, because there is no backyard or place to play outside. I yearn to lie on the sea wall and stare at storm clouds rolling in off the Atlantic Ocean. I ache for thunder and lightning. I miss the jetty. I miss family gatherings, my cousins, and my grandparents. I even miss my great aunties leaving red lipstick kisses on my cheek.

My life improves substantially when one day, on my way home from school, I see a little longhaired, wiener-ish dog in the middle of Pico Boulevard. The poor dog is so scared it is frozen, her legs shaking as cars whiz by in both directions. I drop my books and dash into traffic to prevent her from being crushed by a car. Hugging her to my body, I dodge honking cars and reach the safety of the sidewalk. I name her Honey for the color of her fur.

"Absolutely not!" wails my mother when I return home with my new friend. "You can't just steal someone's dog!"

"No dogs!" shouts my father. "They're not allowed in the apartment! Get rid of that thing—now!" I take Honey to my room and sob into her furry golden neck while she licks the big wet tears dripping off my chin. I take my dinner into my room and share it with her. No one says a word. My mother posts several "Found Dog" flyers near where I found her, drawing a likeness of Honey on each one. After a few weeks, and no one coming to knock on

our door in search of their lost wiener dog, Honey becomes part of our life in LA.

School isn't too bad. Half the kids at Burnside Avenue Elementary School are Black, the other half Jewish. I am befriended by the two prettiest girls in my class, one Jewish, one Black. We three are inseparable. We scorn the poodle skirts and stiff petticoats that are popular, preferring the A-line look for our skirts and dresses. I am ahead of my class in reading, probably because I had filled the last three lonely years with books. I am a good student, and I have nice friends. I'm happy again, and ready to settle into my life's new rhythm.

This happiness doesn't last.

Six months after we arrive in Los Angeles, my parents want to move again. Claremont, a small city thirty miles east of downtown Los Angeles in the foothills of the San Gabriel Mountains, they tell us, is known for its five-college consortium, tree-lined streets, and famous painters and ceramicists. Claremont is experiencing a renaissance of art and artists, and my parents think the city is crying out for a place in the folk music revival. My parents' glamorous description of the artsy town to which they plan to relocate does little to soothe my distress at having my life disrupted yet again, but one look at all the trees and I think I will survive.

"It looks like New England," my mother gushes.

My father sends my mother house hunting with a list of rentals. The first house we visit is the best-sounding one on the list, with three bedrooms, a fenced backyard, and pets allowed. Perfect! Or so it seems. The matronly woman who opens the door assesses us with steely eyes. She sizes us up: a short woman with black hair, swarthy skin, and dark brown eyes, with her skinny, olive-toned girl.

"It's already been rented," she says, and shuts the door in our faces.

My mother doesn't say anything, but I know she's upset.

That evening when my father comes home, my mother tells him what happened. My parents believed we'd left that kind of anti-Semitism back in New England. When he hears the story, my father jumps up from the table, outraged. He calls the woman.

"Hello, this is Mr. Chase, and I'm calling to inquire about the house on Tenth Street. Is it available?"

"Why, yes, Mr. Chase, it is. Would you like to see it?"

My father explodes. "My wife had an appointment to see the house today and you turned her away!" he yells into the phone. He lambasts her about anti-Semitism and reminds her that we fought a war against fascism.

When the tirade ends, he listens to her for a minute, looking confused. Then he mumbles something I can't hear and hangs up the phone. The expression on his face is a mixture of dawning awareness and disgust.

"What did she say?"

My father shakes his head in disbelief. "She said, 'Oh no, Mr. Chase, I made a mistake. I'd be happy to rent to Jews. I thought they were Mexicans.'"

We finally find a house on the "wrong side of the tracks," on St. Bonaventure Avenue. My father applies and is accepted to Claremont Graduate School (today called Claremont Graduate University), and he is thrilled—but still worried about his political status. Before he starts, he confides in his advisers about being blacklisted and his refusal to name names. Initially they aren't sure how to handle this news. Are they obligated to tell the dean? Ultimately the advisers decide that the information was given in confidence and need not be divulged to higher-ups. My father enters the Teacher Education Internship Program, and after a six-week summer intensive, is placed in a classroom at Baldwin Park High School.

The majority of my father's students are Latino, and he soon learns that they prefer the term *Chicano* to *Mexican*. My father learns as much from his students as they do from him. They teach him about their culture and language, and how they help their families by working in the fields, which means they have to miss a great deal of school. They even teach him about marijuana. They are amused by his cultural ignorance and accent but come to like and even trust him. When the police raid the school, my father never betrays his students, even though he knows who among them have "grass" in their lockers and are selling it at the bus stop.

In exchange for my father's trust, the students agree to learn. My father is shocked at the inadequacy of their prior instruction in reading and math, and he rails at the principal and the other teachers for not doing their job.

"Charles," says the principal, "these kids are going to be gone in the spring, and we won't see them again until winter—if ever. Why bother?"

My mother enrolls me at Oakmont Elementary School—my third school that year—to finish the last two months of sixth grade. The girls wear full skirts and crinolines to school, and as much as I want to fit in, I refuse to wear those huge, foolish petticoats. It doesn't make me popular, but I don't care. It's a relief to be different for something of my own choosing.

"What are you?" I am asked. "You talk funny."

I do? No one had said that in LA. Then again, everyone in LA was from somewhere else.

"What do you mean, what am I?" I ask, fearing some threat.

"Where are you from?" they say, rolling their eyes.

I am worried that if I give the wrong answer, they will turn against me, as in Weymouth. I decide to go undercover.

"Italian," I answer.

No one bats an eye. I am an Italian.

My classmates enjoy making fun of my Massachusetts accent. They tease me when I say "cah" for car or "mahket" for market, or when I say thank you for being invited to a "pahty." I can't hear the difference, but one day in math class I hear myself.

"Nine is a squayah numbah." The sudden awareness stuns me, and I resolve to eradicate any trace of my New England accent.

Claremont is ripe and ready for folk music. The day we arrive, musicians show up at our house for lessons, repairs, jam sessions, and most important of all, a sense of community. Free from the tyranny of New England winters and enchanted with California's climate, my father erects a tent in our backyard to accommodate the out-of-town visitors he knows will come.

From the day we arrive, Dot has people asking her to teach them to play banjo and guitar. She creates a space in our living room for one-on-one lessons. Anticipating the need for instruments, my parents run an ad in the *Los Angeles Times* offering to buy banjos and guitars for five dollars apiece. Soon there are guitars and banjos everywhere: in the garage, the living room, under the beds, and on the dining room table. In order to watch TV, we usually have to move two or three guitars off the couch. Finally, my mother says enough is enough.

"Charles, we have too many instruments. We need to sell some," she says. "What we need is a store."

At first I think she's joking. But she most definitely isn't. Before long, the Folk Music Center is open for business.

THE HOUSE ON SEVENTH STREET

The Folk Music Center is the brainchild of my mother and father, but they have a lot of help. After the many financial and geographical upheavals throughout their marriage, our family budget is stretched to the breaking point, so my mother's brother, Harry Udin, provides the initial funding for the center. Harry is a researcher and professor of metallurgy at MIT—or, at least, he was before he was blacklisted for his wife's communist affiliations.

On August 12, 1958, my parents open the doors to the Folk Music Center, a small, windowless room with a wall of guitars and lined with shelves for songbooks, toys, and albums. The Folk Music Center is sandwiched between two other businesses: a potter and a real estate agent named Boots Beers, whose office takes up the storefront. The excitement of creating a new business is contagious, and though I have little to contribute, I manage to round up my neighborhood friends to share the fun.

We canvas the town, announcing the grand opening to everybody we see. It's a typical hot Southern California day, with a thick shroud of gray-brown smog concealing the San Gabriel

Mountains—the kind of day that makes your chest hurt when you breathe deeply. By late afternoon, after the last of the visitors join in a song circle of "This Land Is Your Land" and "Goodnight, Irene," I plop down on a bench in front of the store. I am wound up, worn out, and winded, and my mother makes me drink a glass of orange juice before sending me home to rest. It's an early sign that I have caught the music bug.

Boots Beers doesn't like the idea of a bunch of beatniks behind her real estate office. She makes it clear that it doesn't matter, since no one is going to come to our store anyway. But Boots Beers is wrong. In a matter of weeks, customers and visitors, pickers and players, lookers and touchers, curious people and people hungry for musical experiences come to the Folk Music Center in an endless stream. Boots is furious. This is not what she bargained for. But my parents have already decided to move to a bigger space. With the traffic they've had so far, they can handle double the rent. They wave goodbye to Boots Beers and to the potter and move the store to a little building next to Bud's Bike Shop at 211 West First Street.

For sixty dollars a month, the store has its first true home. The space isn't much larger than the last one, but it has enough room for the racks of albums and songbooks, an additional cabinet for strings and accessories, and a wall of guitars and banjos. An added attraction is a fenced-in backyard where my father installs benches and a small stage for trying out instruments, jamming, and small performances. This is an ideal place for me to hang out after school.

In the early days, the identity of the Folk Music Center is as much tied to my maternal grandfather, Albert Udin, as it is to my parents. When Grandpa retired from the Udin Shoe Corporation he and my nana, Bess Aronoff Udin, sold their house in Newton, Massachusetts, and moved to Claremont to help my parents with the new business. Grandpa works full-time at the store so my father can keep his teaching job until the store is making enough money.

Everyone in town comes to know Grandpa from his long walks around town and looks forward to his passing by.

"Shalom!" Grandpa calls when he catches the eye of a neighbor, and then *"Das vedanya!"* a Russian form of goodbye, as he continues on his way.

Grandpa is short by American standards, with silver-white hair, swarthy, olive skin, and dark brown eyes that tilt up over his high cheekbones. He always wears a button-down shirt, sweater-vest, and slacks, dressing for work whether it is a work day or not. He loves the Folk Music Center. Selling shoes or selling guitars—it's all the same to him. When he isn't busy helping customers, ordering merchandise, or keeping the books, he sits in a chair at the front of the store whittling with his pearl-handled penknife. His long walks yield acorns and eucalyptus pods that he turns into "peace men." He draws a face on one side of an acorn and a peace sign on the other, glues the acorn cap to the seed pod or the acorn itself, and screws a little eye bolt into the cap for a necklace. He hands them out to everyone.

"Wear it for peace."

I like being around my grandpa. I nag him about life when he was a kid in Russia, but he doesn't want to talk about it. I learn that he had siblings who didn't make it to America, but he won't say what happened to them. Grandpa immigrated to the United States when he was nine, after his father was murdered in a pogrom that devastated the shtetl that was his home in the Pale of Settlement in the Ukraine, the part of the Russian empire where most Jews were confined. His mother, three older sisters, and he made it to America. Bubbe, Grandpa's mother, was considered odd. She wore men's clothes and sat on the porch of the Newtonville house smoking cigarettes and watching the world go by. She refused to do any work or help with the children.

"Ich hob genug getun," Bubbe said in Yiddish, the only language she was willing to speak. "I did enough."

Grandpa hates war, despises the makers of war, and pities "the poor, brainwashed soldiers fighting and dying to line the pockets of the rich and powerful." He blames World War II and the rise of anti-Semitism for his son Bernie's untreated "battle fatigue." My uncle Bernie's regiment was bombed on the front lines in Germany. He was badly wounded, the only survivor, and never recovered from the experience. This makes Grandpa angry. What he wants more than anything else is an end to war, violence, and hatred. He wants harmony in the world, and he is always pondering the paradox of man's inhumanity to man.

Grandpa loves children. When families come into the store, Grandpa entertains the children with magic tricks while the parents shop. When negligent parents let their children pound, bang, or blow on the instruments, he is always gracious and patient, gently leading the noisy child toward a more appropriate plaything. Still, he has his ways of making a point. When the parents are ready to leave, he gives each child a free kazoo and shows them how to play it. Then, with a smile and a bow, he suggests that the child play it on the way home in the car—"to make your parents happy!" What can the parents say to this free gift of music other than thank you?

The Folk Music Center is rapidly gaining a reputation as folk music central. Half a mile away from the store, our small house barely accommodates us, let alone one more friend, one more cousin, one more student, or one more folk musician. We move to a larger home on Seventh Street, six blocks from the store, a substantial old Craftsman with the original sleeping porches upstairs, two balconies, a grand entryway and staircase, a sunroom off the kitchen, a roomy living room with a ceramic tile fireplace, a library, a large front porch, and a back porch featuring an old-fashioned "water closet" with a pull-chain flush. I love it all.

My parents are happy, too. There is space for a workshop in the basement and plenty of room to reinstall the tent in the new

backyard to accommodate the never-ending stream of visitors. Soon the house is home to a repair shop, a guitar class, house concerts, folk song society meetings, visiting musicians, two parents, four daughters, two dogs, two cats, and a rabbit.

Our home is an extension of the Folk Music Center. We live, work, think, and socialize around folk music. In some ways I am a typical teenager. After school I want to come home, drop my books on the catchall by the front door, take off my shoes, go to the kitchen to get something to eat, and have some privacy, just like my friends do in their homes. But our home isn't like my friends' homes, where kids do homework, eat snacks, play games, and watch television. When I get home I push past a horde of kids coming, going, or waiting for guitar class with my mother. Unlike parents of today who hover and wait, pace, or sit in with their children while they are learning an instrument, parents in those days dropped their kids off and split. Some kids would wait on the porch until evening for a ride home. Others had to trudge to school, to their lesson, and home carrying their guitars the entire way, in chipboard cases that thumped against knees and shins, not today's lightweight backpack gig bags. These kids were dedicated.

I never deign to join one of my mother's classes, but I like to sit in the living room pretending to read or do homework while I listen in. If no one is looking, I pick up one of the guitars and follow along. I keep my guitar playing a secret until I develop some mastery. I don't want to be like one of those struggling schoolboys with their crappy Zenon or Silvertone guitars, plunking away and murdering "Tom Dooley" before the mob gets a chance to hang him.

I am teaching myself a song one day when I get stuck on a particular chord and decide to ask my mother for help. She shows no signs of surprise—she just reaches over, shows me how to play

the chord, and turns back to her own work, preparing for her next class. I wonder if my endeavors haven't been so secret after all, or if playing guitar was something expected of me, like going to school and doing my homework—except that nowadays I often play the guitar *instead* of doing my homework.

Listening to songs on my mother's records is how I'm learning most of my repertoire. I've run through her song sheets and I'm tired of the Alan Lomax collection *Folk Songs of North America.* Several of my mother's record albums reflect my enthusiasm and have incurred a few small scratches and worn bands, no matter how carefully I lift and set down the phonograph needle. To learn a song by ear, I have to play it over and over while scribbling the words and jotting in the chords. Woody Guthrie singing "Gypsy Davy," The New Lost City Ramblers' "How Can a Poor Man Stand Such Times and Live," and Joan Baez's recording of "Mary Hamilton" have all taken a beating. When I eye the albums at the music store, my father says I can work off the cost of whichever ones I want. I have a lot to choose from.

Folk music is the art form that is most effectively challenging social conventions. Poets and novelists, jazz musicians, comedians, filmmakers, and intellectuals are all questioning the status quo, but the songs of folk musicians are reaching a far wider audience, one that is not limited to urban and university elites. The Folk Music Center is the first place in Claremont where you can buy vinyl LP records that aren't classical music. "Jobbers," or independent wholesalers, come to the store once or twice a month to restock the records that have been sold. They keep track of stock and display the newest releases. One of my after-school jobs is to file the new piles of albums into the bins in alphabetical order by the artist's name. Into the bins go the Folkways Anthologies: the New Lost

City Ramblers, Pete Seeger, Lead Belly, Woody Guthrie, Big Bill Broonzy, Cisco Houston, Odetta, right along with the Kingston Trio; Limeliters; Peter, Paul and Mary; Bill Monroe; Flatt and Scruggs; Joan Baez; the Beatles; Bob Dylan; the New Christy Minstrels; and oodles more.

The Folk Music Center carries international or "ethnic" albums that can be found in only one wholesaler, Festival Records Distributors in Los Angeles, John Philsitch's shop for international folk music and dance records, a specialty shop that fits our needs perfectly. My mother goes to Philsitch's shop to handpick the albums she wants for the Folk Music Center, such as Israeli Line Dancing or Macedonian Circle Dance. Once we load the albums into our trunk, we walk next door to the Middle Eastern deli for lunch, buy some pita bread, string cheese, hummus, and halvah, and head home.

Before the Folk Music Center offers records for sale, Jay Doty's is the only record store in Claremont. Doty wears a suit to work and is director of the Bridges Auditorium Concert Series. His store focuses on classical music, but eventually Doty adds rock and roll 45 singles because that's where the money is. He has three single listening booths, which have just enough space for two teenagers to squish inside. All of us kids head to his store after school to listen to music, flip through the bins, and flirt and chatter among ourselves before going home to our homework, chores, and dinner.

Some kids tuck the small records—Brenda Lee, The Drifters, and Elvis—into their notebooks while waiting for a turn in the listening booths. Doty sits imperiously at his desk, missing all the signs. I don't like Doty, so I have mixed feelings about the stealing. He is arrogant and out of touch. I want to believe he deserves it because he is a snob and isn't nice. But stealing isn't right. I hear my father's disapproval in my ear, but I say nothing. Doty doesn't miss a thing when the Chicano kids come into his store. He follows

them everywhere, not allowing them to touch the merchandise or listen to any records.

One afternoon I head to Doty's store with Estela and Otélia, friends from seventh-grade homeroom. As soon as we walk through the door, Doty comes out from behind his counter and squawks at us.

"Nothing here for you, nothing here for you," he says, peering peevishly over his reading glasses and herding us to the door.

The blatant racism startles me. Serves him right that he gets ripped off, I decide.

My father says Jay Doty is a narrow-minded bigot who probably believes himself to be doing his part to keep Claremont's music *respectable*—as in, free of the "lesser" forms such as rock and roll and folk music. Doty and his friend Kenneth Fiske, a violin player, orchestra director, and professor of music, want Claremont's youth to learn the orchestral instruments and classical repertoire that they believe to be superior to other music forms. In their view all other musicians are beatniks and not worthy of the community's respect. For our part, we ignore him. We know he's wrong. Classical music is not capturing young Americans' imaginations—or, for that matter, many adults' imaginations. The evidence in support of our position is overwhelming. Young people want to learn how to play the guitar and the banjo, not the violin and classical piano. People young and old are moved by folk music, chain gang songs, prison songs, civil rights and gospel songs, murder ballads, union songs, antiwar songs. They are moved by protest songs and ballads about hard times, the dust bowl, and the real stories of the poor. All this offends and aggrieves the sensibilities of men like Doty and Fiske, who believe the best music is the most elite music.

One day Fiske walks into the Folk Music Center and stands with his arms folded over his chest, an expression of contempt on his face suggesting he is smelling something unpleasant.

"*This*," he declares, indicating the store, the people so foolish as to be in it, and the world at large with a sweep of his hand, "will never last." Turning on his heels, he walks out, never to set foot in the Folk Music Center again.

I am glad to see Fiske leave. His disdain of folk music, social activism, bohemians, nonconformists, and anyone else his elitist group disapproves of makes me uneasy. I disagree with him but feel the sting of his rebuke and his unchecked resentment toward my family and friends. My father laughs at his snobbery and brushes the incident away, but it isn't so easy for me.

In the early 1960s the folk music revival exploded culturally and commercially, producing a new generation of folk performers and singer-songwriters that included Bob Dylan; Peter, Paul and Mary; Tom Paxton; Buffy Sainte-Marie; and an appreciation of older artists such as Pete Seeger, Utah Phillips, and Jean Ritchie. Young people are flocking to concerts and coffeehouses to hear songs by known communists and socialists, longhaired dissidents, and barefoot beatniks, and they are loving what they hear. Instead of joining orchestras or marching bands, they are forming their own bands and playing banjos, guitars, mandolins, spoons, jugs, fiddles, washboards, and doghouse basses. In a nation of intense conformity, there are small signs of individualism that hint at the possibility of deeper rebellion. Crew-cut boys let their hair grow down to their collars.

Joan Baez is one of the most important voices popularizing folk music. With her pure, piercing soprano she produces cool but sensitive renditions of traditional and modern folk songs, inspiring many girls and young women to start singing and playing guitar. With her long black hair, olive skin, slender frame, and love of folk music, it is no surprise that I am drawn to her. People say that

I resemble her, which I find flattering. I didn't know that anyone could look like me and be famous.

I admire Joan for more than her repertoire. I've heard most of the songs she favors by Barbara Dane, Peggy Seeger, Jean Ritchie, Bonnie Dobson, Odetta, and many other balladeers of the folk music revival. It is Joan's appearance, demeanor, and politics that impress me. I learn that she comes from a family of Quakers and is drawn to pacifism, social causes, and civil rights that fit right in with my family's dinner table conversations. She is only nineteen years old, but she seems like the epitome of sophistication to me, six years her junior.

My parents are friends with Joan's parents. Her mother, also named Joan Baez, and her father, Dr. Albert Baez, live in Claremont from 1960 to 1961, while Albert is a visiting professor of physics at Harvey Mudd College. Albert is an accomplished physicist and inventor of the X-ray reflection microscope, but most people know him for his famous daughter. Joan's fame has reached the point that Dr. Baez is referred to as Mr. Joan Baez, an epithet he tolerates.

Joan visits her parents several times that year and often winds up at our house. Her father is straitlaced about raising his three daughters, and Joan prefers the bohemian atmosphere of our home, where she is free to hang out with her beatnik boyfriend, Michael. To me, Mr. Baez is a nice man and I can't imagine why Joan is so intent on defying him. He always includes me in conversations and asks me about the childhood games my sisters and I used to play to see if they are similar to the ones his daughters liked. Of course, he isn't my father.

One day Joan arrives at our house unannounced, wearing jeans, a striped blouse, and sandals, her hair long, loose, and a little wild. She's angry, and since I open the door, I'm the one to get the blast about her uncompromising father not letting her boyfriend spend the night with her.

"Not under my roof," she says, imitating her father perfectly. To me, she sounds spoiled. "Well, it's his house . . ." I begin, but my mother shows up just in time to cut off the rest of my thought: *and he makes the rules, so like it or lump it.* I have not yet learned that one of the expected perks of celebrity is deference.

One hot summer afternoon, my mother organizes a picnic for the Chases and Baezes at a friend's cabin in Palmer Canyon. A heat wave has settled over the inland valley cities, and it is a welcome relief to escape the smog and sit by the side of the cool stream, shaded by live oaks and sycamores in the faint breeze that lifts our spirits. Joan has a guitar that she wants to break in before playing it in concert, a New York Martin, built when Martin was located in New York City in the mid-nineteenth century. The guitar is a collector's item that once belonged to my sister Sue, but Joan convinces Sue to sell it to her for one hundred dollars.

Joan loves that guitar, and she arrives at the picnic carrying it, a big smile on her face. Just then she trips; everyone watches helplessly as she falls backward, clutching the guitar to her chest. She lands on her butt, and the guitar never touches the ground. She holds it aloft and we give her a round of applause.

"Always save the guitar!" she shouts triumphantly.

Joan's guitar save is awe-inspiring to me and I resolve to do the same should I ever fall down while holding a guitar. I am not naïve; I know Joan enjoys being the center of attention in social gatherings, though I'm not sure if this is a response to being famous or a pre-existing condition. The important thing is I like Joan's stories, which are a little subversive, sometimes self-deprecating, and always have a twist of wry humor. I recently read Philip Roth's *Goodbye, Columbus* and am deep in a sardonic phase.

One of Joan's stories is about folksy Joan standing in a show-room waiting to buy a Jaguar XK-E and being snubbed by a salesman, only to blow his mind by writing a check for the full

price of the car. In another story, Joan, who loved to ride in her friend's hearse, would comb her long hair in front of her face and put dark glasses on over her hair. Then she would rise up and stick her head out the window like the living dead or a zombie. What I realize after attending a few of her concerts is that telling friends like us a story is her way of trying out new material for her performances. Many of the stories I hear her tell in my living room eventually make their way to the stage.

I soon realize that Joan isn't as comfortable with her extraordinary success as I initially believe. In December 1960, when the Harvey Mudd physics department brings Joan to Bridges Hall of Music for a concert, she is so nervous she can't eat all day, and when we arrive at the theater, she disappears into a bathroom. Showtime approaches and I am sent to check on her. I find her throwing up in a locked stall. Unsure what to do—I am an adolescent girl and she is a famous artist—I run to get my mother, but when we return, Joan insists she is okay. Joan emerges wearing her trademark white cotton performing dress, looking pale and fragile. She hands my mother her shoes—she always performs barefoot—goes to the greenroom for her guitar, walks on stage, and sings like an angel.

I'm thirteen. I'm used to judging things and people as good or bad, right or wrong. War is bad, peace is good, discrimination is wrong, equality is right; greed is bad, generosity is good. It is all very clear-cut. Joan has presented me with a dilemma. I admire her, but sometimes her behavior is less than admirable. I'm not sure I even like her, but it does not diminish the pleasure I get from hearing her singing the songs. I love her magnificent voice and I continue to learn her song arrangements. I run this paradox by my father. He thinks it over for a bit and says philosophically, "People can be bad, people can be good, people can be good and bad at the same time, but they are more good than bad, or we wouldn't still be here."

CHAPTER 5

EAST MEETS WEST

Because my father owns a music store, everyone assumes he is a musician, and he does not dissuade them. But he is not a musician.

One reason my father is decidedly not a musician is his hearing. Although he manages to hide it, he is hard of hearing. Grandmother Elba says his hearing loss is a result of a bad case of measles he had as a boy but my father insists that his hearing was damaged in the war. My mother always jokes it is a coincidence that the range of his hearing loss is identical to that of his wife and four daughters' voices. That said, he *wants* to play an instrument, and one day he decides it is time for him to learn.

But which instrument?

He tries one after another, never finding the right fit. He goes through a classical guitar phase and a Chinese opera phase. He makes a stab at the mountain dulcimer, then moves on to the spoons, the lap harp, and the oboe. And his family goes through these attempts with him.

Then he tries the violin. And he *loves* the violin.

Every night after supper, out it comes. Time for violin practice. First he checks the tuning with a tuning fork, which he claims he doesn't need to hear because he can *feel* the vibrations. Then he carefully removes the bow from the case lid, adjusts the screw at the bottom of the bow, tightening the hair just so, and with great care rosins the bow hair. Finally, after all this preparation, he assumes the proper position, lifts the bow, and plays "Go Tell Aunt Rhody."

"It's an instrument of torture," declares Joanne.

Joanne's comment aside, my sisters and I mostly keep quiet, but after the first three or four days of the violin phase, my mother's Siamese cat, Shelly, begins expressing her displeasure. One evening, before my father can finish the first line of "Go Tell Aunt Rhody," Shelly finds my mother and bites her ankle.

"Warn me," Mom tells us after this happens a second time. "The moment you see the violin case come out, warn me—or put the cat out."

Just when we think this torture is never going to end, my father's violin disappears. There is a detectable pattern to our father's musicianship, and once he understands how an instrument works, the desire to make and fix them is stronger and more successful than his desire to play them. Which is a good thing.

That's when he takes up the mouth bow, an instrument made out of a single string stretched the length of a curved bow thought to have derived from a hunting bow. My father has found his musical match. The mouth bow, a drone-type instrument in which the bow is placed on the side of the cheek and gets its resonance from—as my father likes to joke—his hollow head, is his go-to instrument from then on. In time, he designs the quintessential mouth bow, then goes into production and makes, plays, and sells them. He can be seen playing it in Danny Clinch's documentary *Pleasure and Pain*.

My dad has limited talent as a musician, but he has an expert-level fascination with rare instruments—the more unusual, the better. One of the things he marvels at is how function and form blend into every instrument. To him, even a simple one-string spike fiddle is a work of art. He has the foresight to introduce and sell instruments from remote places that are lesser known in the United States, and his timing is excellent. There is an emerging interest in the music of other cultures that continues to this day.

One day, Mike Fay, a member of the locally famous Twelfth Street Mini Band, comes by the store with a sitar and a tabla set, drums that traditionally accompany the sitar in Indian classical music. My parents are keen to open an ethnic instrument exhibit showcasing what are now called world instruments, and the sitar and tabla are exactly the sort of instruments they need. They now have enough to substantiate an exhibit. They carefully research, label, and display each instrument and then put an announcement in the *Los Angeles Times,* officially introducing the Folk Music Center and its exhibit of international instruments to the world.

My father tracks down a supplier and, after many language-challenged phone calls and letters, is able to order two sitars directly from India. When the ship carrying the instruments arrives at the Port of Los Angeles, my father drives to the docks to pick up the crates. They are beautiful. One is a honey-gold color and the other is a rich, dark brown. They are carved and inlayed, with mother-of-pearl dots in every tuning peg. Our first sitar customer comes to the store the moment he hears they have arrived. After seeing and holding the sitar at the international instrument exhibit, he'd fallen in love.

He pays 150 dollars—equivalent to 1,300 dollars today—for the dark brown one. My father demonstrates how the Indian players sit cross-legged on the floor, holding the sitar just so. This is happening several years before George Harrison of the Beatles

discovers the sitar in 1965, which is when most Westerners first hear the instrument. Very few people are willing or able to make the trek to India to learn yoga and meditation and study sitar. Most listen to the records of master sitarist and composer Ravi Shankar and copy as best they can.

The next afternoon the young man comes in the store red-eyed and shame-faced, holding the instrument in one hand. The big gourd has a gaping hole with raw, jagged edges. In the other hand he holds a small box. The box is filled with many little jigsaw-like pieces from the gourd.

"What happened?" we all ask at once.

"Well," he hiccups, tears welling from his bloodshot eyes. "I was so excited when I got home, I sat on a cushion on the floor and played the sitar all the rest of the day . . ."

"But what happened?"

"When I finally stood up, my legs had fallen asleep, and I fell on the sitar." He is weeping now, unable to catch his breath.

"Leave it with me," says my father. "Come back in two weeks."

Later that night, my dad lays all the pieces on his workbench and sets to work. Little by little, piece by piece, the gourd finds its shape again. A little wood filler here and there, and a little lacquer over the patches slowly brings it back to life.

One evening, almost two weeks later, my father doesn't come to dinner. My mother goes to his basement workshop.

"Charles, what are you doing here so late?"

He is leaning on the bench, chin in hand, staring at the sitar.

"I'm stuck," he says. "Look at this scar across the gourd. I can't hide it."

"Give it to me," she says. "Let me see what I can do."

That evening, after everyone goes to bed, she gets out her oil paints and her palette. The next morning she shows us the sitar. The scar is hidden under the image of Saraswati, the Hindu

goddess of knowledge, music, art, wisdom, and learning. It's beautiful.

When the young man is reunited with his sitar, he weeps again, this time with tears of joy. He hugs my Yankee father, who, unaccustomed to open expressions of affection, backs away and says gruffly, "Uh, that'll be forty dollars."

The other sitar sits on a shelf, taking up too much space but attracting plenty of attention. When our friend Matel sees it for the first time, he gasps and freezes, misty-eyed as he stares at the instrument. "I am homesick for India," he laments.

Matel is a Sikh student from the Punjab region of northern India. He is the leader of a group of fifteen Sikh students on a special study grant from the Indian government. India needs engineers, and Harvey Mudd College and Claremont Graduate University have a one-year program in the field. Matel is quick to laugh and fun to be around. He is five foot six inches tall, wiry, and dark skinned, with perfect teeth and brown, almost black eyes. He dresses in American clothing—slacks and button shirts—but like all Sikh men wears a turban, or *dastār*.

Matel discovers the Folk Music Center soon after arriving in America. During his study breaks he often stops by to chat with my grandfather. I meet him when I come to the shop after school to help Grandpa, and he talks to us about his studies and life in India. One day Matel explains the symbolism of Sikh men's garb. The steel bracelet is a reminder to do God's work, he says, which has no beginning and no end. The *dastār* protects his hair, which is never cut out of respect for the Creator. The sheathed dagger at his side is a reminder to defend the rights of the oppressed. I am fascinated by the culture and impressed by his dedication.

I tell Matel the story about the smashed sitar. He laughs.

"Ah!" he says. "So you are interested in sitar. I will take you to the Hollywood Bowl this Saturday evening to hear the master,

Ravi Shankar. Do not worry! I will seek permission from your father and mother." Ravi Shankar is raising the world's awareness of Indian classical music and the sitar.

On the appointed Saturday evening a bus pulls up in front of our house and fifteen Sikh men get out to be introduced to my parents. I come down the stairs wearing my prettiest dress with orange and white flowers. After much consideration about what to do with my hair I settle on a single braid that comes over my shoulder—rather India-like, I think. I am introduced to the fifteen men.

"Such gracious, lovely people," my mother whispers to me, as Matel chivalrously helps me up the steps of the bus.

"Enjoy the music! Bye-bye!" she calls, waving as the bus pulls away from the curb.

It doesn't occur to me to question the wisdom of my mother sending me, her thirteen-year-old daughter, in a bus alone with fifteen men who are wearing daggers and whom she barely knows, off into the night with no clear expectation of when we will return. But despite her questionable parenting and because of her open-mindedness, I witness a virtuoso performance by one of the world's greatest artists. On the stage, three musicians are seated in a semicircle on bright cushions. Ravi Shankar on his sitar, accompanied by his longtime partner Alla Rakha on the tabla and another musician on the tanpura, the instrument that supports the sitar with a harmonic drone.

When the first piece ends, most of the audience claps and whistles. Following Matel's cue, I do not. Ravi Shankar speaks gently into the microphone.

"If you liked hearing us tune up that much, I know you will like the performance even more." This becomes his standard quip at American concerts, because Western audiences can't tell tuning apart from the compositions.

It is a long concert, and throughout the evening, Matel explains the changes and movements in the pieces. Out of respect for him, I pay close attention, but it isn't easy for me to follow. I was raised on three- and four-chord songs with the focus on melody and lyrics. To my Western ear, Indian classical music all sounds the same, and I suspect most of the audience is having a similar experience. I'm not disappointed when the concert ends. When my mother asks me if I enjoyed the concert, I wonder if she's being sarcastic.

That November, my mother invites Matel and his Sikh student friends to our house for Thanksgiving dinner.

"Indians are Hindu," says my mother. "They don't eat meat."

She makes two dinners, one with a traditional turkey and the other vegetarian, and when Matel and his friends arrive, she explains which dishes contain meat and which do not. They listen politely, then devour the turkey, stuffing, gravy, more turkey, more stuffing, and more gravy.

"Sikhs are allowed to eat meat," explains Matel. "As guests we want to honor the food you serve."

After dinner Matel presents my mother with a delicately woven striped silk scarf from India. My mother is impressed with his manners, which are more polite and respectful than those of many American men. After that evening, Matel becomes a regular guest at our house. He always brings gifts: a carved incense holder, an inlaid box, a blue and silver silk sari. He comes to my fourteenth birthday party, though he doesn't have a gift for me. Instead he brings my mother a beautiful green sari with gold embroidery. After we've all admired it, he wraps me in the sari in the traditional manner.

"Doesn't she look beautiful?" he asks. "Just like an Indian girl."

Everyone tells me how pretty I look.

I'm enjoying the attention, but my aunt Helen raises an eyebrow.

"Watch out," she says when we have a moment away from Matel. "I think he likes you."

"Nonsense," my mother interjects. "It's a gift to me. Matel said so. It's his way of saying thank you for all the nice meals and giving him a home away from home."

That's how we leave it until one day in May, when I arrive home from school to discover my father waiting for me at the breakfast table.

"Sit down," he says. "I want to talk to you."

"What? What about?" I ask, feeling panicky. "Did my math teacher call again?"

My father waves away my concern.

"Matel arranged a formal meeting with me today," he says. "He asked for your hand in marriage. You are fourteen and old enough to be a bride, and he would like to take you to India to be wed. We are all invited."

I sit down and take this in. I'm having difficulty comprehending what he is saying. A bride? I'm only fourteen!

"Your mother didn't understand—none of us understood—that all the gifts were the traditional way of courting a daughter in India," my father explains. "By accepting the gifts and inviting him to dinner, he thought we were agreeing to marriage."

"What did you say?" I cry as the reality begins to settle in. "Please tell me you said no! I don't want to go!" Had my father given me away, like a kitten or a puppy?

"I told him that I thought you were a little young and I preferred that you finished school before marrying," says my father. "He understood that as 'no.' He is disappointed—heartbroken, even—but he wished us the best and apologized for the misunderstanding. He asked me to say goodbye for him. He is leaving for India tomorrow."

In an instant I go from relieved not to be on a plane headed to India to angry that I wasn't consulted in this decision. How dare he make my choice for me!

"How come nobody asked me? Maybe I want to marry Matel and go to India!" I say, indignant. "Maybe I love him and want to marry him! It's my decision, not yours!"

"Were you even aware he had feelings for you?"

"Well . . . no. I mean, yes, we were friends."

"Do you know that in India you don't choose your husband—that your parents do?"

"Well . . . this isn't India."

"Exactly. That's why I said no. You're too young to decide for yourself. Besides, I don't think you would like being an Indian wife. In India you wouldn't be able to question your elders—or your husband."

I'm grateful that my dad didn't give me away, and I feel a little silly that I'd worried. Of course he wouldn't give me away. What was I thinking?

Later that evening Joanne teases me. "I was there, listening in the kitchen. It took Dad a long time before he said no to Matel . . ."

Annoyed, I snap back, "He didn't ask to marry *you*, did he?"

I find the blue sari, the green sari, the box, and Matel's other gifts all dumped on my bedroom floor. My mother doesn't want them now that they remind her of her serious inattention to the subtleties of another culture.

"Pick out a guitar," my father says. "It's your birthday present."

Any guitar?

This generosity—coming three months after my birthday—seems at first like a consolation prize, a gesture to pacify me. But I know my dad really wants to make me feel better. I am in one of the best places in the world to choose an acoustic guitar. I scan all the guitars in the house and the store—dreadnoughts and parlors, Brazilian rosewood, Martins and Gibsons, fancy inlayed

Washburns, Brunos, a Lyon and Healy, and on and on, before choosing a Martin 00-18, a simple spruce and mahogany that plays like a dream.

I keep the green and gold sari and the striped silk scarf. It is the only proof of the strange, misconstrued fairy tale of the "Indian Prince and the Little Princess." Matel disappears from my life and my family never mentions the incident again, except for Joanne, who likes to remind me every now and then that our father almost gave me away.

CHAPTER 6

REVELATIONS

Our next-door neighbors in the Seventh Street house are Ray and Barbara Fowler. Ray is a minister at the Claremont United Church of Christ and Barbara is a kindergarten teacher. They are kind and generous people. One day, Ray comes to our door with a petition. The Fowler family is going on a mission to Turkey for a few years, and before renting the house out Ray wants to make sure their neighbors are okay with his renting the house to a Black doctor and his family. My parents would have preferred that the Fowlers had rented to Dr. Vines and his family without the fuss of a petition, but they sign it. Ray troops around several square blocks asking the neighbors for their support, and in the end the yeas outnumber the nays, though just barely.

Claremont is a largely white community, a status maintained by written and unwritten covenants that are common throughout the foothill and valley communities of Southern California. A typical covenant from an exclusive housing contract reads: "No part of said property shall be sold, conveyed, rented or leased in

whole or in part to any persons of African or Asiatic descent or to any person not of white or Caucasian race."

Dr. Ben Vines establishes his practice in downtown Claremont, where he has the support of Dr. Griggs and Dr. Smilkstein, respected members of the local medical community who see to it that Dr. Vines has admitting privileges at Pomona Valley Hospital.

My mother befriends Dr. Vines's wife, Verma, and Sally, now five, becomes fast friends with the Vineses' two young daughters, Sharon and Dara. Ben and my father strike up a nice friendship, too, and spend many hours talking about politics and race relations over dinner and glasses of wine.

Verma Vines is a tall, slim Black woman with a spray of freckles across her nose and high cheekbones. Elegant and refined, she is uncomfortable with the barefoot, longhaired beatniks who hang around our house, and a little embarrassed when Black musicians come through singing country blues and playing guitar and harmonica, which she sees as feeding Black stereotypes. She prefers the symphony. To please my mother, she visits the local ethnic, embroidered, beaded clothing stores, and the Middle Eastern and Jewish delicatessens, but she prefers more luxurious shopping-and-lunch excursions at Bullock's department store in Pasadena.

Ben Vines is tall and slim. He dresses impeccably no matter the time of day or night; even when relaxing at home he wears a button-down shirt tucked into slacks. He spends most of his time working: House calls, night shifts, and admitting privileges at Pomona Valley Hospital help his practice grow. Dr. Vines is gentle, compassionate, and knowledgeable and always has time for his patients.

One day I get a sliver of metal in my foot. Barefoot is a way of life in our household and I probably stepped on it while wandering through my father's basement workshop. I ignore it at first, but as time goes by the wound evolves into a painful lump. I show it to

my mother, whose medical advice is typical Chase stoicism: *Soak it in Epsom salts. Leave it alone. Don't pick at it.*

I follow her instructions, but the situation doesn't improve. One day after school, desperate to be free from the pain, I visit Dr. Vines's office. His receptionist, clearly uncomfortable that an unaccompanied teenager is in her office, tells me to come back with my mother or father. I refuse to leave, insisting that the doctor is a friend of mine. She is dubious but finds Dr. Vines, who ushers me into his "surgery," as he calls it. I tell him my foot hurts and I am tired of it, and he sits me on his exam table to examine the lump. His forehead creases with concern.

"I shouldn't perform this procedure without your parents being here, but this needs to be taken care of right away," he says. "You did the right thing by coming in."

He gives me a local anesthetic, slices the lump with a scalpel, removes a tiny metal shard, drains the pus, cleans and bandages my foot, and gives me a ride home in his giant car.

Later that evening, after I am supposed to be in bed, I listen from the top of the stairs as Dr. Vines scolds my parents. He tells them to bring me to his office in five days for a follow-up examination. After he leaves, my mother comes up to my room.

"Whatever possessed you to go to a doctor by yourself?" she asks.

I roll my eyes. What else was I going to do?

Not long after the foot operation, I am waiting in the entryway of the Vineses' house to walk my sister Sally home. Dr. Vines greets me, then gently takes hold of my chin and tilts my face up to the light.

"Girl," he asked, "what have you got yourself into now?"

I duck my head out of his grasp and turn away. I have a bumpy rash on my chin and cheeks and didn't want anyone to notice. It's on my hands as well, so I slip them behind my back as he takes my chin again and studies the rash.

"Do you have this anywhere else on your body?"

Reluctantly, I show him my hands.

"How long have you had this?"

"Weeks and weeks. And it's getting worse," I say, choking up. He looks from my hands to my chin to my hands again.

"You're sleeping with your hands tucked under your face, ain't you, baby," he says, dropping his professional tone.

Dr. Vines comes to the house later that evening and gives me an ointment. He says to put it on my face and hands and cover my hands with gloves so they can't touch my face when I'm sleeping. Then he scolds my father for the second time in as many months.

"Charles, your daughter is getting to courting age. She deserves to be happy and pretty. You and Dorothy are being unkind. You should have brought her into the office as soon as this rash appeared."

My father, unaccustomed to being on the defensive, mumbles, "She's too pretty. Doesn't do to be too pretty. She'll get swellheaded."

"Don't be an ass, Charles," the doctor retorts.

One rainy night—a relatively rare occurrence in Southern California—I am sitting at the round oak table in the sunroom with my mother, Joanne, and Verma, while my sister Sally and Sharon and Dara Vines are building a fort of sofa cushions, chairs, side tables, and blankets in the library. Sally had dismantled her slinky-repair shop for the cause, and her ringlets of brown hair bob up and down from the effort. Baby-faced and pretty as a Victorian porcelain doll, Sally always has a plan bubbling behind her bright blue eyes. I'm surprised she hasn't called Bekins moving company to do the heavy lifting.

Just then Dr. Vines stops by and asks to talk to Verma privately on our front porch. A few minutes later the two of them return, looking strained and unhappy.

"We need to talk to your parents privately," Dr. Vines says to Joanne and me. "Do you mind going in the other room with the girls?"

We leave the room but of course we listen. Apparently a threatening letter written in cut-out magazine letters, like in the detective movies, has been slipped under Dr. Vines's office door. It was meant to be anonymous, but Dr. Vines is pretty sure he knows who is responsible. As long as he is in a rental house, Dr. Vines is tolerated by the local doctors and real estate agencies, but recently he bought an empty lot and is planning on building a home. The lot is just around the corner from the home of a physician and prominent Claremont resident who protested giving Ben Vines hospital privileges. The anonymous letter is delivered within a day of the papers being signed on the sale of the property. It warns that if Dr. Vines doesn't back out of the sale and get out of town, he'll be sorry. They don't want "negroes" ruining the neighborhood and the hospital's reputation.

Dr. Vines stands firm, and more threatening letters follow. "Move to Pomona where you n*****s belong," says one. "Move to Pomona and you won't have anything to worry about." And, "You fucking n*****s always ruin everything. You'll be sorry."

Dr. Vines is hurt and angry, but he refuses to be intimidated. "They'll get over it, Charles," he tells my dad.

They don't get over it. One night a cross is burned on their lot. My parents insist that Ben and Verma stay home for their safety while they drive over to check it out. They arrive just as the fire is being doused by the Claremont Fire Department.

"These are dangerous people," my father tells Ben. "They won't stop for anything. You better be sure about this property, because you could be endangering yourself and your family."

Dr. Vines insists he will break ground for his new house within the month. Verma is right beside him.

"We've come this far, Dotty," Verma tells my mother. "We are not about to turn and run now."

The Vineses are my neighbors and I fear for them. The threats and harassment of the Vineses recall the nightmare of my family's experience in North Weymouth—the red-baiting, firing, blacklisting, hate mail, and rocks thrown through our windows. I lost my friends and home. Now something similar is happening to the kind man who took care of me. My doctor, my friend. And there is nothing I can do, nothing my parents can do, to stop it. Our songs about the heroes of the past fighting for justice and a better world are impotent. They don't protect the people we love.

One afternoon one of my teachers takes me aside and asks what happened the night of the cross burning. I am too frightened to answer truthfully, but the conversation spooks me. How did my teacher find out I lived next door to the Vineses? Were we going to be targeted? My parents don't shield me from difficult things, but they don't explain them, either. Maybe they think it's better for me not to know how cruel the world is. I do what I had been taught—I hide my distress and stay silent.

After the cross burning the harassment quiets down, and I start to think we've seen the worst of it. But then it gets worse—much worse.

Late one night we are awakened by pounding on the front door. We hurry downstairs to find a distraught and disheveled Verma with her two half-asleep daughters. My mother settles the kids in Sally's room while my father puts on the teakettle. Verma struggles to explain what's happened, but she can't get the words out. My father takes a bottle out of the freezer and pours her a shot of vodka.

She tosses it back, coughs, and catches her breath. "Charles, that was perfectly awful! Couldn't you have given me something civilized, like whiskey?"

The story emerges. Ben was arrested.

"For what?" Charles asks.

Verma takes a deep breath. "Ben is homosexual. I know, I know. He has a family and all, but he has always been and I have always known and I have always loved him and we have worked things out. It's best for him to have a family. He couldn't survive otherwise. The world is unfriendly enough being Black. Being queer and Black is deadly."

The story comes out in bits. After a stressful day at the hospital, Dr. Vines had driven to the train station in Pomona, on his way to see friends in Los Angeles. A good-looking young man tapped on his window, smiled, and asked Ben to let him in his car. The man was an undercover policeman, and in less than a minute the police surrounded the car and arrested Ben for soliciting. At this time homosexual sex is illegal and homosexuality is classified as a mental illness.

The perilousness of the situation dawns on my father.

"Where is he? What jail? We've got to get him out! I'm calling Dan."

Dan Fox is a violin player and regular attendee at the Folk Song Society meetings. He is also an ACLU attorney. Dan and my father rush first to the Pomona police station, and then to a bail bondsman. Hours later my father brings home a despondent Ben. It's strange to see him this way. My doctor, who always knows what to do, is a defeated man.

"They set me up, Charles," says Ben. "I should have seen it coming. I didn't think they knew. I didn't think anybody knew. They've been following me all this time . . . I've been such a fool. I'm ruined."

The next day Ben meets with an attorney who encourages him to fight to have the charges dropped on the grounds that he had been entrapped. Ben comes home and seems to be reassured that all will be well. But that evening, a frantic Verma is at our door again.

"He's gone. I left him alone downstairs while I put the girls to bed," she tells us. "When I came down, I found a note. He took some pills, and his car is gone."

My father and Verma run out the door, and my mother sends me to the Vineses' house to babysit the girls. When I arrive, Sharon and Dara are awake and anxious, so I walk them back to our house for a slumber party with Sally.

My mother paces. I watch her wring her hands and join her.

Verma and my father drive all over Claremont until they find Ben slumped half in and half out of his car, unconscious. They wrestle him into the back seat of our Ford and drive him home. My mother meets them in the driveway and helps Dad and Verma carry him into the living room.

"Don't let him lie down, he can't fall asleep!" Verma orders. "Dot, make a big pot of coffee! Keep him walking!"

They douse him with cold water at the kitchen sink and keep him upright and walking, taking turns supporting him. Dr. Griggs comes by to check on Ben. He gives him something to induce vomiting and says we should keep him awake for a few hours, and if possible get some food in his stomach.

On his way out the door, Dr. Griggs catches sight of me on the staircase, peeking around the newel post.

"You should be in bed," he tells me, not unkindly.

"He's going to die, isn't he," I whisper.

Dr. Griggs sets down his black bag and sits beside me on the stairs. He rubs his index finger over his chin.

After a few seconds he says, "No. He's not going to die. He has a lot to live for." When he sees my doubtful frown he pats my hand and adds, "Really, he's going to be okay."

All night there is walking, vomiting, coffee, vomiting, more walking, and coffee. Finally, after hours of this, Ben starts sobbing—huge, gut-wrenching, heartbreaking sobs. He collapses in a chair, puts his head down in his arms, and cries until there are no tears and no shame left—no despair or agony or pain. Just a man—and the woman who loves him.

"Benjamin Vines," Verma says, "you will never let me down this way again. We have come too far, you and I."

He nods in agreement.

That night it takes me hours to fall asleep.

The charges are dropped, but Ben loses his privileges at the hospital. He keeps his office on Bonita and attains privileges at another hospital. He moves his office to Montclair, and the Vineses build their two-story house with white plush carpeting and chandeliers.

Meanwhile, Joanne's rebellion is gaining momentum. She resents our parents' preoccupation with music and the Folk Music Center, and she resents Sue for playing guitar because Joanne sees it as kissing up. I didn't learn to play guitar earlier, because I am intimidated by Joanne's hostility to our parents' musical life, and when I do learn I keep it on the sly because it feels as if I am betraying her. I don't share her wrath at our parents, but I can't avoid it either, because Joanne and I share living quarters. She has the main part of the bedroom, while my area is on the sleeping porch that can be reached only by going through her room. There isn't much we can hide from each other, and I know she is living on the edge.

One morning I wake to a sour smell and see the rug in her room rolled up.

"Did you get drunk and throw up?" I ask.

"Mind your own business!" she retorts. She wrestles the rug down the stairs, comes back upstairs, runs to the toilet, pukes, and collapses on the floor.

"What's wrong with you?" If she didn't get drunk, maybe she is dying from some terrible disease.

Joanne looks at me and comes clean. "I'm pregnant," she says. "Don't tell Mom! If you tell, you'll be sorry."

Here is my older sister, barely eighteen and pregnant, and she is worried about me telling our mom? I figure she has a lot more to worry about than that.

When my mother discovers the rolled-up carpet in the trash can, she confronts Joanne. Joanne is silent. I am not. This is too big a deal and my role is too complicated for me to be complicit in a secret that can't be kept for long.

"Joanne's pregnant!" I blurt, after which I make myself scarce. My mother hammers Joanne with questions.

"How far along? Why didn't you tell me sooner? Have you been to a doctor?"

Dad has only one question. "Who's the father? Call him and get him here right now!" Joanne resists. She squirms and dissembles, but Dad is relentless, and a young and terrified Joe Gonzalez shows up at our house that night.

My father informs Joe that he will be marrying Joanne. I'm shocked at my father's reaction. He ignores my mother's concerns and takes charge. I thought we were a modern, progressive family. I think it is a terrible idea for Joanne to marry, to force them to marry. To my lifelong surprise, my hard-core, partying, defiant, hardheaded sister Joanne says she wants to marry Joe and settle down and have a family.

Two weeks later, Joanne and Joe get married in our living room. The newlyweds go to live with Joe's mother in Montclair.

Sue also has an unexpected change of plans. At the end of her sophomore year at Scripps College, which is located five blocks from the family home, she decides to drop out and not return for her junior year.

"It's a finishing school," she tells my parents. "I'm sick of it. I'm sick of dressing up for Sunday dinner, I'm sick of the curfew and all the other restrictions."

My parents respect her decision. My mother gets her a job in Boston with her old friend from the folk music scene Manny Greenhill. Manny's management company, Folklore Productions, has grown rapidly. Some of the people he bet on when they were starting out have become major artists: Joan Baez, Pete Seeger, Bob Dylan, Mahalia Jackson, Doc Watson, Taj Mahal, John Renbourn, and Dave Van Ronk.

With Joanne gone and Sue on the other side of the country, 1961 is a lonely year for me. I had never given any thought to my sisters leaving and am unprepared for how much I miss them. Claremont and my friends are boring, and I mope around the house. When my mother asks me what's wrong, I mumble, "Nothing." I can't admit how empty I feel, and the house feels, without them.

And yet their leaving allows me to grow, as a person and musician. Out from under the critical eye of Sue, who is always alert about the proper thing to wear, the smartest thing to say, and the most appropriate attitude to employ, and liberated from being the primary audience for Joanne's bully pulpit, I discover the freedom to express myself. Without my two older sisters stepping into the vacuum left by my mother's hands-off parenting and with no one around to shut me up, I discover I have a knack for sarcasm and repartee. These are handy weapons for hiding my fears, covering up shyness, making a point, and getting a laugh. The hardest lesson is learning when to keep them holstered.

My newfound confidence gives me a rush of energy, and I devote myself to my music more than ever. I figure out just how much schoolwork I have to do to get by with passing grades and spend the rest of my time practicing guitar, learning dozens of songs and licks. I watch and copy—even pester with questions—the

musicians who come around the house and the Folk Music Center. I memorize, practice, rehearse, and even perform now and again.

I am surprised how much I enjoy performing. The musicians who are available for me to play music with are boys—another discovery. Growing up with three sisters, boys are an alien species. They are competitive, sometimes reckless, and prone to showing off. I take it upon myself to put them in their place with standard quips like "Yeah? You and who else?" or, more pointedly, "It's a great song. I wonder what it would sound like if your guitar was in tune." My mother tells me I have to be nicer or no boy will ever like me. I don't find this particularly concerning.

With Sue and Joanne out of the house, I become the primary big sister, a new role that I take on reluctantly. Sally, six years old, has more space to become herself, and graduates from paper dolls to magic. She develops her act and I am her audience. Her show begins exactly the same way every time:

"Ladies and jellyfish! I come before you to stand behind you, to tell you something I know nothing about! Next Thursday, which is Good Friday, there will be a mothers' meeting for fathers only. Admission is free, pay at the door. Pull up a seat and sit on the floor. We will be discussing the four corners of the round table!"

After this recitation come the magic tricks. Scarves play a major role in these performances, and items appear and disappear under and inside them. Random belongings of household members—that we have turned the house upside down looking for—come out of her sleeves or from under the hat she dons for these occasions. Though the tricks are unconvincing, the show is, I have to admit, hilarious.

CHAPTER 7

GRAVY, GRAPEFRUIT, AND THE BIG GREEN CHAIR

As my mother adapts to life in California, she gains confidence and develops her own sense of style. Gone is the idea that she must pay tribute to the conservative shirtwaist dresses and cardigans of the era. Somewhat plump, she feels most attractive wearing simple, loose blouses and skirts that she embroiders herself with colorful tableaus of floral, astrological, pastoral, and animal designs. She often goes barefoot or wears soft moccasin-like shoes, rising up on tiptoes in the company of tall people to add an inch to her five-foot frame. She is a progressive patron saint; she loves dogs, cats, babies, and kids. Like a Jewish female St. Francis with lefty political leanings, she communicates with wild birds, whom she finds more responsive and pleasant to be around than her daughters. She is dealing with her third teenage girl, and even I can see she is weary of dealing with the whims and vagaries of this particular type of self-centered beast.

My mother finds an artistic home in the cocoon of the Idyllwild School of Music and the Arts (ISOMATA), where she is surrounded by like-minded students, teachers, and performers, many of whom become lifelong friends.

Idyllwild is a quaint town in the middle of a pine forest in the San Jacinto Mountains eighty miles southeast of Claremont, accessible only by a narrow highway with precipitous drop-offs and perilous curves. Under the leadership of Max and Beatrice Krone, it had primarily been a classical music and arts school for affluent city people seeking culture and fresh mountain air. But when the folk boom became too popular to ignore, the Krones added a two-week folk music camp, and by 1960, attendance is burgeoning.

The staff and teachers include musicians whose names are synonymous with the folk music revival. Pete Seeger was invited in 1958, after the worst of McCarthyism was past. Sam Hinton, legendary musician, singer, harmonica player, and marine biologist, ran the folk music school for the Krones. He brought in people like Frank Hamilton, founder of Chicago's Old Town School of Folk Music; Pete Seeger's half-brother, Mike Seeger; the "mother of folk," Jean Ritchie, with her mountain dulcimer; the blues duo Brownie McGhee and Sonny Terry; guitarist and singer Doc Watson; and banjoist Clarence "Tom" Ashley.

The summer of 1961 is the third year my parents close the Folk Music Center for two weeks and head to Idyllwild for the folk music camp. They pack up practically the whole store, repair bench and all, and create a pop-up store in a little cabin space near the outdoor stage in the woods. My father repairs instruments and sells banjos, mandolins, dulcimers, guitars, and accessories, while my mother teaches banjo and guitar. I make friends with other camp kids, swim, hike, and help around the store. There are workshops all day and concerts every evening and lots of jamming.

This is a confusing, fun, exciting summer for me, perched between childhood and, if not womanhood, then a precocious adolescence. I meet everyone coming into the store and watch and listen carefully while my father assesses a person's repair or

matches someone with a new instrument. By now I'm a true guitar player, and I eagerly attend every workshop I can. Most of the workshops take place in outdoor classrooms under lean-tos or in shady open spaces tucked among the trees, so it isn't hard to make a quick getaway if a workshop isn't what I'd hoped it would be and just as easy to slide into another one in progress.

I sit in on Clarence "Tom" Ashley's class on sawmill banjo tuning. In the middle of the class Clarence looks up to see the students dutifully taking notes. No one is playing their instrument.

"Just play!" cries Clarence. The pens and pencils go down.

I slip into a workshop on ballads put on by Marais and Miranda. Josef Marais is from South Africa; his wife, Miranda, is from Holland. Classically influenced and politically appropriate, the two are known for singing traditional folk ballads and are a staple of ISO-MATA. The class is attended by a mix of old-school progressives and younger folk music revivalists. The two are performing their shtick, as my mother calls it, which I find quaint and campy. Marais sits on a slightly higher stool than Miranda, who coyly looks up at him. "A ballad is a story of peoples' own experiences," Marais says, sounding like a kindergarten teacher. "A ballad is the oldest form of folk music. We don't even know how many people wrote most ballads, which were passed on from generation to generation. We could make up a ballad right now about Idyllwild."

Marais and Miranda are an attractive couple with a polished and urbane style. Miranda is wearing a modest white blouse with a Peter Pan collar buttoned to the throat and an accent scarf; Marais is similarly buttoned up. They have an operetta-influenced manner of singing, featuring plummy vowels and carefully articulated consonants. I don't last more than ten minutes before abandoning the session.

I peek in on my mother's beginning guitar class; she has everybody singing "Michael, Row the Boat Ashore." There isn't

an empty seat, and I head off in search of Brownie McGhee's twelve-bar blues workshop. He acknowledges my presence with a chin nod and his incomparable smile, making me feel special. Brownie and Sonny came to our cabin for dinner the evening before, and as I listen to Brownie play and sing, it strikes me that I come from a remarkable family.

One afternoon, I'm sitting in the dappled sun on the large flat rock in front of the temporary Folk Music Center, chatting with my friends Barbara Byxbe and Anna Lomax. Barbara's parents run another summer folk music camp near Fresno called Sweet's Mill. Anna is Bess Lomax Hawes's niece and the daughter of Alan Lomax and granddaughter of John Lomax, the renowned folklorists. The three of us are the next generation of folkies. We are looking over the ISOMATA program, carefully choosing our workshops and making recommendations to each other. I warn them off the ballad workshop. I decide to attend Doc Watson's flat-picking class.

Just then Warren Cox drives up in his convertible sports car. Warren is a tall young man with a big smile and reddish hair. He works at McCabe's Guitar Shop in Santa Monica, which opened shortly after the Folk Music Center. Warren asks me if I'd like to go for a ride up the mountain. Warren is single, good-looking, and a flirt, and rumors float around the camp that he is well-off.

"Sure," I say, hopping in the car. The day is sunny and breezy, perfect for a drive in a convertible. We speed out of camp and up the winding mountain road. The ride isn't as much fun as I expected, as the wind blows my long hair into my eyes and mouth, and I wish we would get wherever we were going. Finally Warren pulls to the side of the road, jumps out, and skips around the front of the car, bumping into me as I climb out of my seat.

"A lady always waits for the man to open the car door for her," Warren chides. Pulling a blue plaid Pendleton blanket from the trunk, he leads me down a dirt lane to an outcrop of rocks with a magnificent view. He spreads the blanket on the ground and lies down on his side, propped on his elbow. I sit as far as possible from him on the edge of the scratchy wool blanket, wishing I was wearing jeans instead of shorts. We look out toward the horizon and chat about guitars, the only thing a twenty-something-year-old man and a fourteen-and-a-half-year-old girl have in common. I'm increasingly uncomfortable, but I don't know why.

A lizard runs onto the rock in front of us.

"Look!" I say, pointing.

"You like lizards?" Warren asks in a sleepy voice. "I'll catch him for you if you give me a pretty."

Do I like lizards? Not really. The more important question is, what the hell is a *pretty*? I am out of my depth, but I'm not going to admit it.

"Get me the lizard first," I say, playing for time.

Warren abruptly stands. "Let's go," he says. He folds the blanket and I follow him to the car. The wind whips my hair into my face as he speeds down the mountain, never saying a word.

I'm baffled. I did or said something wrong, but I don't know what it was. I want to be a grown-up, to be sophisticated and understand men, but I'm just a teenager—more child than not. I don't understand the first thing about the rules of romantic engagement. I don't even know how to know if I'm being engaged romantically.

After an interminable drive, Warren roars into camp and lets me out in front of the main stage, which is empty at this hour. I get out of the car and watch him speed off. Barbara appears out of nowhere and insists I tell her the full story.

"What happened?" she asks, tossing her short dark curls. "What did you guys do? Where did you go? I'm so jealous!"

I tell her about the lizard, and the "pretty." She is impressed.

"I'd give Warren a pretty any day," she says. "He's so handsome."

I'm too embarrassed to admit I don't know what a "pretty" is, and too proud to ask her, so I just nod.

Back at the store my mother is learning "Shady Grove" on the mountain dulcimer, Jean Ritchie style.

"What's a pretty?" I ask.

"*Pretty,*" she says, looking up from her dulcimer, "is an adjective, not a noun." She goes back to practicing, and I never find out what it is.

The Idyllwild School is an important link for my mother. Her reputation as a connection for touring artists on the folk circuit leads to a steady stream of musicians staying at our home. Our living room becomes an important way station in the world of American folk music.

One afternoon early in tenth grade, I arrive at home after school to find Mike Seeger sitting in our big green rocking chair with his feet on the ottoman, reading the newspaper. Mike has an intense energy, like a coiled spring. He has a thick mop of dark hair and is thin like his older half-brother, Pete, but not as tall. I'd met him the previous summer when I attended his autoharp and mandolin workshops at ISOMATA. His skill in playing traditional music on a variety of stringed instruments impressed me, but I didn't expect him to remember me. I'm hungry and too shy to remind him who I am, so I hurry past him to the kitchen.

As I'm leaving the kitchen, I bump into Mike.

"Is there anything to eat in this house?" he asks.

"Sure!" I say, eager to please. "Want some walnuts and chocolate bits?"

"Are you trying to kill me?" he shrieks. "I have an ulcer! Do you know what walnuts would do to me? Get me a bowl of vanilla ice cream!"

It doesn't dawn on me to ask why he assumes there is vanilla ice cream; for that matter, there is no reason to expect me to know he has an ulcer or what walnuts would do to it. I am too intimidated to see how presumptuous he is being. As with Warren, I am mystified by the behavior of a man.

As it happens, we do have vanilla ice cream—or, rather, we did. I have just eaten the last of our vanilla ice cream (with walnuts and chocolate bits mixed in). Desperate to please, I go to the kitchen and fill a bowl with cottage cheese and top it with maple syrup. I hand it to him and run upstairs to my room. I don't know if he eats it.

I can stay upstairs only for so long before I'm bored and curious to see if anything is going on downstairs. I am overjoyed when I come back downstairs and see Mike's wife, Marge, sitting in the green rocking chair, nursing her baby. I adore Marge. She is a professional model from New York and treats me like an adult. She is beautiful, with smooth skin and straight, shiny brown hair. She is the most graceful and beautiful person I have ever seen. I sit on the ottoman at her feet and tell her I don't want to have babies because the moms always get stuck home and never get to do anything. Marge laughs and says it's not that bad, but agrees it's something to think about before getting pregnant. She seems to be glad to have somebody to talk to. I know I am.

In the other room I hear Mike practicing "Hot Corn, Cold Corn" on his mandolin. He is the first person I know who excels at many instruments. If it has strings, Mike can play it. He doesn't have the level of fame that his half-brother, Pete, does, but he is an important figure in American folk music. He is more of a purist about the tradition than Pete, and his interpretations of traditional songs are synonymous with what folkies dub "old-timey

music"—music played in the manner of the oldest recordings available from 78s, reel-to-reel tapes, and the ancient wire recorders of intrepid American song collectors.

Mike is a founding member of the New Lost City Ramblers, the influential string band that plays old-time Southern music. Mike is dedicated to keeping the traditional songs alive in their original form for future generations. Unlike the popularizers of folk music—such as Burl Ives; Harry Belafonte; Peter, Paul and Mary; and the Kingston Trio, whose commercially viable interpretations of the traditional songs smooth the jagged edges and render them more nonthreatening—the New Lost City Ramblers strive to present the songs on their own terms.

The New Lost City Ramblers don't soften their lyrics. Women are stereotyped, murdered, and property in these songs. Mike says they represent a different time, and rewriting history is a loss for everyone. The instrumentation duplicates the old players' styles. It's not smooth and streamlined. He is adamant that the songs should be played the way they were created and not sanitized for acceptance by a modern popular audience.

Mike isn't the only musician who stays in our home who is committed to originality, be it gritty, sweet, or suggestive. My mother has a special connection with Doc Watson from the moment they meet at Idyllwild. From then on, whenever Doc plays the Ash Grove in Los Angeles he also comes to Claremont to perform. Doc is blind, due to an eye infection before his first birthday. His sky-blue eyes are cloudy, unfocused, and permanently squinted. He has a shock of blond hair and dresses casually in a button-down or work shirt.

Doc is one of the most influential American guitarists alive, yet he is remarkably humble. He comes from a North Carolina

mountain family and grew up steeped in folk music and sacred hymns. Although he played guitar professionally from a young age, it is his work as a vocalist, acoustic guitarist, and banjo player that garners him international fame. He is a regular at folk music festivals and coffeehouses and on the college circuit. I am spellbound by the sound of Doc Watson's voice and guitar.

Doc and his banjo-playing partner, Clarence "Tom" Ashley, are staying at our house after a concert that my mother organized at the local elementary school auditorium. The morning after the show we gather around the breakfast table while my mother cooks scrambled eggs and bacon and, beaming with pride, brings out a huge platter of fluffy golden biscuits fresh from the oven. The smell is heavenly.

Doc picks up one of my mother's biscuits and turns it in his hands, feeling the warmth.

"Whoa," he says, "this is going to be good."

"Here's some butter and real maple syrup," says my mom.

"Dorothy," Doc drawls, "why would you want to ruin a perfectly good biscuit with maple syrup? Don't you have any white gravy?"

"Doc, why would you ruin a good biscuit with that . . . *gravy?*"

"Here we go," says Doc, laughing. "It's the North and South all over again. What we fought the war over."

"You just wait a minute," my mom says. She dashes into the kitchen and mixes up some bacon fat with butter, flour, milk, salt, and pepper. She heats it all together in the frying pan, puts it in a gravy pitcher, and presents it to Doc. Wide-eyed, I wait for his reaction, wondering where an East Coast Jewish girl like my mother learned how to make Southern gravy.

"Well, I'll be darned," Doc says with a wicked grin. "That's the best biscuits and gravy I've ever had. I guess the North and South can work it out."

I gamely try a biscuit with gravy, but to me it tastes like eating milky flour on top of a biscuit. I prefer the maple syrup—that's the Yankee in me, I suppose. In New Hampshire, our family had a maple sugar farm. We ate syrup on everything.

When Doc stays with us, I lurk about the house making up things to do, waiting for him to sit on the living room couch and ask for a guitar. I know he prefers the big Martin or Gibson dreadnoughts that are designed for flat-picking, but one time I hand him my smaller Martin 00-18. Doc's large frame and hands engulf my guitar, which sounds unbearably sweet under his fingers.

Doc gets a kick out of never knowing what guitar will wind up in his hands, and we enjoy never knowing what music will emerge. Hearing a song that comes from him is like receiving a magical gift. "Matty Groves," "Pretty Little Pink," "Sitting on Top of the World," "Omie Wise"—what will he play?

One afternoon when Doc is playing, Fred Price, a fiddler from Tennessee who is touring with him, grabs his fiddle and plays along. Then Clarence Ashley joins in on the banjo, and the three of them play on. I listen and watch, mesmerized by the hypnotic richness of the music. Even I know that I'm experiencing something incomparable.

Barely a week later I arrive home from school to find Brownie McGhee and Sonny Terry, the blues duo we first met at Idyllwild, are guests in our home, sitting in the sunroom enjoying coffee and apple pie. I'm thrilled to see them, though a small part of me resents having to share the bathroom yet again with what I consider old men. Sonny smokes a lot—everybody smokes cigarettes—and the bathroom reeks. I don't know what it is about men and smoking in the bathroom. They all seem to do it. I quickly

dismiss my annoyance. I know that this kind of thinking will gain me no sympathy in this household. It's all part of being good hosts to good friends.

Sonny Terry plays the harmonica—but that's like saying Michelangelo made statues. Sonny plays the harmonica like no one else; he talks to it and through it, and it talks to him. Between his playing, singing, whooping, and hollering, Sonny is a one-man hocket—a conversation, a call-and-response, a story. Like Doc, he is also almost blind; when he was a boy, his eyes were injured, and now thick plastic glasses aid what little sight he still has. His vision is so poor that as a young man he was unable to work the family farm in Georgia, which was the only work available to a poor African American in the South.

Brownie McGhee's childhood was also difficult. Stricken with polio as a child, he was left with a somewhat atrophied leg that limits his mobility. Unable to do farm or factory work, Brownie learned to play the guitar and sing.

Music was both men's means of survival and ticket out of poverty. In 1942, Sonny and Brownie teamed up, and the two were an instant hit in New York. Brownie likes to quip that when he and Sonny walk out on stage, elbows linked, it is the "lame leading the blind. He does my walking, and I do his looking." Brownie is Sonny's ballast. Brownie's soulful guitar playing and mellow voice balance out Sonny's rough-edged vocals, producing an almost perfect acoustic blues duo. The two become extremely popular on the folk revival college festival circuit.

Brownie and Sonny use their time at our house to relax. They enjoy sitting around the sunroom table, engaging us in conversation. A big man with a warm, handsome face, Brownie can charm you right off your chair just by smiling.

"Hey, pretty girl," he says, making me giggle and flutter my eyelashes.

I'm shy around Brownie, and I never know what to say, but he makes up for any lag in the conversation by asking me about myself.

"Do you play guitar?" he asks. "What kind of music do you like?" One day he asks me what my favorite song is.

"I don't know," I say. "It changes every time I hear a song I like."

He thinks about this for a few beats and responds with an unexpected insight. "I hear you, girl. It depends on your mood."

Brownie and my father often talk into the night about the racism embedded in the national psyche and institutions. Malcolm X, the Nation of Islam, Martin Luther King Jr., and the ongoing struggle for civil rights are in the air. Brownie and Sonny are successful enough on the festival and coffeehouse circuit to give Brownie a platform to speak out against racial injustice, enabling him to reach a young white audience that is discovering America's great blues artists. He encourages his audience to go beyond the music and put themselves on the line in the struggle for civil rights.

My mother's generous table is a legend among touring folk musicians. Sonny is partial to Dot's chicken and dumplings and Brownie likes her lasagna, but he *loves* our grapefruit. The grapefruit tree in our backyard is always either in bloom or bearing fruit. Dot cuts one of the large yellow globes in half, slices the individual sections, and sprinkles the halves with a generous layer of brown sugar.

"Dorothy," says Brownie, "I don't know how you do it, but these are the best grapefruits in the world." When he leaves he packs as many grapefruits as he can in his bag.

I credit our large pet rabbit, Fluffy, for providing the fertilizer for the terrific crops.

FREIGHT TRAIN, FREIGHT TRAIN

It's 1962, a year filled with music and musicians, when a young woman named Molly shows up on our doorstep with two suitcases and a guitar. Small and dark-haired, with long bangs cut straight across her forehead, and wearing stylish horn-rimmed glasses, Molly was a member of Sue's old-timey trio the Barn Jumpers at Scripps College. She had just been expelled from school at the start of her senior year.

Her alleged crime, according to the Scripps disciplinary committee, was being caught in a same-sex relationship with a graduate student. Molly's parents won't let her come home, won't fight for her right to complete her last year of school or support her attempt at an appeal. My father advocates for Molly and tries to change the administration's mind, to no avail. Molly is out. Her expulsion is final.

Abandoned by her family and school, a desperate Molly turns to us. We welcome her into our home. I feel badly for all she's lost, but I enjoy her company. She is quick to laugh and one heck of a guitar picker.

Molly sleeps until noon every day and once up all she has is coffee and cigarettes until about three in the afternoon. When I suggest that this doesn't seem very healthy, she responds that it's her weight-loss program.

"If I'm only awake half the day, I only eat half as much."

I know she's joking but it isn't that funny. She doesn't need to lose any weight and she ought to eat some breakfast.

I know how much being kicked out of school hurts Molly and I can't understand how her parents can be so cruel. It makes my blood boil that the college expelled a student who was getting top grades and not hurting anyone. It seems to me that Scripps is doing the same thing to Molly that McCarthyism did to my family in the 1950s.

Molly feels the weight of the injustice and struggles to recover from her anger and disgrace. As the months pass, she grows more and more depressed, sleeping most of the day and refusing to go out with friends. At one point she confides to me that her father has always been cold and rigid, while her mother is a lonely alcoholic. When Molly was still in high school, her mother often asked her to stay up late into the night sharing a bottle of wine. Molly says she still craves wine but refuses to give in out of fear that she will wind up like her mother. I find this unfathomable and am grateful for the parents I have.

I persuade Molly to teach a fingerpicking class at the Folk Music Center. Molly is an expert fingerpicker, one of the few women fingerpickers in the folk world. She's a marvel. As it turns out, she is also a remarkable teacher. There are three of us in the class, and we learn the secret of fingerpicking: It's all in the thumb. The right thumb keeps a strong rhythmic alternating bass while the index and middle fingers pick the melody simultaneously. She teaches us Elizabeth Cotton's "Freight Train," Mississippi John Hurt's "Richland Woman Blues," and the traditional "Roll On

Buddy." One night a week for eight weeks I unlock the store, and for two hours we lose ourselves in powerful rhythms and melodies.

Eventually Molly gathers up the pieces of her life and moves out of our house, but she continues to stay in touch. A failed marriage sends her into a tailspin for a time, but ultimately she becomes and stays sober. One of the students in Molly's fingerpicking class is Chris Darrow. Chris is a good pal, always game for a fun excursion or to stay up late talking. We go to art openings and art shows and hang out together at the Folk Music Center.

One day Chris is driving me home from work in his "woody," a faux wood–paneled station wagon that is popular with surfers, when he says he needs to make a quick detour.

"I have to stop at Goldstein's Auto Supply," Chris says, casually adding, "although he's kike-y in his ways."

I'm speechless. I stare at him, perfectly at home in his anti-Semitism and oblivious to my reaction. I'm not so much angry or offended as disappointed. After that, something is broken between us, and while we stay friends, it's never really the same.

Life rolls on. Music is always the center of my world, and I do just enough schoolwork to get by. As with any high school, Claremont High School has its most admired students, such as the football players and cheerleaders, and other, less popular students, like the nerds with straight As. There are cliques and shifting allegiances and loners and misfits. I refuse to be classified in any of these groups and go my own way, wearing my hair long and loose, in contrast to the more popular teased and sprayed bubble haircut, and favoring sling-back flats, embroidered blouses, and the new knee-length culottes that the dress code hasn't yet caught up with to forbid. My behavior implicitly dares anyone to question my choices, and to my surprise, my feigned detachment is interpreted

as cool, and I have friends across the spectrum: nerds, football players, and misfits. Still, I don't fully feel that I belong. As a result, I keep my own counsel and resist being close to anyone.

My real social life revolves around the Folk Music Center and Claremont's flourishing counterculture of poets, pickers, painters, and sculptors. When I'm not at the store, I hang out at the Art Studio two blocks away, which is owned by local high school art teacher Robert George and is an informal gathering place for unconventional young artists and musicians trying to find themselves. We are a cohort coming of age in conflicted, Cold War, conformist America, and yet we are an innocent, idealistic bunch. We sing folk songs, write poetry, paint pictures, and read novels by Kurt Vonnegut, Philip Roth, and Joseph Heller. There is no alcohol, drugs, or hanky-panky. We are students of the human condition and take ourselves very seriously.

In my fifteenth year, I meet Bill Guthrie, the eldest son of America's most famous folk musician and songwriter, Woody Guthrie. Bill is different from any of my other friends. He is twenty-two years old and has seen a different side of the world of music. He barely knows his famous dad, who long ago abandoned Bill's mom, Mary, and their three small children. Woody divorced Mary when Bill was three years old, leaving them penniless in a run-down shack in Pampa, Texas.

Best known as the composer of the iconic song "This Land Is Your Land" and an inspiration for songwriters such as Bob Dylan and Bruce Springsteen, Woody Guthrie is a legend. He is also afflicted with the fatal genetic disease Huntington's chorea, better known as Huntington's disease. He is no longer able to play or compose and has been hospitalized in New York for years. The disease hangs over his children like the sword of Damocles, always

there, threatening to alter their lives forever. It often starts when people are in their thirties but can strike as early as twenty or as late as fifty, and Bill and his sisters live in perpetual fear. Woody and Mary's eldest daughter, Gwenn, first exhibited symptoms at twenty-six that soon advanced beyond the point where Mary and her other daughter, Sue, two years younger, could care for Gwenn at home. They found a nursing home not far from us in Claremont, and soon our two families became very close.

Bill has just finished his tour of duty in the army. At loose ends following his discharge, Bill moves in with his mother and older sister Sue until he can sort out his next step. He is devoted to his mother and sisters, and they are to him.

I love Bill from the moment I meet him. He is the spitting image of his dad—slim, even gaunt, with deep, sad eyes and a great sense of humor. He sounds like his father, too, though his mannerisms are softer and more boyish. Our first connection is through music, which is no surprise in two people whose families are so steeped in the folk world. Bill says he doesn't know how to play his dad's songs and asks me to teach him. I already know many of his father's songs, which are a significant part of the folk music canon. I am flattered that this man wants my help and I'm happy to oblige.

My mother trusts Bill, which is great for me because he has a car and is happy to take me places. We frequently head to the Ash Grove in Los Angeles, the folk music club that is often a touring act's first stop in Southern California. It might be the Greenbriar Boys one night and the Stanley Brothers on another. Whoever it is, it's always good. I love these drives with Bill, which are the perfect combination of freedom and companionship.

One night Bill confides that he desperately wants to go to college. He gave his GI money to his mother to help pay for his sister Gwenn's care and has no other savings. Summoning his courage, he goes to New York to talk to his father's second wife, Marjorie

Guthrie, who manages the Woody Guthrie Foundation's funds, to see if she could help him. Bill tells us Marjorie says no. Bill says she tells him the money is for her children's future and she can't jeopardize their security.

While he is in New York, Bill also visits his dad in the hospital, which is difficult in light of his father's neglect. Later, back in California, Bill attempts to describe what it was like to have witnessed his father's deterioration; he says little, but I can sense his agony. I notice the way his resentment is superseded by pity—and a fear so profound he can't breathe. Woody was flailing. His body was wracked with shudders, and he shouted deafening blasts of incoherent words that tumbled through clenched teeth from his foaming mouth in a hideous, perseverated mockery of his songs.

Bill can't hide the hurt he feels from his stepmother's rejection, and how frightened he is of the disease that could ravage his family. We all feel helpless. Then my father has an idea. He suggests that Bill reach out to Pete Seeger, who is on the board of the Woody Guthrie Foundation. Pete has a lot of clout with Marjorie and arranges for Bill to have the money he needs to attend college.

The Guthrie family was star-crossed from the time of Woody's grandparents, when there were several mysterious house fires and accidents, and when Woody's mother was confined to a mental institution. Sadly, the stars continue to fail them. One day my mother notices that Sue Guthrie is listing to one side as she walks. She doesn't mention it, preferring to allow the Guthries time to come to terms with the truth themselves.

One night after a concert at the Ash Grove, Bill and I are sitting in his car when I ask him if he's noticed anything about Sue's health.

"Yes," Bill says, after a moment of silence. "The other day she was trying to light a cigarette and missed. She couldn't line the

match up with her cigarette." He pauses, gathering himself. "There are other signs. Mom knows. Inside she knows, but she won't say it out loud. It's as if by saying it, it'll make it true."

Soon after that night the inevitable comes to pass. Sue Guthrie is diagnosed with Huntington's disease.

A few weeks later, Bill and I are once again sitting in his car talking when Bill asks me if I want children one day. I am caught off guard. I'm only fifteen—I can't even drive a car yet, so I'm definitely not giving serious thought to having children.

"Well, no," I stammer. "I mean, I guess maybe someday. I don't really know."

"I do," says Bill. "I want children, but I can never have them. I could never subject them to living with the possibility of having this disease. I saw what it did to my dad. I could never make someone live with the fear we've lived with—the knowledge that any time they miss a step or do something cockeyed, it could mean they have it. I can't make someone live with what that does to you—what it does to the people who love you."

I absorb the significance of what he is saying. This is different than the blacklist. The blacklist was terrifying, but it was created by the evil of men. Someone was at fault; blame could be placed. This is an accident of nature. This is a tragedy without a villain.

Our late-night talks have made me feel close to Bill. Often, as we are talking in the dark of his car, I imagine him putting his hand on my knee or his arm around my shoulders. He never does, though. One time, I reach out and take his hand. He squeezes it and says, "No touching till you're eighteen." No wonder my mother trusts him.

But this conversation about children is more intimate than any touching could be. As much as I want to comfort him, I'm not brave enough to hug him. I am confused and start to cry. He cries, too. We sit side by side, wet-eyed and silent.

Thanksgiving break arrives. I come home from school excited to be on vacation and ready to help my mother make pies. Instead I find a cold house with no delicious smells and my mother and father seated at the sunroom table, silhouetted by the late November light. I can't see their expressions, but I don't need to. Something is wrong. They are never both home at this time of day. They look at me, glance at each other, and then turn back to me. My father clears his throat and sips some tea. I sit down and pour myself a cup, bracing myself for whatever I am about to hear.

"I have some bad news," my mother says. "Bill was in an accident last night. He's in the hospital."

I jump up. "What? What happened? Is he okay? Let's go to the hospital! I have to see him!"

"You can't," says my mother. "He's in bad shape, and the doctors don't expect him to live. His car was hit by a train. It stalled while he was crossing the tracks."

I struggle to understand what I am hearing. I shake my head, refusing to accept what my mother is telling me.

"We have to go!" I insist. "I have to see him! I have to!"

I am screaming now, but my mother keeps saying no, we can't go. "Mary and Sue are with him," she says. "Mary said they just want the family there."

"I have to see him before he goes," I demand. "He would want to see me."

Then a thought occurs to me, a thought I can't keep inside. "I think he tried to commit suicide," I tell her. "I think he tried to kill himself—"

"Don't say that!" my mother says, cutting me off and shocking me into silence. "Mary is Catholic. You can never mention suicide. Do you hear me?"

I stare at her, and at my father, as my father explains that Catholic teaching views suicide as a mortal sin that prevents people

from going to heaven. It is a kindness to Mary not to suggest that her son's soul wouldn't be saved.

Before the end of the day, Bill is dead.

The next day, Thanksgiving, is a blur. Once again, I broach the subject of Bill's death with my mother, hoping for some clarity, or maybe just some comfort. I tell her about the conversation about having children, and about the palpable sadness in the car. I tell her I suspect he saw signs that he had Huntington's.

"I think he had symptoms, or he thought he did, and couldn't face living like that."

"He's too young to have symptoms," my mother insists, brushing my suspicions aside. "It was an accident. That railroad crossing is dangerous. His car stalled on the tracks. He would never have done that to his mother."

After that, we don't talk of Bill again. I am left alone with my thoughts of Bill, of his short life, and his kindness. I miss him. But how does a fifteen-year-old grieve? I cry. I bemoan the unfairness of it all. And I write a song in my diary set to the tune of the ancient ballad "Lord Randall." I call it "Young William."

Where have you been, young William, my son?
Where have you been, my handsome young one?
I've served Uncle Sam, Mother
I've served Uncle Sam, Mother
I've served Uncle Sam
Now I don't understand
Why I'm left to stand
In the shadow of a man
> *Chorus:*
> *Oh, make my bed soft*
> *For I'm sick to my heart*
> *And fain would lie down*

Where have you been, young William, my son?
Where have you been, my handsome young one?
I've blown from the dust bowl, Mother
I've blown from the dust bowl, Mother
I've been coast to coast
To the man I love most
Whose words spill like foam
Into rhythms unknown
These word-rattled rhymes
Are all I take home.
 Oh, make my bed soft
 For I'm sick to my heart
 And fain would lie down
Where have you been, young William, my son?
Where have you been, my handsome young one?
I've been to the queen, Mother
I've been to the queen, Mother
I've been to the queen
Who couldn't see me
She has eyes for just one
Her own heir and son
But she holds the key to the
To the kingdom I fear
She won't lend a hand
And she won't give an ear
 Oh, make my bed soft
 For I'm sick to my heart
 And fain would lie down
What'll you do now, young William, my son?
What'll you do now, my handsome young one?
I'll play my guitar, Mother
I'll play my guitar, Mother

I'll play my guitar
And I'll get in my car
And drive to the one
That's close to my heart
But tears blind my sight
On that terrible night
　　Oh, make my bed soft
　　For I'm sick to my heart
　　And fain would lie down

CHAPTER 9

THE CAT'S PAJAMAS

The 1960s is unfurling as a decade ripe for change—a much-needed rebirth after the tyranny of the 1950s, a decade that featured the political and cultural repression of FBI Director J. Edgar Hoover and Senator Joseph McCarthy, bent on destroying political activists; the violent nationwide repression of people of color; and women, after doing men's jobs during World War II, being sent back to their kitchens. After more than a decade of postwar conformity, people are crying out for radical change.

Baby boomers, the largest generation of young people in world history, are coming of age. Many in this largely affluent, well-educated, and restless generation, seeking inspiration and hope, embrace the authenticity of folk music as a powerful medium for expression. Folk music is an antidote to the cynicism of Cold War politics, the hypocrisy of racism, and the ever-expanding dominance of conscienceless corporations and technology. In the face of mass media and the commercialization of art, folk music offers a communal and humane form of self-expression.

There is always a tension between what is considered authentic and what is thought of as *commercial*. The folk music revival is a story of blurred lines, and navigating those often poorly defined boundaries is complicated. There can't be a folk music revival without a music industry. The industry has the means to reproduce and disseminate the message to a wider audience; without it, folk music will remain on the picket lines, protest marches, front porches, and living rooms of America's struggling working classes, a valuable but marginalized form of expression. In our economic system, the folk industry is forced to grow in order to survive, and in the process devours its own grassroots origins. It loses the authenticity that derives from community. We folkies are well aware of this dilemma and grapple with it every day. We want more for the folk movement than to be a shelf in the libraries of Smithsonian folklorists and musicologists: We want folk music to spread across the country and reach the souls of Americans ready for change. But we don't want to be co-opted by the commercial music industry in the process.

"Ugh!" my mother says one afternoon as she hangs up the phone. "John Stewart is coming over to meet with me. Whatever do you suppose *he* wants?"

John Stewart is a regular on the Southern California folk music scene. He is a singer-songwriter and had recently been invited to be a member of the folk music group the Kingston Trio, who had a number one hit with "Tom Dooley" in 1958. My mother considers the Kingston Trio to be the epitome of the crass commercialization that is taking over the more traditional folk song societies and get-togethers to which she has dedicated her life. To my mother, John—a regular at the Folk Music Center, a tall, strapping, and brash young man—is not "the real deal."

Nonetheless, she invites him over, and soon there is a knock on the door. I invite John in and deliver him to my mother, who

is sitting in the green rocking chair and making no move to get up. I sit down on the sofa across from her—I'm not going to miss this for anything.

"Thank you so much for agreeing to meet with me," John says, standing by the side of her chair. My mother offers him her hand, and he gallantly brings it to his lips, bowing slightly as if he is kissing the pope's ring.

"May I?" he asks, and sits on the ottoman by her feet without waiting for an answer.

"So, John, what could a famous folk singer like you want with the likes of me?"

John leans forward. "Dorothy," he says, pleading, "make me authentic!"

My mother is silent for a moment. Then she bursts out laughing. She laughs until tears are running down her face. John is stunned.

"Oh, John," she gasps, "that is the funniest thing I've ever heard!" After an uncomfortable silence—for John—my mother adds, "You either are or you aren't. Nobody can *make* you authentic. That comes from inside."

John does not argue with my mother. She doesn't think he has learned anything and neither do I. We agree that John's sudden interest in being authentic is likely a self-serving attempt at building up his folk credibility.

My mother tells that story many times, and it always gets a laugh. As for John, he never becomes "authentic," but he has a successful career with the Kingston Trio and makes plenty of money as the composer of the Monkees' hit "Daydream Believer."

Around the time of John Stewart's ill-fated attempt to boost his authenticity, Hedy West becomes a guest at our house. Hedy, best

known for her song "500 Miles," which is covered by Peter, Paul and Mary and sung at many folk music gatherings, is unquestionably authentic. She comes from a musical family from Cartersville, Georgia, where her father is a coal miner, union organizer, and poet. Hedy's instrument is the banjo, played in the frailing, or clawhammer, manner—an old-time style that beautifully accompanies her voice. Rooted in the Blue Ridge Mountains, her singing is slightly nasal and purely natural, without professional coloration. She writes about the travails of her people, which she has seen and lived. Her songs "Anger in the Land" and "Pans of Biscuits" reflect this background.

From the moment Hedy arrives at our home for her first gig in Claremont, she is absorbed into the femaleness of our household. My mother brings Hedy back to perform as often as possible and the two become dear friends. To me, Hedy is like a hip, young aunt. She has wide-set blue eyes, a Cupid's bow mouth, and a distinguished chin, and she wears her hair in a thick brown braid. Unlike many musicians, she is not eager to steal or monopolize the spotlight. She doesn't have to, because she has the musical and cultural knowledge to be genuinely comfortable as an artist. She has nothing to prove and much to share. I think the world of her.

The more time I spend with Hedy, the more inspired I am to become a performer myself. When I listen to her sing and play, I hear a musician for whom there is no artifice. She means every word she sings, and her musical truth-telling gives me courage to share who I am through my music. Because of Hedy I begin to imagine myself in front of an audience.

Bill Guthrie's death leaves a hole in my life that I can't imagine anyone ever filling. My parents say I am being melodramatic and tell me it's time for me to get over it.

"Life isn't fair," they tell me. "You have to move on."

My parents' emotional reserve is typical of New Englanders and a generation that views most emotions as self-indulgent. I wish my parents were more understanding, but at the same time I admire and absorb their stoicism. One afternoon I am slumped over my guitar, trying and failing to climb out of feeling so lonely and bereft. I wonder if it is possible to lift my own spirits. What would Bill want me to do?

On my sixteenth birthday a few of my Art Studio friends decide to cheer me up by taking me to an Ingmar Bergman film festival. After watching *The Virgin Spring* and *Through a Glass Darkly*—possibly the most depressing movies ever made—we gather at the Art Studio, where I entertain my friends by playing one tragic folk song after another: "Long Black Veil," "Banks of the Ohio," "Springhill Disaster," and "Wagoner's Lad." That night I realize that playing and singing for friends is actually performing—and it feels good. I allow myself to feel good for a few moments before reminding myself that there are already so many great singers. The world doesn't need me and I have serious doubts about my talent. Still, my friends enjoyed my singing. Maybe I'm good enough. Maybe I should at least try.

I start performing on the backyard stage of the Folk Music Center, usually playing two or three songs to open for the opener for the evening's headliner. I practice endlessly and rehearse the lyrics and guitar parts in my head at night as I fall asleep. When I finally feel ready to do a whole set, my mother schedules me to be the opening act for the Reorganized Dry City Players, a local band Chris Darrow put together. I feel some stage fright, but I get through it.

My first real gig—meaning a gig outside the store—is at the Cat's Pajamas, a small coffeehouse in Arcadia. It is on Foothill Boulevard, a stretch of the famous Route 66, situated directly

beneath a railroad trestle. The location gives the house bluegrass band their name, the Smog City Trestle Hangers. Those boys are great musicians. They play fast and furious and have fun doing it.

The Cat's Pajamas is owned and operated by the movie star– handsome identical-twin brothers Ron and Roger Giles, who opened it with inherited money. They are only in their twenties, but they seem old to me. I suspect the Cat's Pajamas is a money sinkhole, but it is a happening place, beloved by musicians and audience alike.

The Giles brothers are friends with my parents. Roger, who plays old-time banjo, loves to talk shop with my father and has a great eye for good instruments. One day he asks me to open for the Trestle Hangers. I notice for the first time that he speaks with a hint of a lisp. He is sweet and I don't want to say no to him. I'm terrified—and thrilled. I say yes, of course. I put a lot of thought into my outfit, choosing a short-sleeved cheongsam and sandals, and I select a Martin guitar decorated with mother-of-pearl. I'm still anxious about the gig, but I figure at least I'll look good.

There is nowhere to warm up at the Cat's Pajamas, which doesn't help my nerves. Will my voice falter? What if I flub the first note? What if I blank on the lyrics? But when the moment arrives, my voice is strong and clear. I get through my set of traditional folk songs and my nerves settle. Eventually I'm feeling confident enough to take a chance and sing the new Bob Dylan song "Blowin' in the Wind." The Cat's Pajamas is a traditional folk and bluegrass scene and not a Dylan crowd, but I like the song, and the crowd seems to enjoy it, too.

After my set, I sit by myself and go over every minute of the performance. Had the audience noticed the shakiness I felt inside? Did I choose the right songs? I start to worry, then agonize, convinced that I failed. I sink down in my chair and wish I were invisible. *I was probably terrible,* I think. *Sure, everyone applauded, but*

they were probably surprised to see a girl performing solo with a guitar and are just humoring me.

I sit watching the all-male bluegrass band that I opened for. Music is a male-dominated world. The bluegrass bands at the Cat's Pajamas are interchangeable arrangements of various young men.

My miserable reverie is interrupted when Roger comes to my table and hands me a nonalcoholic drink.

"You should smile more. You're so pretty when you smile."

Smile more? That's what he thinks I should do? I'm eating my artistic heart out and he wants me to *smile more*? Tears come to my eyes. How can smiling more help me compare to all those witty, brilliant bluegrass players?

"I was terrible," I say.

"No," Roger says, "you were beautiful."

I know he means well, but is how I looked the only thing he noticed? It doesn't matter what I looked like if I didn't sound good. Roger sits with me on and off the rest of the night and eventually manages to cheer me up. I'm flattered by the attention, and after closing I accept a lift home in his sports car. We stop at Henry's drive-in restaurant on Foothill Boulevard and wolf down burgers, fries, and Cokes. After that night, Roger often picks me up to go to the Cat's Pajamas and occasionally coaxes me to perform a few songs. Eventually even I realize my folk music is a welcome relief from all that bluegrass.

Each summer Virgil and Edith Byxbe hold a summer-long folk music camp at Sweet's Mill, a former logging camp they had purchased in the foothills of the Sierra Nevada. Whenever a summer breeze carries the smell of sage and yarrow through the canyon chaparral, I am reminded of the long, luxurious days at the Byxbes' camp—breakfast in the main hall, rowing

on the lake, and music all day and into the night, when we are joined by a backup chorus of crickets and frogs. I make a good friend in Virgil and Edith's daughter Barbara, learn some new guitar licks, learn to flirt, survive a crush or two, break a heart or two, and play music with musicians like Kenny Hall and the Sweet's Mill String Band. Kenny, blind since birth, is a dynamic performer and an enthusiastic teacher. He wants the old-time music preserved for the future and insists that all the old songs he records be written out in notation.

In the summer of 1963, when I'm sixteen years old, I decide I'm capable of going to Sweet's Mill on my own to perform on the open mic stage. I invite my Art Studio friend Leslie to join me, and we take the Greyhound bus to the camp unchaperoned, with our parents' blessing. Leslie, blonde, lightly freckled, and gangly, comes from a conservative family. Her dad is an executive at General Dynamics and her mother is a stay-at-home mom. They enjoy cocktails every evening and highballs during and after dinner, by which time they are quite mellow. Leslie may be the only kid in town who has less supervision then me, although the lack of attention comes from a very different perspective. I'm the bohemian artist child of bohemians who is finally admitting I play guitar. She is the child of upper-middle-class parents who longs to be a bohemian artist and is learning to play the guitar.

We board the bus in Claremont, each carrying a bag and a guitar. Our first stop is the downtown Los Angeles Greyhound bus depot where, not surprisingly, two longhaired teenage girls in tight jeans and bright-colored tank tops attract unwanted attention. A man wearing a white shirt open at the collar with a gold chain at his throat, slicked-back dark yellow hair, and a swaggering confidence approaches us, apparently under the impression that we just rolled into LA from a small town in the middle of the country looking to get famous. He says he is a scout on the lookout for

My father, Charles, in early 1944 at age thirty. He was drafted into the army even though he was farming and the father of two children.

My mother in a "cheesecake" photo taken on the Chase farm in Washington, New Hampshire, that she sent to my father when he was serving overseas.

My father (eighth from left, back row) with his army unit at the Arc de Triomphe during the liberation of France, 1944.

Our home at 189 Sea Street, North Weymouth, Massachusetts, winter 1954.

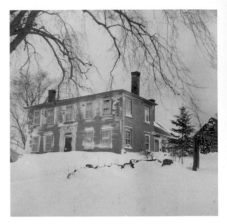

Me with my third-grade class (front row, fifth from left between the twins, Maureen and Marleen), Bicknell School, North Weymouth, 1954.

Preparing for a ballet recital with my dance school in North Weymouth, Massachusetts. Kids were put in toe shoes as early as seven years old.

Commonwealth of Massachusetts

Suffolk , ss

General Court

✦ SUMMONS ✦

To Charles Chase

............ 189 Sea Street

............ North Weymouth, Mass.

Greetings:

You are hereby required, in the name of the COMMONWEALTH OF MASSACHUSETTS, to appear before the Special Commission created by Chapter 89, Resolves of 1953 to Study and Investigate Communism and Subversive Activities and Related Matters, in the Commonwealth, holden at the office of Thomas H. Bresnahan, Room 1019, 6 Beacon Street, Boston,

on the........ fifthday of....... March195 4 ...at...3...o'clock in the........ afternoon, and from day to day thereafter, to give evidence of what you know relating to...... Communism, subversive activities and related matters

and you are further required to bring with you........

Hereof fail not, as you will answer your default under the pains and penalties in the law in that behalf made and provided.

Dated at Boston, Mass., on the....... thirdday of....... March, nineteen hundred and fifty-four, A.D.

By

PHILIP G. BOWKER, *Chairman of Commission.*
WILLIAM A. RANDALL, *Vice-Chairman of Commission.*

My father Charles's summons from the Massachusetts Special Commission to Study and Investigate Communism and Subversive Activities, a state version of HUAC, 1954.

Unknown guitar player (left); my mother, Dot; and Joe Buchman performing together for a Hootenanny at Hecht House, Boston, 1957.

My sister Sue's infamous school photo, 1957.

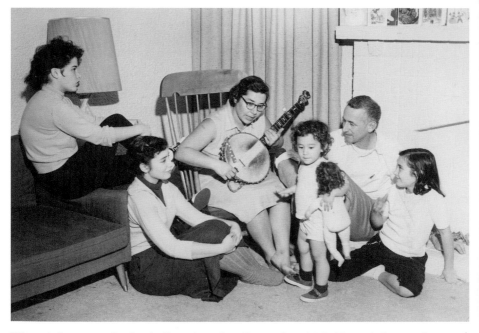

The pink stucco duplex in Los Angeles, December 1957. From left: my sisters Joanne and Sue, mother Dot, sister Sally, father Charles, and me.

The Folk Music Center on First Street, Claremont, California, April 1961. Photo by Will Marcotte.

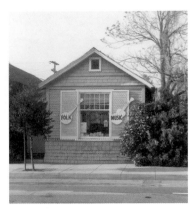

Claremont Village looking north from First Street and Yale Ave. Photo by Christopher Michael Photography, Claremont, California.

The *Progress Bulletin* preview of an early 1960s Mike Seeger concert at Sycamore Elementary School Auditorium, produced by my mother.

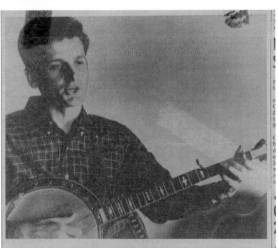

MOUNTAIN MUSIC—Mike Seeger plays the five-string banjo, one of the instruments he will use in his performance of folk music in Claremont Friday night.

Folk Singer To Perform In Claremont

CLAREMONT — Mike Seeger will sing and play songs of the mountain people of the southeastern United States in a performance here Friday night.

The recital will be in the Sycamore School auditorium at 8. Tickets may be bought at the door or from the spon-

sor, the Folk Music Center.

Seeger plays the guitar, banjo, mandolin, fiddle, harmonica and autoharp, all of which he uses in his concerts. Some of his songs are centuries old and some have been composed by the mountain people during the last decade. He learned them all from per-

formances or recordings by the people of the Bluegrass country. He has made many field recordings of the music.

Seeger is the son of a musicologist, Charles Seeger, and a musician, Ruth Crawford Seeger. His brother, Pete, has given several concerts at Pomona College.

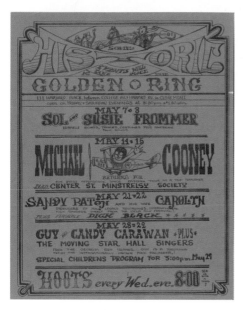

Flyers designed and hand-lettered by my mother for shows at the Golden Ring coffee house in Claremont between 1965 and 1968.

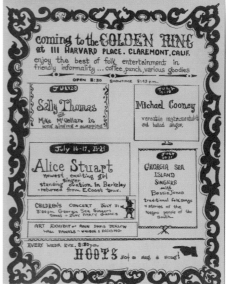

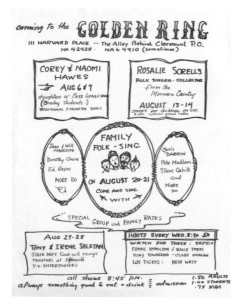

Mixed Company, 1967: (from left to right) Clabe Hangan, Joe Real, Keith McNeil. They later became Music Americana.

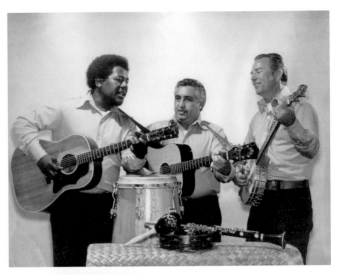

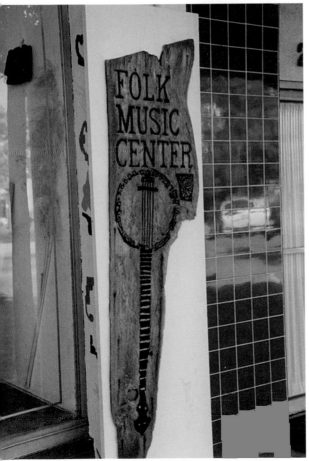

Woodcut sign by Pat Chapman, early 1970s.

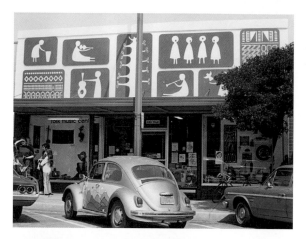

Folk Music Center,
220 Yale Avenue,
Claremont, California, 1973.

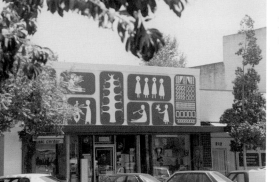

Folk Music Center,
Claremont, California, 1986.

Guitar wall, Folk Music
Center, early 1970s.

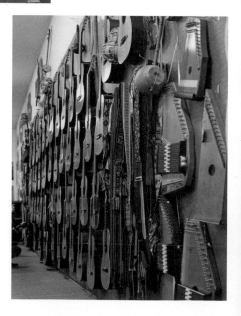

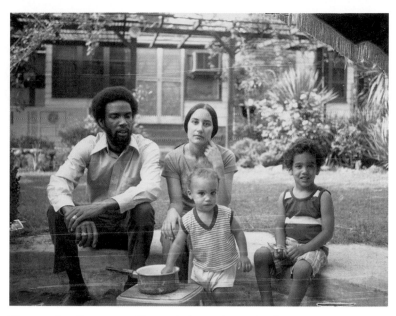

Harper family at our Eleventh Street home in Claremont, 1973.
From left to right: Leonard, me, Joel, and Ben, sitting on the side of
what had been a fishpond we converted to a sandbox for the kids.

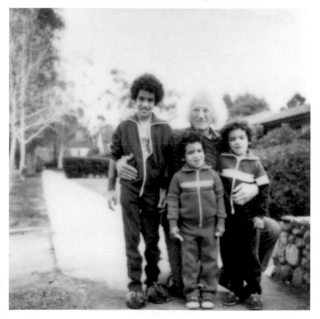

Christmas, 1977: (from left to right) Ben, Grandpa
Charles, Peter (in front), and Joel. My three boys are
each wearing new sweat suits.

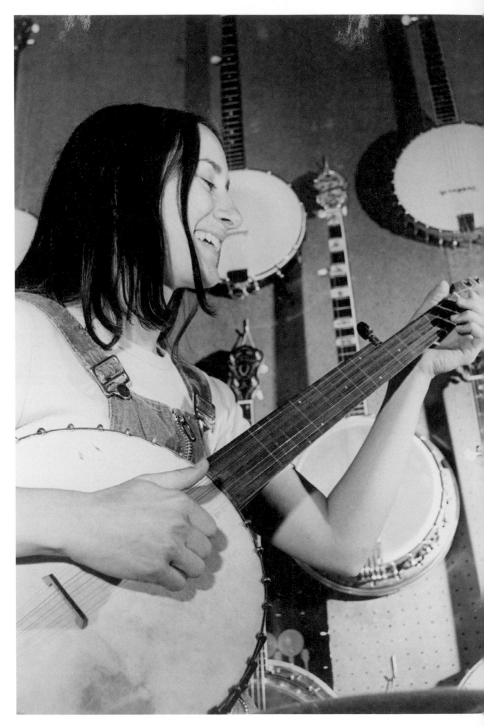

Playing an 1880s frailing banjo at the Folk Music Center, 1978.

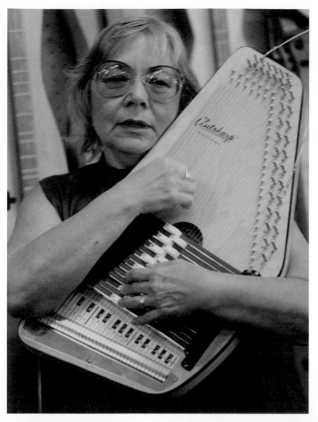

My mother, Dot, playing her autoharp at the Folk Music Center, 1982 (left), and playing the guitar in Memorial Park, 1978 (below).

Publicity photo for promotion of the EZ Band, 1979, by Richard Hayhurst.

My father, Charles, playing Tibetan temple horn for an elementary class on a field trip to the Folk Music Center, late 1980s.

My parents, Charles and Dot, behind the counter of the Folk Music Center, 1987.

With my son Ben at sound check, Santa Barbara Bowl, 2000. Photo by Trifon Trifonopoulos.

My mother Dot's self-portrait at her memorial, the Folk Music Center, 2005.

Poster from Pete Seeger's ninetieth birthday concert at Madison Square Garden, 2009.

Madison Square Garden, backstage with Pete Seeger; my sister Sue; and son Ben. Photo by Danny Clinch.

At the White House, 2013.

My father, Charles, working
on an upright bass, 1988.

Working on a guitar, 1978.

My son Ben working on a guitar, 1989.

talented girls like us. He names some famous people he discovered, but he goes too far when he mentions Elvis Presley. I roll my eyes.

"C'mon," he cajoles, sensing resistance. "Let's go. I've got a car waiting outside. I'll take you to meet a producer I know. You girls will be famous in no time. Trust me."

"No, thank you," I say. "We don't want to be famous. We're folk singers."

I mean it, which proves I am my mother's daughter. Regardless, I am done with this guy. I try to edge Leslie away but she's not following my lead.

"Oh, come on," she whispers to me. "It might be fun."

The man steps between us, picks up our guitars, and starts toward the door.

"Let's go!" he commands.

This is too much for me. I grab my guitar from him and push Leslie to do the same, which lights a fire under her, too. She grabs her guitar and we run to our bus, which had just pulled in.

"Thank God we escaped!" says Leslie, gasping for air. "He was going to turn us into sex slaves!"

Sex slaves? That's what she was worried about? I was scared he wanted to steal my Martin!

We aren't able to get seats together on the bus and I wind up next to a man who says he is a criminal lawyer. I think he means he is a lawyer who committed a crime and imagine he is on the run.

"I don't have a problem with that," I say politely, even though the thought of being seated next to a felon for the five-hour bus trip makes me uneasy. Luckily, some people get off in Bakersfield and Leslie and I are able to sit together.

When we arrive at the camp, Leslie runs her sex slave theory past Virgil and Edith. Neither of them say much, but on our return journey my mother waits for us at the LA Greyhound station—just in case.

I spend the rest of the summer working at the Folk Music Center. Business is slow in the summers when all the college students go home, and my father takes advantage of the quiet time to catch up on repairs in the basement at the Seventh Street house, which stays pleasantly cool most of the day. Grandpa and I survive the best we can with an overwhelmed little swamp cooler my father set up in the back door.

My grandfather has gone home and I'm languishing by myself on a late August afternoon. It's 105 degrees and desert dry, reminding me that I live next door to the Mojave Desert. Suddenly a man with a big, beat-up guitar case crashes through the door.

"Fred Gerlach," he declares in a rough voice.

I give the guy, who's wearing a leather jacket in a heat wave and can't even manage a doorway, a bored once-over. I shake my head and slowly amble over to the record bins, find *G*, flip through until I find the Folkways album *Twelve String Guitar* by Fred Gerlach, and hand it to him.

"Three ninety-nine," I say.

"No, dammit—*I'm* Fred Gerlach! I'm looking for Chase. I called a while back."

Fred Gerlach is a disciple of Pete Seeger and Woody Guthrie similar to Ramblin' Jack Elliott. Fred first heard about the twelve-string guitar from Huddie Ledbetter, better known by his stage name, Lead Belly, the singer and songwriter whose music was a major influence on the folk revival. Lead Belly's most famous songs are "Goodnight, Irene" and "Midnight Special." Fred's claim to fame was having been Lead Belly's roommate, lending him a reflected toughness, because Lead Belly served time for assault and murder.

I try to turn the bad start around with a friendly "How can I help you?"

"*You?* You can't. I need Chase to fix my twelve-string. I've heard he's good, but I don't have all day."

His rudeness eliminates any desire on my part to be friendly. Besides, I do have all day.

"I have to see it," I say, staring him down.

He thuds the case down on the linoleum floor, snaps the latches open, whips up the lid, and pulls out a huge Stella twelve-string with a trapeze tailpiece. It is identical to Lead Belly's guitar and is tuned down to C—just the way Lead Belly tuned his guitar. I call my father.

"Send him to the house," he says.

When I get home, Fred is still in the basement with my father. In addition to being a musician, he is a luthier, and they are talking twelve-string guitars. There aren't many available, and my father thinks they'll soon be in demand. Dad is solving the current demand by taking the jumbo Kay six-string guitars to be converted into twelve strings by Pilo Delgado. Pilo and his brother Candelario Delgado founded Candelas guitars in Los Angeles in 1948. For a more cost-effective model, my father applies his own logic and creates the snaggletooth twelve-string using two sets of six-string tuners, one set facing sideways and the other spaced between facing up. They work pretty well and can be made inexpensively out of any large sturdy American Kay, Harmony, or Regal guitar. I find these to be awkward to tune. Fred is fascinated by these solutions.

My mother is laughing at my Gerlach impersonation and my faux pas with the album when Fred and my father come up from the basement.

"Dorothy," says Gerlach over his shoulder as he bangs into the door on his way out, "book a concert for me out here in Claremont." My mother and I burst into another fit of giggles.

A month into my senior year, my mother announces that she has booked a flight out of Ontario Airport to San Francisco so I can

visit San Francisco State University, which is my top choice. She books a nice hotel downtown near the cable cars. I don't have an appointment and we have not signed up for a tour; instead, we get a campus map and create our own tour, chatting with people here and there and exploring on our own. I discover that my mother has an ulterior motive—vacation—and for the next three days we shop, go out to restaurants, ride the cable cars, drift through Ghirardelli Square, take a taxi across the Golden Gate Bridge, spend a couple of hours admiring the giant redwood groves in Muir Woods, and catch a first run of *Tom Jones,* which is immediately my favorite movie ever. The weather is overcast and rainy with a bout or two of sunshine, which is a marvelous break from the hot and dry southland. We head home and back to reality.

I'm planning to visit two more state universities that fall when the world is turned upside down. On Friday, November 22, 1963, I'm walking from the P.E. building on my way to US government class when a girl comes running toward me, weeping.

"President Kennedy's been shot!" she shouts.

In disbelief I run to Dr. Polos's classroom. The school campus is strangely quiet. He has a television and he's whispering "no, no, no, no" at the screen. I'm stunned to see the arrogant, cynical, above-it-all Dr. Polos—the man who says "don't call me Mr. Polos, call me *Dr.* Polos"—weeping.

The feed from Dallas is on a loop, showing news of the assassination over and over. Other students file in. Everyone is in shock—some crying, others praying, many pale as ghosts, staring at nothing. This is the United States of America in 1963. Presidents of the United States, the most powerful nation in the world, do not get assassinated. Especially not this president. John Kennedy is handsome, young, and articulate. He represents the nation's hope and confidence. He's leading us into a better future. He can't be dead.

The bell rings and I leave with my friends Maryanne, Beverly, and Lucy. Nobody knows what to do. We drive around for a while and then Maryanne says, "I need to go to church." Beverly agrees. I say that the United Church of Christ is always open, thinking about that peaceful, quiet place I sometimes visit on my walk home from the store. They look at me scornfully.

"We want to go to *church*," they repeat. They discuss going to a Methodist church service on Sunday morning. Lucy says nothing; her family is Quaker. To me it seems odd to have to wait two days to find solace with their God.

I go to the Folk Music Center, where Grandpa is closing up.

"War is what we get now," he says, shaking his head. He locks the store and heads home, his head down, hands in his pockets. I feel his anguish as a sharp pang in my chest. My father picks me up and we ride home in silence.

On February 25, 1964, Bob Dylan is booked to perform at the Barn at the University of California, Riverside, and my family is invited to the concert and the after-show party to meet the young phenomenon who is taking the music world by storm. I can't wait. A group of girls from school are driving themselves to the concert; they invite me to join them but I choose to go to the concert and party with my parents rather than hang out with girls who only asked me because they think I'll get them backstage.

We've been selling lots of Bob Dylan's albums, mainly pushed by my grandfather for the same reason he pushed Simon and "Garfinkle"—because Dylan is Jewish. His real last name is Zimmerman, Grandpa tells us. He's a landsman, and Grandpa is proud. Others in the folk community are not so welcoming, but this has nothing to do with Dylan's heritage. His musical skills are limited, these folkies say, and he is inauthentic. They treat Dylan's

first album like a joke. The second album is taken more seriously. His musicianship remains suspect, but songs like "Blowin' in the Wind" and "Masters of War" demonstrate his singular prowess at socially conscious songwriting. The dyed-in-the-wool folkies are still not convinced, insisting that folk songs must be old and originate among the people. You don't write folk songs, they insist—you discover them.

Dylan's newly released third album, *The Times They Are a-Changin'* is sweeping all these criticisms aside. The title track is becoming the ultimate anthem, the protest song that blows the mind of my generation. It is a beautifully crafted protest song suitable for all occasions. The lyrics fit any social or political agenda: antiwar, civil rights, gay marriage, legal marijuana, climate change, equal rights, gender rights, immigration, you name it. It is pure genius, a wake-up call for change for whatever cause one finds relevant.

The Barn is funky but cool. It is a great space to see a concert, and our reserved seats are close to the front along the right-hand side of the hall. The concert is mesmerizing. I can't stop the tears pouring down my face as Dylan sings "Ballad of Hollis Brown." He is a commanding stage presence, but there is something about the way he holds himself, not his singing but his overall mien, which seems fabricated.

After the concert we are being escorted backstage when Babs, one of the group of girls who invited me to go with them and whom I barely know, suddenly appears by my side, blathering on about her new idol, "Bobby." As my parents and I walk past the guard at the backstage door, Babs slips in behind me, saying over her shoulder to the guard, "I'm with them." And just like that, she is.

We go backstage.

We are introduced to Bob Dylan.

As he shakes hands with my father and mother, his eyes slide back and forth under hooded lids canvassing the room. Before he registers my existence, his eyes land on Babs—or, rather, on her large, untethered breasts, which are living a life of their own under her clingy sweater. His eyes rest there and he doesn't look up. Gaze fixed, he invites her to the after-after-show party, grabs her by the hand, and they split without saying goodbye.

As I see them leave, I think about why he chose her. I just turned seventeen. I act grown up and can talk like a grown-up, but in this moment I feel very young because under my fashionable Nehru jacket I still wear a training bra. When I don't get even a hello or a handshake from Bob Dylan, I'm hurt. I feel betrayed by this man, this idol to so many, whose music and message I have championed only to find myself dismissed. I feel betrayed by Babs, too. But then again, I know in spite of my disappointment and humiliation, that Babs is the better choice for an "after-after-show" party.

If you are able to sing a song, whistle a tune, tell a story, dance a dance, strum, bow, pick, pound, blow, or tap on an instrument, you are welcome to stay at our house. Or so it seems. If you have ever taken in stray cats, you know that as soon as one is gone, another shows up in its place. There were so many guests in our home: Molly, and the storyteller Richard Chase—the only guest ever asked to leave—and a friend of Joanne's named Sharon, and Mike Seeger and so many other performing artists. There is Guy Carawan, a frequent guest over the years, famous for introducing the protest song "We Shall Overcome" to the American civil rights movement, and the accomplished folk dancers Peter and Polly Gott. Polly teaches me an old Halloween song about getting lost in a hayfield while my father teaches Peter how to build and repair instruments.

Not everyone is a famous performer or gifted musician. One day a young man named JC arrives on a motorcycle, builds a lean-to in the backyard, and moves in. My father lets him stay there and do some odd jobs in exchange for food and a guitar. I don't ask why. This is just the way it is.

Another stray in my parents' collection is Dave Copeland, a fisherman who specializes in singing whaling songs and sea shanties. He is good, but the demand for whaling songs and sea shanties is limited and his music career soon runs aground. He sells my mother his little green Hillman Husky, an English car she thinks is cute. I love the Husky—and hate it. I have to park it facing downhill so I can jump-start it. Parts fall off when I drive over railroad tracks and speed bumps. Sometimes the hatchback pops open. I have to stomp the brakes to get the door to slam shut. The Hillman finally dies for good on Garey Avenue in Pomona, leaving me and my mother stranded by the side of the road.

"Not such a cute car, now, is it?" asks my father when he picks us up.

As the end of my senior year approaches, I introduce an actual boyfriend into this chaotic lifestyle of people and music and instruments and houseguests. Jeff is my age. He wears white fitted T-shirts and jeans, works on his car, and listens to KFWB, the local radio station that is popular among kids our age. We go to In-N-Out Burger and park in the orange groves. Jeff is my idea of normal because our relationship isn't complicated by politics or an age difference or life-and-death issues. Jeff has never seen anything like my family and does not know what to make of us, but he likes me and he tries gamely to fit in. We're looking forward to summer break.

During the summer of 1964, between my high school graduation and college, the undercurrent of change that has been

simmering beneath the surface of America's veneer of contentment erupts.

In June, three civil rights workers who volunteered to register Black voters in Mississippi are abducted and murdered. On July 2 President Johnson signs the Civil Rights Act into law, ending de jure segregation in public places and banning employment discrimination, returning to many of us the hope we felt before President Kennedy was murdered.

That summer Guy Carawan pays us a visit. He gives a concert and speaks poignantly about the important social justice work and leadership training they are doing at Highlander Folk School in Tennessee, where the activist Rosa Parks was trained in nonviolent protest. He comes to the Folk Music Center and speaks to small groups and individuals about boycotts, sit-ins, protests, and volunteering. He stresses the importance of nonviolence and supporting the work of the Freedom Riders and the influence of the freedom songs—spiritual-based protest songs—in the fight against racism and hate. His descriptions of the civil rights work in the South is inspirational, and for a moment I imagine hitching a ride across the country to join the freedom fighters.

Instead, I'm headed for Cal State Long Beach in the fall. The school is my third choice—I'd rather go to San Francisco State or San Jose State—but the 65 million members of the baby boom generation are causing a housing crunch at the nation's colleges and universities. When I find housing at Cal State Long Beach, I accept the offer of admission.

I tell Jeff that we should start to see other people. I'll be moving away, and it seems like the right choice for both of us, but it isn't easy for either of us. He argues that we can see each other on weekends. I'm tempted to agree, but in the end I can't. I'm going away to college and I need to move on, even if it hurts.

TUNED IN, DROPPED OUT

Summer finally ends and my parents drop me off in front of the off-campus dorm. They put my boxes and suitcase on the walkway, say goodbye, and drive off, leaving me to start my new adventure. The other parents are hovering, helping, carrying, unpacking, making beds, and shedding tears for the children they are going to miss. That is not my family's way. I watch them go and find my dorm room, eager to meet my new roommate.

I find Barbara in our room with her parents. Barbara is an only child from conventional Orange County. Her mother is helping her unpack. She hangs Barbara's blouses, skirts, and dresses in the closet, carefully folds her angora sweaters into a neat stack on the shelf in her side of the closet, places her "delicates" in their own drawer, makes her bed, and organizes her books, notebooks, pens, pencils, and typewriter on her desk. Satisfied that Barbara is settled in nicely, her family heads out for dinner. They invite me along, taking pity on me since the dorm cafeteria isn't serving until the next day.

On the drive to the restaurant I learn that they are conservative Christians. Just then we get stuck behind an eighteen-wheeler,

on the back of which some graffiti artist had skillfully amended the commercial slogan "Eat Out Tonight" to read "Eat Her Out Tonight." Barbara's mother gasps. Her father breaks into a sweat. Barbara colors. I stifle a giggle.

The majority of the students in my dorm come from Orange County families similar to Barbara's. For most of the women, college is a fallback plan in case they can't find the husband most are unabashedly looking for. The men are preparing for white-collar jobs. They wear madras plaid, neatly belted. The women wear tucked-in blouses and angora sweater sets with skirts and stockings. Nearly everyone has a part-time job at Disneyland. There is only one Black student in my dorm.

In spite of our different backgrounds, Barbara and I fashion a nice friendship. She is a generous, good-natured girl majoring in teacher education—like most women here—and she turns all her assignments in on time, resulting in decent grades. She encourages me to be a better student and can't understand how I get by doing so little. My major is social anthropology, but as a freshman I have two years of general education requirements to complete before I can take the classes that interest me.

I'm pretty happy at school and adjust easily to dormitory life. My home prepared me for lots of noise and people. Our dorm rooms are arranged in suites, and two roommates share a connecting bathroom with another two women in a room on the other side. Four young women sharing one bathroom gets crazy when we are trying to get to class in the morning, so I start skipping morning classes. It feels like a luxury to have the suite to myself to write or sing and play the guitar, alone until lunchtime. After lunch I take a bus or hitch a ride to campus for classes in ceramics, literature, and introduction to anthropology.

Long Beach State is a party school, and weekends are devoted to drinking binges and nursing hangovers. I'm open to new

experiences, so one night, when cautious, levelheaded Barbara invites me to attend a frat party, I put on the closest thing I can find to party clothes and head out with her. After a few drinks she throws her cardigan aside and cuts loose, drinking, dancing to the Beach Boys, and flirting. I attempt to join in on the tequila shots and beer chasers that are the highlight of the evening, but the first gulp of tequila burns on its way down my throat, attempts to come back up, then burns its way down again. The beer chaser gives me just enough time to bolt out the open back door and throw up behind a bush.

"Lightweight!" someone shouts while the others laugh. Embarrassed, I accept a ride back to the dorm from Susie, a friend who is an art major. This sort of party is not her milieu, either, and she is happy to leave.

The next day, Susie and I head to the beach for fresh air and sunshine. Susie, who specializes in ceramics, is a tall woman whose baggy boho black sweaters and jeans can't disguise her sensational figure. She wears her long dark hair pulled back in a ponytail and exaggerated black eyeliner to complete her dramatic look. At the beach we happen upon some of her friends from the art department, and one of them invites us to their apartment.

"You guys want to go to our place and get straight?"

I arch a questioning eyebrow at Susie.

Susie giggles. "It means to smoke marijuana and get high."

"I have to study," I say, picturing another raucous party.

"Okay, see ya," says Susie, and strolls off with the artists, leaving me to walk the three miles back to the dorm alone. I'm disappointed by my new friend. I expected her to stick by me and wonder as I plod along if I'm missing out on something.

In addition to being an art major, Susie is a blues singer. On stage she transforms into a gorgeous, sexy diva in low-cut, shiny dresses. She performs at local bars using a fake ID that puts her

age at twenty-two. She made it herself using scissors, liquid paper, glue, and a typewriter, but if anyone notices, they let her get away with it. She makes one for me so I can watch her act and sometimes play guitar on a twelve-bar blues number. No one challenges my ID, but the guys in the house band call me jailbait.

The art department is a refuge for nonconformists. It turns out the artists we met at the beach don't have blowout parties on the weekends. Instead, they engage in an ongoing night and day blend of hanging out, smoking weed, and fomenting imaginary revolutions interspersed with bursts of artistic inspiration. Marijuana is their drug of choice, and I far prefer pretending to share a joint with strains of Charles Mingus in the background while engaging in erudite if discombobulated discussions of Foucault, to the frat scene of binge drinking, dancing to "Louie, Louie," and vomiting.

Together, we conform to the counterculture. The men wear beards, work shirts, jeans, and sandals, while women wear their hair long, with Levis instead of skirts and stockings. Lace-up sandals are popular, and instead of sporting events, we go to concerts. The local musical venues are bars or coffeehouses, or hybrid nonalcoholic nightclubs, which are essentially folk club/coffeehouses that don't serve alcohol. For the artist, the upside is a sober audience. The downside of sobriety is a more discriminating, and thus critical, audience. Another positive is that customers don't have to be twenty-one to come inside and listen. Many clubs have an eighteen-or-over rule, but most are open to teenagers, if they manage to get there. As college students living away from home, the only supervision that limits us is the in loco parentis dormitory rules for women. Our curfew is 10:30 p.m. weeknights and 1:00 a.m. on Friday and Saturday. There are no curfews for the men.

One night, Susie invites me to see the Ike and Tina Turner Revue at the Cinnamon Cinder club in Long Beach, a show that burns itself into my memory. Guitarist Ike Turner is a pioneer of rock and roll, and the band he has created with his singer and dancer wife, Tina Turner, is one of the most exciting live shows of the 1960s. Nothing I have heard or seen prepared me for Ike's searing guitar; Tina's powerhouse dancing, thick shoulder-length auburn wig, and gold lamé dress, the long fringe in strategic places revealing lots of leg and thigh; the Ikettes echoing her outfit and moves. I am mesmerized. They rock the house, and when Tina sings "Fool in Love" I am undone.

Worldly wise, freethinking, ahead of her time, Susie becomes pregnant by a man she refuses to name. Her options for an unwanted pregnancy in 1965 are limited to a back alley abortion or adoption, neither of which she is willing to consider. She quits school and goes home to have her baby, which she chooses to keep and raise on her own—a brave and surprising decision for a time when unwed mothers are shunned.

One afternoon, while trudging up the hill from the parking lot to class, I spot a few students sitting quietly on the lawn in the central quad. They are listening to an impassioned but poorly attended lecture about the Gulf of Tonkin Resolution, which gives President Johnson the freedom to take whatever military action he deems necessary against the North Vietnamese. The speaker's predictions of what lies ahead are dire. There is no winning if the United States becomes more deeply involved in Vietnam; we will be trapped, the speaker warns, into playing the same tragic role as the colonial French before us. Unbidden, I hear Grandpa's voice on the day of President Kennedy's assassination, "War is what we get now."

I don't realize it in the moment, sitting serenely on the lawn, the salty sea breeze barely stirring the warm fall air, but the storm clouds of war in a faraway country many of us have never heard of are about to cast their shadow over the entire country. That November, President Johnson wins his reelection bid by a landslide and proceeds to fulfill Grandpa's prophecy.

In February, during my second semester, my parents open the Golden Ring Coffee House. The Golden Ring is Claremont's first coffeehouse and folk performance space, housed in a characterless cinderblock cube in an alley behind the post office. My mother gives the building some personality by painting the front door bright red and hand-lettering a sign with the venue's name, also in bright red.

The Golden Ring offers live music every Friday and Saturday night, as well as hootenannies, open mics, art exhibits, and classes. Rather than study, I spend many weekends helping out at the coffeehouse, selling tickets, setting up tables, selling snacks and drinks, escorting the performers through the back door and onto the stage, and acting as general assistant to the promoter and MC, Eddy Hayes. Sometimes Eddy headlines the show. He favors traditional folk songs, but the music of the Beatles and other rock artists run a close second. On occasion he invites me on stage to play a few songs with him. For our debut performance we play an interesting combination of Elizabeth Cotton's "Oh Babe, It Ain't No Lie" and the Kinks' "A Well Respected Man." It improves my cachet among my Long Beach friends who make the trip to hear me perform at the club.

The folk music scene in Long Beach is limited and some of us start going to the *Rouge et Noir* coffeehouse in nearby Seal Beach. I'm not impressed by the whitewashed commercial folk music that makes up most of their shows, but that doesn't stop me from applying for a job as a waitress. I figure my experience at the

Golden Ring has prepared me for the job, but on my first day, I'm called into the boss's office at the end of my shift. I thought I had done well enough during the shift, and most customers seemed happy with my service.

"You weren't honest with me," he says.

Confused, I start to assure him of my willingness to learn anything I don't know how to do, but it turns out he isn't talking about my waitressing skills.

"You're a spy," he says, pounding his desk. "You told me you worked at the Golden Ring. You didn't tell me *your parents* are the owners."

"But I did work there—"

"You're here to steal my clientele for your parents' coffeehouse. Get out—you're done."

I might have laughed at the absurdity of what he was saying if I wasn't so offended. Ridiculous as his accusation is, my feelings are hurt—and on top of that, I don't have a summer job. When I tell my parents, they burst out laughing.

"You? Waiting tables? He should have hired you to spy. You'd be better at it."

I barely squeak through my first year in college. My As in my *Catch 22* class (an entire course analyzing this one novel) and physical anthropology are balanced out by my Ds in tennis and biology. My low grade in biology is a result of my refusal to dissect a cat. I'm not planning on going into medicine and the whole idea is nauseating. Besides, I don't want a cat's death on my conscience. As for tennis, I am told I "am not taking it seriously." Which is true.

That summer, I get an apartment with my suitemate Caroline in Belmont Shore, where cheap, run-down apartments are still available even though they are right across the highway from the

beach. Caroline is tall and glamorous and has long highlighted hair that I envy. She is sophisticated, sarcastic, dyspeptic, and arrogant. She wears white silk capris and slacks that are all the rage at her boarding school in Switzerland. Her Italian father left her mother for his mistress, bestowing on his ex-wife a high-end boutique in Newport Beach's Fashion Island. Caroline has adjusted well enough to her reduced lifestyle. She models to make money for her expensive clothing and makeup habit.

Embarrassed by my steady diet of Levis, black sweaters, and T-shirts, Caroline takes me to her mother's boutique. She and her mother call it "dressing our dolly" because I'm a size 2, which seems to amuse them. Her mother decides I am a suitable model for petite clothing, which is becoming fashionable, and soon I am walking down the runway at a department store fashion show wearing white hip-hugger bell-bottoms and a navy blue cropped halter top that exposes my midriff to below the navel. For a brief, fleeting moment, I am on the cutting edge of fashion.

One day, Caroline and I are on a modeling job at the high-end department store Buffums. Buyers make up half of the audience; the rest are local business executives on three-martini lunches who are there to ogle the young, scantily clad models. When we arrive in the dressing room, I learn we will be modeling lingerie. I take one look at the lacy teddies, satin undies, and negligees and refuse.

"You don't get to say no," Caroline says, drawing herself up to her full height. "They are paying you. Anyhow, what do you care? You wear a bikini at the beach."

I can't help it. I care. It's not the same as wearing a swimsuit at the beach, which is for my own recreation. I am not comfortable walking down the runway clad in sexy underwear so men in suits can stare at me. I'd seen their lecherous faces on my way in and it creeped me out. The designer is not happy.

"Get dressed!" he says, shoving a teddy and panties at me. "You're on in five!" *More like undressed*, I think. I shove them back.

"I'm not wearing this. If you try to make me, I'll leave."

"If you walk out now, I'll see to it you never work in modeling again!"

I walk out.

Once again, I am out of work and broke, and it isn't fun. I go home to earn some money at the Folk Music Center and the Golden Ring.

That summer, Bessie Jones and the Georgia Sea Island Singers are booked at the Golden Ring between shows at the Ash Grove in Los Angeles and the Penny University in San Bernardino. The Georgia Sea Island Singers is a vocal ensemble that features the songs and stories of the Gullah people, a culture richly informed by African heritage. The music is unlike any other style of music in the world. Their leader is Bessie Jones, who makes a significant contribution to the folk revival. She is lovely and kind—and a musical force of nature.

To my delight the Singers decide to rehearse while they are staying at our house. They aren't keen about rehearsing inside, so they grab our dining room chairs and carry them outside. Sitting in a circle wearing colorful dresses and headscarves, they remind me of a ring of bright flowers on the green front lawn.

"It's ninety degrees out there," my mother protests.

"We just need some ice and a few glasses," they tell her. "We'll be fine." My mother brings them a big bowl of ice cubes, glasses, and water.

"Dorothy, we're clean out of 7 and 7," says Bessie. "Could you run to the store and pick some up?"

"I could," says my mother, "but I don't know what that is."

"It's Seagram's 7 and 7Up. If you would be so kind as to pick us up a few bottles of each, it would be greatly appreciated."

This does not sit well with my mother. She doesn't mind a glass of wine at Passover or with an occasional meal, but she doesn't approve of people overindulging in alcohol. She has seen too many musicians who can't stay away from booze. But she takes pride in being a good host. If the Georgia Sea Island Singers want 7 and 7, she will provide.

While she is gone, Bessie teaches me the body percussion of the play-party songs, a combination of clapping, foot tapping, and patting thigh and chest that drives the music as it accompanies the singing. When my mother returns we are singing "Sea Lion Woman" in call-and-response, a vocal tradition in which a leader sings a part and the group responds with an answering part. It's loads of fun and gets even more fun—and loud—once the 7 and 7 is passed around.

My mother watches crossly for a few minutes, but finally can't help herself and joins the circle, singing and clapping to "All Hid." Afterward, though, she makes a point of telling me that no one needs alcohol to make good music.

In August, it's hot in Claremont, on the border between the Inland Empire and Los Angeles, away from the coast and the ocean breeze, and nothing much is happening. The beach would be better, so I return to Belmont Shore. Caroline suggests we take a drive up to Westwood in Los Angeles to see the movie *What's New Pussycat*, a comedy written by Woody Allen and starring Peter Sellers, Peter O'Toole, and Romy Schneider. After the movie, the skyline glows red as we drive south to Long Beach. It looks like Los Angeles is on fire. We see orange flames and sparks and smoke, and suddenly I realize this isn't just another pollution-enhanced sunset.

"That's Watts!" I gasp.

Caroline grips the steering wheel, white-knuckling it until she comes to an exit. We pull over and stare at the conflagration. The TV news variously calls it a riot, a race war, an uprising, and a rebellion. The residents of Watts in South Central LA are called looters, lawbreakers, monkeys in a zoo, and enemies of society. More sympathetic people call it a cry for help by the Black community and a struggle between the haves and the have-nots.

To me it's an inevitable response of the Watts residents to the systematic discrimination and brutality they have suffered at the hands of the Los Angeles police. I'm hopeful that it raises awareness of the desperate situation, but I am not naïve. I'm frightened for what the outcome will be.

I make it through an uneventful fall 1965 semester. I still don't have a job, and money is tight. That spring Caroline and I invite two more girls to live in the apartment to save on rent. We are crowded and in each other's way. Boyfriends come and go. One roommate is dating a cop and we find his gun on the kitchen counter, the sofa, or the coffee table. This is disconcerting, but I suppose it is just as well that he doesn't take it into the bedroom.

Unhappiness settles over my life like a fog. My home life is chaotic and my coursework is frustrating. For a while I'm drawn to creative writing, but my teacher doesn't like my writing. One day he returns a story of mine with "See me" scribbled in the margin.

"The writing is harsh," he tells me. "Stop trying to write like a man. Women don't write this way. Rethink your style."

I'm shattered. I tear up the paper and throw it away, dump my books and notebooks into a trash can, grab my meager belongings, and head to my parents' house. Neither of my parents ask what happened. Perhaps this is what they expected. Just like that, I am a college dropout.

My parents are glad for the extra hands because the Folk Music Center is moving into its third home. For the first time my father has enough space for a workshop connected to the store itself and he doesn't have to lug all the repairs back and forth between the Seventh Street basement and the store. There are two small upstairs rooms that are perfect for lessons and two designated parking spaces by the back door.

The new location quickly settles into a rhythm: The division of space and labor is unspoken but ironclad. My father rules the back, and my mother rules the front. He hires his people, and she hires hers. He is in charge of instruments, accessories, and repairs. She is in charge of books, records, toys, and whatever else strikes her fancy, and a lot does: Makonde carvings, Dahomey tapestries, Huichol yarn paintings, Benin bronzes, millefiori trade beads, dashikis, Oaxacan tin art, ropes of fat amber beads, Bambara mud clothes, Caran d'Ache colored pencils sets, Thai temple rubbings, Inuit soapstone figures, Cyrk posters, psychedelic concert posters with a separate black light room to display them, *matryoshka* dolls, "no face" corn husk dolls, Sasha dolls, *wayang* puppets, and Edward S. Curtis photographs.

Around this time my father hires his first nonfamily employee to work in the shop. David Millard is sixteen years old. He comes to work every day after school and on Saturdays, and in time the student comes to be a better luthier than his teacher. I get used to having David around, thinking that this must be what it's like to have a brother.

While David learns how to repair instruments, I start teaching private guitar lessons in one of the upstairs studios. Between students I hang around the workshop changing strings or listening for buzzes on repairs that my hard-of-hearing father can't hear. One day he is hammering nails into a frame for shaping a mountain dulcimer side and misses his mark. The hammer comes down squarely on his thumb.

"*Goddamn son of a bitch!*" he hollers. He carefully puts down the hammer, looks around his tool bench, finds what he wants, threads a thin drill bit into the electric drill, and matter-of-factly drills a hole through his thumb nail. The pressure is instantly relieved as the accumulated blood from the injury spurts out. I go down on my knees, my vision telescoping. Seeing my father do this is alarming, but it isn't surprising. My father—tall, broad shouldered, able to fix anything and solve most problems—does not cater to what he perceives as weakness: whining, pain, sadness, neediness, cold, flu, or god forbid, helplessness. Especially his own.

Once I regain my composure I say, "I don't think that was a good idea. Why didn't you sterilize the drill?"

"Bah! Yours is not to reason why . . ." He shrugs me off and continues on with his work.

I leave my father to his dulcimer frame and go to the front counter, which gives me an advantageous view of the Folk Music Center and street. Several Igbo students from Biafra who are studying at one of the local colleges enter the Folk Music Center and look around in awe. Ambrose Ena, the self-appointed leader of the group, is a very large, very black-skinned, and imposing figure in dress slacks and white shirt. He smiles a delighted smile, revealing a charming gap between his bright white two front teeth.

"This is a beautiful store," he announces. We begin to talk, and soon he suggests we might be interested in highlife, a West African dance music that is sweeping through Biafra and Nigeria. Highlife blends Western and African instrumentation and rhythms and features the guitar. This conversation is the beginning of a new friendship in my life.

The Biafran students have wonderful parties. They cook a thick, cream of wheat–like porridge that is dipped into spicy, meaty vegetable stews and scooped into the mouth with your hand. The music and dancing go on until the wee hours. My Igbo friends

express interest in American folk music and sometimes I bring my guitar and play for them.

Ambrose has the upright posture and proud bearing that befit the son of a village chieftain. Once, when Ambrose and I are shopping for one of the parties, he says, "When you visit me in my village in Biafra, I will not carry the groceries. In my country the man never carries groceries. That is a woman's job. The son of a chieftain cannot be seen carrying bags."

Ambrose describes the Igbo as the "Jews of Africa," by which he means they are a minority group that excels within a larger society. He tells me they are the most educated and financially successful group on the continent. The new, mostly Igbo nation of Biafra is sending its young men to the best schools all over the English-speaking world: Oxford, Harvard, Pomona College, UCLA, and so on.

The history of Biafra is bloody and brutal. The Republic of Biafra has only recently come into existence when the eastern region of Nigeria it represented declared independence. The Biafrans live atop a huge oil field that the British claim for Shell Oil and British Petroleum. The Biafrans want some control and a fair share of the proceeds from this oil, but Britain has joined forces with Nigeria to end the newly formed republic. They have set up a blockade around the small country.

The horrors of the war in the homeland of our Igbo friends reach around the globe. The highlife parties come to an end. Bernard, a friend of Ambrose and a promising economist, receives a telegram from his parents that reads: "DON'T COME HOME STOP YOU CAN'T HELP US STOP THEY ARE MURDERING OUR BOYS WHEN THEY STEP OFF THE PLANE STOP DO NOT COME HOME STOP." That is the last he hears from them.

Ambrose hears nothing from home. He doesn't expect to. His father is a well-known leader and Ambrose assumes he is one of

the first to be killed. Some of the young men can't bear not help-ing their suffering families and go home in spite of the warnings. Reports come back that Nigerian soldiers were waiting on the tarmac and shot them as they descended from the planes.

The evening news shows images of starving Biafran babies and children and the Niger River—the lifeline of western Africa—running red with the blood of the bodies of slaughtered Igbo. Ambrose buries his face in his hands.

"We are lost," he says, "but we are not defeated."

I am restless. It is time that I do something with my life. I apply to Pitzer College, but the admissions counselor is unimpressed with my transcripts and advises me to go to a junior college. Instead, I apply for and—much to my surprise, given my school and work history—win a scholarship to study Spanish in Claremont's sister city, Guanajuato, Mexico.

At the University of Guanajuato I diligently study Spanish and the history of Mexico. On the weekends I tour as much of Mexico by bus as time will allow. I eat avocado ice cream in Guadalajara, swim in the ocean at Acapulco, and buy a silver ring in Taxco. One day a professor takes a few of us on an impromptu tour. I watch in dismay as my professor's air-conditioned car zooms past mothers walking miles of dusty road in San Luis Potosí with their babies on their backs and water for their pueblos on their shoulders.

"They're used to it," says the professor. "They don't mind."

I do well enough overall to get a second scholarship in Bogotá to study Spanish with a Peace Corps program called CEUCA (Centro de Estudios Universitarios Colombo-Americanos) in conjunction with the University of the Andes. Just before my second semester in Colombia an educational TV film crew shows up at our study center. They are on their way to the cordilleras in the Andean rain

forest near Cali to film some indigenous tribes and ask me and two other girls in the program if we want to go. We are on semester break and never think to mention it to the director of our program.

The next day we are all in a small plane on our way to Cali. We stay the night in a dumpy little hotel in downtown Cali. Early the next morning we get on a bus and head out of the city. We pass through a large shantytown where I see entire families who are eking out an existence picking through the refuse of a gigantic dump. Babies sleep in hammocks outside the corrugated tin lean-tos that surround the dump. We speed past ever-thickening woodlands on the treacherous, narrow highway that leads into the tropical rain forest. Finally we are dropped off next to a dirt road leading into the bush. The film crew says they are searching for an isolated indigenous tribe that is said to live in this region. Glad to be off the bus, I stroll in the humid shade accompanied by the racket of countless exotic creatures in the trees above me, trying not to think too much about what they might be.

We set off up the road into the forest. We haven't been hiking for more than fifteen minutes when I feel something hard jammed into my back.

"Don't turn around!" a gruff voice commands. Everyone spins around to see a troop of Green Berets, instantly recognizable by their distinctive hats—dressed in full jungle camouflage and pointing their weapons at us. We do what we are told. They separate us from the film crew and march us through the steamy, bug-infested jungle at gunpoint.

Although we're nervous, we don't think we're in danger because we believe American soldiers won't harm Americans. To be an American is to be nearly invincible, so I assure myself that everything will be fine. After two hours—which seem more like ten—we arrive at a convent of progressive Catholic nuns who provide resources for the local tribes. It is a relief to walk into the

cool of the convent after the heat and mosquitos of the jungle. Having deposited us in a safe place, the Green Berets melt back into the jungle. We stay there for three days, sleeping under mosquito nets, drinking boiled water, and eating fried plantain, while arrangements are made for our return trip to Bogotá. Once we reach Bogotá, the program director orders us home on the next flight out. I never learn what happened to the film crew.

It turns out the United States Special Forces are secretly training for jungle warfare in Colombia before being sent to Vietnam. We had stumbled into this secret world and as a result my studies in Bogotá are cut short. One of the girls I'm with writes me after we return to the United States. She says her father has learned that the program director of CEUCA is in the CIA and had us all under surveillance the entire time we were in Colombia.

I arrive home from South America with no plans, no direction, and parasites in my gut that require several rounds of tests and medications to clear up. When I'm finally better, I go back to work at the Folk Music Center. I take some classical guitar lessons from a teacher named Joe Alba. When he catches me memorizing the pieces instead of sight-reading he makes me go back to the very beginning of my lessons. I return to playing folk music.

Into this moment steps a longtime family friend, Clabe Hangan. Clabe and Emily Hangan are an interracial couple from San Bernardino. They married in 1955, when fewer than 4 percent of Americans approved of interracial marriage.

In 1964 Clabe formed a trio with Keith McNeil and Joe Rael. Black, white, and Latino, they call themselves Mixed Company and a short time later become Music Americana. It is a groundbreaking group. By 1967 they are booking performances at school assemblies all across the country.

With his performing career blossoming, Clabe asks me to teach his adult education guitar classes in San Bernardino and Redlands. I teach the way my mother teaches: Lesson one begins with tuning everybody up and getting them playing and singing right away. I want them to feel successful immediately.

I have forty students in my adult guitar class, all of whom leave the first class playing "Skip to My Lou" and "Tom Dooley." After a ten-minute break I teach an intermediate class of twenty people, which also goes well. Feeling confident and successful, I get in my new 1967 Volkswagen Beetle and drive home at eighty miles an hour, with the wind wings wide open and Linda Ronstadt and the Stone Poneys' song "Different Drum" blaring on the radio. I teach three nights a week, earning enough money to pay back the loan for my new car, buy a pair of leather boots made in Spain, and start saving.

With one semester of teaching behind me and my confidence growing, I join Keith, Rusty, and Clabe at the University of Riverside teaching a course on how to use folk music in a history curriculum. I'm a twenty-year-old college dropout designing a syllabus and teaching courses to future history teachers. I love it.

Around this time the Golden Ring books two renowned finger-picking guitarists: the Reverend Gary Davis and John Fahey. I'm so excited to meet Reverend Gary Davis that I make the trip to the Ash Grove with my parents to pick him up. Davis is a blues and gospel musician whose style influenced many folk and rock musicians, including Dave Van Ronk and Bob Dylan. Davis is wearing his signature stingy brim hat and very dark glasses, and as my parents load him into the back seat of their Ford, the Ash Grove's crusty proprietor, Ed Pearl, takes my father aside.

"Whatever you do," he whispers, "don't let him have one sip of alcohol, no matter what he does or says." Then he slaps the hood

and wishes us a safe drive. Davis says not one word during the hour-long trip to Claremont, which is awkward for all of us, and especially me sitting beside him in the back seat. In an attempt at conversation I ask about his show the night before. The question hangs in the air unanswered.

While the guitar legend rests upstairs for the show that night, my parents discuss Ed's warning. My mother thinks Ed is exaggerating.

"I don't know," says my father. "He seemed very serious."

"You know, Dorothy," Davis says to my mother that evening, "I always enjoy a small glass of wine with my dinner, if that's not too much trouble."

My mother looks pleadingly at my father, who says, "Sorry, Reverend, we don't have any alcohol in the house."

"That can't be! What kind of hospitality is this where a man can't get a sip of something to settle his stomach?"

This is just the beginning. His requests become demands. The situation is agonizing for everyone, and finally my father calls Ed. Ed repeats that if we want to avoid a catastrophe, we must not give Davis any alcohol. Meanwhile Davis calls my parents "white devils" for refusing to give him any liquor.

Eddy Hayes, who is well over six feet, and my father bundle the angry musician into the car and take him to the Golden Ring. Once there, Eddy pours black coffee into him. They get him on stage on time and his set is excellent. I jokingly ask Eddy if he slipped some brandy into the coffee. During his encore, Davis asks if anybody has a flask he could share. Fortunately no one does.

We get through the evening. Eddy helps my father get a belligerent and agitated Davis back to our house and into bed. The next morning, he is still obsessed with getting a drink. We take him to Ontario Airport. Davis is seated in the back between my father and Ed. Once we are all at the gate, Davis tells my father he needs to use the restroom before boarding.

When he doesn't come out, Eddy goes in to get him. He has to crawl under the stall door, where he finds a drunken Reverend Gary Davis with an empty bottle of Jack Daniel's. No one knows how he got hold of it. Supported between Charles and Ed, Davis is half carried across the tarmac and onto the plane.

Tickets for the John Fahey show at the Golden Ring sell out the day they go on sale. Fingerpicking guitarist John Fahey is almost as well known for sowing confusion in folk circles as he is for his guitar playing. For a time he recorded music under the pseudonym Blind Joe Death, leading some to believe that a long-lost blues artist had been discovered. In spite of his eccentricity, Fahey is an important artist who takes the fingerpicking style into a whole new realm, producing remarkable tones from his big dreadnought guitars.

I try to like Fahey's music, but secretly I think his albums are tedious. His use of traditional folk and blues–style fingerpicking played in strange alternative tunings to produce weird, dissonant, and overly long compositions seems self-indulgent to me. Nevertheless, I'm curious to hear him play live at the Golden Ring, where he's booked for two forty-five-minute sets. He arrives surly and disheveled in a work shirt and jeans, the uniform of many male folk musicians. He's late, so there is no time for a sound check.

As a performer, Fahey is distant and erratic, behavior that his adherents see as a sign of true brilliance. Throughout his performance he sits and looks down at his knees, making no attempt to connect with his audience. Fahey is a notorious alcoholic, and Eddy Hayes is supposed to keep an eye on his Coca-Cola bottle, but somehow Fahey manages to fill it with whiskey. Soon he is mumbling and swearing under his breath as he takes swigs from the bottle, but in spite of the liquor he manages two good sets and

makes it to the end of his show, when he abruptly stands up and stumbles off stage. The applause is enthusiastic, but he does not return for an encore.

Fahey's manager gets his reprobate charge into a car and drives off, while my mother and Eddy make excuses for the artist's behavior to those that ask.

Musicians have a long-standing reputation for alcohol and drug abuse. During a live performance, musicians are completely exposed. There are no second takes, and for many this can be a painful experience. Performance anxiety is real and widespread. There is immense pressure to perform at the highest level night after night, leading some artists to turn to substances to boost their creativity. For many musicians bars and nightclubs are their workplace, and the social pressure to drink is constant.

Fahey's behavior is soon forgotten when the folk duo Kathy and Carol come to stay with us and play the Golden Ring. They have an eponymous album on the Elektra label that I have played so much I've worn out every track. Kathy Larisch and Carol McComb are Southern California natives who have pure, gorgeous voices that are perfectly suited for the old British and American ballads. Their harmonies are a slice of heaven on earth. I can't get enough of their music.

Kathy and Carol are also delightful houseguests and my mother has them back to play whenever a date can be managed. I find them a welcome and wholesome relief from the hard-drinking performers such as Gary Davis and John Fahey, men who are tormented by their talent and make everyone around them pay the price.

CHAPTER 11

LOOKING FOR JIMI

The New Year's Eve party is in full swing by the time I arrive at Chris Darrow's house and the music has already devolved into a long jam session. During a break, the conga player, a rare Black person among the usual mix of white Claremont musicians, comes over and introduces himself.

Leonard Harper tells me he is a senior at the University of La Verne. I tell him I'm a guitar teacher. He's intrigued; I'm skeptical. He's too good-looking, with olive skin, enormous dark eyes, long curly eyelashes, and black hair smoothed back in tight waves. His hands, taped for drumming, don't look accustomed to hard work. He's suave, charming, and amiable, and my guard goes up immediately. When Leonard asks to see me again, I demur politely to avoid committing to a date.

"I don't know," I say. "I'm kinda seeing someone."

When they start playing again, I leave.

The next day Leonard shows up at the Seventh Street house. I step out on the porch.

"How'd you know where I lived?"

"I asked Chris. Sorry for dropping in on you but I didn't think I'd left you with a very good impression."

There is truth to this. He's alluring, but I have doubts about his sincerity. I decide to focus on alluring. I'm also impressed that he walked three miles from his apartment in La Verne to my house in Claremont. I invite him in and introduce him to my mother, who is instantly smitten. On our first date we walk to Claremont's Village Theatre, where the stylish thriller *Blow-Up* has finally arrived. We both enjoy it; we feel like we've seen something very avant-garde. We continue to see each other and soon we are an exclusive couple. Leonard gets along easily with the whole family and over a few months has met my three sisters, brothers-in-law, nieces and nephews, grandparents, several aunts, uncles, and a number of my cousins. Leonard, an only child whose father was killed in WWII, has just his mother, Tommie.

On Easter Sunday, Leonard and I go to the Elysian Park Love-In, a huge outdoor concert in a natural amphitheater near downtown Los Angeles. Our generation, which had grown up with the Cold War and its constant threat of nuclear annihilation, is now coping with the death and destruction of a hot war in Vietnam. As we come of age and feel our power, we challenge the decisions of our parents and grandparents that had landed us in this unjust war. We believe we're going to change the world through peace and love and sex and drugs and rock and roll. It is the dawning of the Age of Aquarius, and love has the power to change the world and bring about peace.

Leonard, high on the joints that are freely passed around, looks at the scene—the candles, incense, music, the spirit of free love, people dancing with everyone and no one to the psychedelic rock of Strawberry Alarm Clock—and starts to cry. It's possible someone slipped him a tab of LSD, I'm thinking, as he turns to me in awe.

"Fox," he says, "it's gonna be a whole new world, a different world, a beautiful world."

I'm not high on anything and have serious doubts about the power of the half-formed utopian vision of free love and peace that is sweeping my generation. The number of American troops in Vietnam is approaching five hundred thousand. Ten thousand American soldiers and tens of thousands of Vietnamese are dead. After several hours of observing (and smelling) twenty thousand hippies dance, smoke, shed clothing, share drugs, swig booze, apply patchouli oil, twirl scarves, kiss strangers, trip out, pass out, and generally show the squares a new way of being, it strikes me that the romantic ideals underlying the Love-In are unsustainable. The possibility of a new and beautiful world appear to be quite literally a pipe dream.

"This is all a distraction from a war we don't want but can't stop," I say. But then I drop it. I know that if you are the only sober person in a gathering of totally drunk, buzzed, swirling, twirling, partially clad people dancing to acid rock, it's best not to try to have a coherent discussion. Plus it made Leonard cry harder.

"You're wrong, Fox. This is different."

Leonard has a point. There *is* something new in the air. Our generation is providing the energy to and in some cases the leaders of the civil rights movement, antiwar movement, women's liberation movement, the nascent modern environmental movement, and a wave of spiritual exploration that is creating real change, accompanied by a soundtrack of new anthems and protest songs. But I'm not wrong to have my doubts. Free love and raised consciousness through drugs have become an excuse for hedonistic and self-destructive behavior, and the undefined idea that raised consciousness will bring peace and love to the world is simplistic and naïve.

As the war in Vietnam escalates, so does resistance to the war at home. Already frayed from the stress of the civil rights

movement and white backlash, America edges closer to civil war. Universities are crucibles of antiwar protests. Draft cards are burned, education centers for conscientious objectors are formed, and antiwar groups across the nation mobilize massive marches against the Vietnam War. Other Americans view the antiwar movement, which is centered but by no means confined to the nation's college campuses, as unpatriotic. The nation is dividing itself into two distinct groups: the conservative, crew-cut, clean-shaven patriotic "love it or leave it, better dead than red, my country right or wrong" supporters of the war, and the longhaired college students and their friends who believe it is an immoral, unjust, unwinnable war. The shorthaired folks think the longhaired protesters are spoiled and elitist. The longhaired college students think the shorthaired, often blue-collar pro-war people are ignorant and brainwashed. The contempt is mutual.

When President Johnson comes to speak at the Century Plaza Hotel in Los Angeles that June, Leonard and I join a protest march outside the hotel. The sheer numbers of protesters with their fierce chants of "Hey, hey, LBJ, how many kids have you killed today?" and "One, two, three, four, we don't want your fucking war" rattle the nerves of the establishment. Sensing the gathering presence of the police and aware that he is one of the few Black people there, Leonard grabs my hand and leads us through the oncoming press of marchers to our car. Later that day we hear tensions at the Plaza grow to the point that the LAPD use nightsticks to forcibly disperse the crowd, creating panic as protesters caught in the melee are shoved and beaten bloody.

It is the Summer of Love. It is a daisy blooming from the barrel of a soldier's M14 rifle, placed there by an antiwar protester. The draft is the dominant topic of conversation among the young male

musicians and students hanging out at the music store. The war is being televised and on the six o'clock news we see the violence unfold as a battle for a hill is won one evening and lost the next, along with horrifying images of hundreds of flag-draped coffins daily arriving in the United States filled with our dead boys. Soldiers are resorting to drugs or deserting, preferring prison to participating in the slaughter or being slaughtered in the jungles of Southeast Asia. Rebellion is in the air; in March there had been widespread protests in many American cities against the war. The heavyweight boxing champion Muhammad Ali refuses to go to war, leading to his being stripped of his championship and a stretch in federal prison. "No Viet Cong ever called me n****r," says Ali. The atmosphere of the whole country is charged and volatile.

A new phenomenon arrives on the psychedelic rock, antiwar scene. In 1967 Country Joe McDonald appears at the Monterey Pop Festival and later performs at Woodstock. He steps on stage wearing a thrift store army jacket, his long hair tied with a headband, and sings "I Feel Like I'm Fixin' to Die Rag," which instantly becomes the iconic anthem of the antiwar movement. Joe is the preeminent audacious, sardonic, angry representative of the 1960s counterculture. The *New York Times* calls the song Country Joe's "obscene truth." Halfway through the song, Joe starts talking to the crowd that's singing along with him.

"How do you ever expect to stop the war if you can't sing any better'n that? There's three hundred thousand of you fuckers out there. I want you to start singing!" In actuality there are half of a million fuckers out there and they all leap to their feet en masse and belt out Joe's "Fish Cheer."

My mother and I are unrolling posters to hang in the Folk Music Center's black light room when she sees one of Country Joe and the Fish.

"Joe's mother, Florence, was a communist back in the day," she says.

I don't question how my mother knows this. "Of course she was," I say. I get a huge kick out of hearing this. It makes me chuckle. Joe has all the earmarks of a red diaper baby.

Hair and clothing become the uniforms of a divided America. The male patriots shave their hair close. The male protesters grow it long. Mustaches and beards appear on young male faces framed by flowing locks. Rebellion has its own fashion: denim, leather, fringe, flowers, peasant blouses and skirts, bells and ribbons braided into long hair, and bell-bottoms. The Folk Music Center sells antiwar posters, bumper stickers and decals, peace T-shirts and peace pendants, bells, beads, bandanas, and dream catchers. The changing look has its disadvantages. One look many of the guys adopt is a fringed leather or homemade denim vest over a bare chest with beads and/or neckerchiefs. All well and good fashion-wise, but without a shirt, the underarm sweat eats right into the nitrocellulose lacquer, the finish used on the better guitars, leaving darkened rings on the lower bouts of the expensive instruments if not immediately removed. When I come in to work, Grandpa says, "Here's another one for you," handing me a guitar that reeks of sweat and patchouli. I get tired of polishing stinky, sweaty guitars and forbid these guys to play shirtless. I put up a hand-lettered sign that says SHIRTS REQUIRED.

Beneath SHIRTS REQUIRED my father adds another rule, NO BELT BUCKLES. Most pairs of Levis or blue jeans require a belt, and belts require a big artsy belt buckle. Navajo concho belts with turquoise and silver buckles are in. It is the beginning of the Red Power movement for Native American civil rights, and this is a way of showing support. My father doesn't like the look of having

all these rules posted, but buckle damage is a pet peeve and he doesn't want it happening to his valuable Martins, Guilds, and Gibsons. Belt buckles are pushed around to the side of the gut or the belt removed, or you get an earful from Mr. Chase that won't be quickly forgotten. Personally the buckle rash doesn't bother me nearly as much as the sweat blight.

February 19, 1968, is my twenty-first birthday, and I buy myself a tan-and-navy-blue-striped mini dress made by Courrèges. Leonard and I eat at the Hamburger Hamlet on Sunset Boulevard and then head to the Whisky a Go Go to see the South African jazz trumpeter Hugh Masekela. Two months later, on April 4, 1968, I'm in my room getting ready to go out with Leonard to celebrate his twenty-fifth birthday when my mother comes to my room, her eyes red from crying.

"Martin Luther King's been shot. Leonard's on the phone." Medgar Evers, President Kennedy, Malcolm X, now Martin Luther King? The spirit of the Age of Aquarius had abruptly ended, and with it the hope of peace in our world.

We had lost one of our most important leaders, the moral compass of the nation, and a role model for all Americans. Leonard slides into bottomless despair. There is nothing I can say and no comfort I can offer. I feel helpless and hopeless. Leonard flies to Memphis to join the mourners in the funeral procession, and then on to Atlanta, which had been King's home, for a march.

The nation is reeling. King's assassination leads to a nationwide wave of race rebellion and riots. King's widow, Coretta Scott King; James Farmer Jr.; and other civil rights leaders call for nonviolent protest, but a growing number of people on the political left see King's assassination as evidence that change can be achieved only through violent action.

The violence won't end. Two months later, on June 6, my mother wakes me. "Bobby died."

Robert Kennedy, younger brother of the assassinated John F. Kennedy, has been shot at a campaign rally in Los Angeles. An advocate for the poor and underrepresented, Bobby worked for civil rights and opposed the war. He was poised to win the nomination of the Democratic Party for president and was a ray of hope, especially after King's death. Would he have beaten Richard Nixon? We can't know.

For a while these crushing national traumas solidify the bond between Leonard and me. After a year of dating we are spending more and more time together, often in the tiny house he rents on West Eleventh Street. I'm teaching guitar and working at the music store, and he is recruiting minority students from all around the country for the Claremont University Consortium, a relatively new effort in academia to bring diversity to the schools.

On the weekends we dress up and head out to clubs, concerts, love-ins, and festivals. There is a lot happening around Los Angeles. We see James Brown and the Famous Flames, the comedian Redd Foxx, the soul singers Sam and Dave, and nearly every band that plays at The Cheetah in Santa Monica, including Janis Joplin with Big Brother and the Holding Company, Iron Butterfly, the Chambers Brothers, Buffalo Springfield, Jefferson Airplane, and blues guitarist Albert King. Leonard loves the ear-splitting volume of the psychedelic rock bands. He craves the press of the crowds dancing and tripping out, moving through black lights and pulsing strobes and pounded by the bass that thumps so hard it takes over your heartbeat. I stand on the perimeter, napkins stuffed in my ears, watching this crush of mind-bent humanity and just not feeling part of it.

On weekdays, while I fix a late dinner, Leonard pulls the shoebox with his stash from under the bed (surely, no one would

think to look there) and dumps enough weed for one joint into the shoebox lid. He separates the sticks and seeds from the crushed leaves and buds. The Zig-Zag rolling paper is smoothed flat, filled, rolled, licked, twisted, and lit. Then comes Leonard's first puff, an inhale that seems to suck his whole head into his lungs. For him it is a soothing ritual. He says the weed improves his appetite.

I ask Leonard why he never drinks. "I had a problem with alcohol in high school," he explains, "but I handled it. It's not a problem anymore."

I take him at his word. I'm glad he doesn't have a problem with alcohol anymore, and everyone smokes pot, so I don't see a problem.

One night we hear someone sneaking through the bushes on the path between the house and the walled-off graduate student housing next door.

"They're coming for me, Fox! They're coming for me! Shut off all the lights! Dump the stash!" he says. We freeze in the darkened house for a terrified minute while the soft rustling advances closer and closer.

I don't dump the stash. Instead, I grab the flashlight and go to the backyard. There is no one in the neighbor's yard or alongside the house. Then I hear a hiss behind me and spin around to see two yellow orbs reflecting back my flashlight. A raccoon is perched on the wall right at eye level. He curls his lips, flashing impressive incisors at me before shuffling noisily along the wall. I holler for Leonard to come out and meet his nemesis. He refuses, continuing to insist a human had been sneaking down the path next to the house.

A few weeks later, during an early summer heat wave with nights as hot as the days, we are in his stifling little house with a couple of electric fans struggling but failing to cool us off as we watch the *Tonight Show*. Leonard is wide awake, but I'm drowsy and relaxed, drifting toward sleep.

"You know what, Fox?" he says, stroking my arm.

"What?"

"This is wrong."

"I know . . . " I mumble, only half awake. "Racist stereotyping."

"What are you talking about?" he asks.

I gesture at the television ad of a cartoon mustachioed Mexican wearing a bandolier, sombrero, and double holster who is threatening to steal our Fritos. "Frito Bandito. What do you think?" I say.

"I'm talking about us," he says, still stroking my arm. "Look at this—it's wrong." He gestures at my arm. "You're so white and I'm so dark. Look at the difference. It's wrong."

I'm awake now. I study his arm and mine and try to make sense of where this discussion is going. "I don't understand."

"You're white. I'm Black. It can't work. We can't do that to our kids. It's too hard and it's wrong."

I'm confused. "Kids? Why are you worried about kids? We've never even talked about marriage."

"We will if we stay together. It's the next step."

Next step? Isn't everything okay the way it is? We are the counterculture. We don't have to pursue the conventional trap of middle-class house, picket fence, 2.5 children. Is he breaking up with me? I feel fear leak into my bloodstream and course through my veins.

"What are you saying? I don't care about kids and marriage. I care about you."

He's adamant. "It's over. We have to end this."

And that is that. No more discussion. He's morose, his eyes flat. He's falling away from me like Alice falling down the rabbit hole.

In a daze I pack up my things and drive home. I wake my parents and tell them that Leonard had broken up with me. I need to talk to someone before the hurt completely crushes me, so my father gets up and joins me downstairs. He makes us tea with cream and sugar.

"Relationships are like bank accounts," he says. "You have to deposit enough good feeling so when you make a withdrawal there's enough left in your account to see you through the bad times."

My father—the socialist who thinks like a capitalist. I tell him I don't understand why after a year Leonard suddenly believes our relationship is wrong. I'd understand if he didn't love me. I'd understand if he'd found someone else. I don't understand us being wrong.

My father offers a historical analysis of race relations in the United States and why it is a much heavier burden on the Black man than the white woman; how it is the man's job to protect the family and what an enormous task this is for African American men in racist America. I hear him. But I still hurt.

I slog through weeks of agony, alternately trying to get Leonard to talk to me and trying to stop thinking about him altogether. I feel as if I'm walking underwater, barely getting through each interminable day without him.

And then I start feeling better. I regain my appetite. I hear that Leonard is seeing an old flame and it doesn't kill me. I even go out on a few dates and discover I can have fun without him. I'm moving on.

One day, Leonard calls. I don't take the call. He calls again. I don't take the call again. He calls again and again and again, reinforcing my theory that as soon as you start recovering from a breakup, you become desirable again.

I'm doing much better, healing from heartbreak, but I still have an urge to get away for a while and clear my head. So I go to New York for two weeks to stay with my levelheaded sister Sue in Long Island. It's a wonderful trip. I get to know my niece and nephew, Laura and David, and Sue and I learn a beautiful version

of Dylan's "Boots of Spanish Leather" from a guitar-playing friend of hers.

One day I take the train from Wantagh to Manhattan to visit my friend Elaine. We do the town: We are shoppers, tourists, explorers looking for adventure. I buy a cream-colored miniskirt with a delicate mud cloth–looking print, matching top, chocolate-colored tights, and a pair of boots. I feel great. The trip is just what I needed, and I'm sad when it's over.

Sue drives me to JFK Airport. I'm traveling light, wearing my new tights, boots, and a dress that covers my rear by a discreet few inches. Sue finds a place to sit while I stand in line to get my stand-by seat assignment.

"I want to sit next to her," I hear a man say to the neighboring ticket agent. I look over and am surprised to see he's talking about me. A quick glance reveals a fashionably mod-looking man dressed in a sports coat over jeans and a light blue shirt.

"But, sir, you are in first class. She is in tourist."

"Make it happen," he replies.

He turns to me and introduces himself. "Michael Goldstein, artist management."

"Ellen Chase, folk singer," I reply coolly, turning on my heel and heading back to find Sue. A minute later he catches up with me.

"I'm Jimi Hendrix's East Coast manager. There's trouble in LA. I'm going to go straighten it out. And I'm sitting next to you on the plane."

This is going to be an interesting flight, I think.

"Who is this man?" Sue asks, making no effort to hide her wariness.

"He wants to sit next to me. He manages musicians."

"Worse than I thought," she says, rolling her eyes. She worked for Manny Greenhill in artist management in Boston and has a

jaundiced view of people in the entertainment business. "Be careful," she warns, and leaves me to my new friend.

Michael turns out to be a fun and attentive companion. Since I'm so often surrounded by notable musicians and my popular parents, I'm not accustomed to someone taking an interest in my life. We chatter away and in no time at all we are across the country and landing at LAX.

"Come to the hotel with me," he urges.

"I can't. My parents are picking me up at the airport."

"Call them."

I call them.

"Leonard has been trying to reach you," my mother says. "I don't know what to tell him. He wants to come to the airport to pick you up."

"Tell him I won't be there."

Michael's car takes us to the famous Beverly Hills Hotel, bright pink and tropical. The Jimi Hendrix Experience is in town, and the hotel is jumping. Michael is pounced on by worried tour staff the minute we arrive in the lobby *Jimi's being difficult. Jimi won't listen to anybody. Jimi does whatever he wants.* That turns out to be the good news. The bad news: *No one knows where Jimi is or how long he's been gone.* Our bags are sent up to the room and we hit the streets looking for Jimi. This becomes the theme of my time with Michael Goldstein: Looking for Jimi.

First we go to Jimi's bungalow. No Jimi. We head to the Strip, and to the Roxy. No Jimi. We go by the Whiskey a Go Go. No Jimi. We go back to the hotel and look inside several rooms, which is easy because everybody seems to leave their doors open. People wander in and out, helping themselves to stashes of weed and pills and liquor, and even to clothing. No Jimi.

"Where the fuck is he?" a frustrated Michael shouts into one room.

"Don't know, man."

"You're fucking supposed to keep track of him!"

"Sorry, man. You know how he is, man. That's why you're here, man."

"Screw it," Michael says to me. "Come and meet this young band I'm working with. They're very cool." We drive to a funky hotel off of Sunset Boulevard. Michael opens a door into a rumpled room filled with guitars and tussle-haired boy-men smoking weed and drinking beer. They are a British band that plays acoustic guitars, and soon it's revealed that Michael has ulterior motives.

"She's a folk singer," he announces. That gets their attention.

"Sing something!" they demand. I pick up a guitar and impress them by singing several verses of "Boots of Spanish Leather." One of them grabs his guitar and plays along while another keeps time on the coffee table. Then I play Hedy West's "500 Miles." The guys want me to stay and sing more but Michael says we have to go.

"Ellen, stay with us." They implore. "Management's a drag." As we make our exit they cry out, "She's got it! Make her a star, Michael."

"You actually can play the guitar!" Michael says once we are outside, as if he'd just seen a poodle juggling fire torches. He means it as a compliment—men in the industry still aren't used to women playing guitar.

I like being with Michael. I wonder if he is married but never ask. He is kind and generous and is surprised I don't want to go out shopping to spend his money on jewelry and clothes, something he wants to do for me. The idea of shopping with someone I barely know makes me uncomfortable. However, it does not make me uncomfortable to go to a hotel with someone I've just met on an airplane.

The next afternoon, we return to the business of finding Jimi. We walk the Sunset Strip from the Roxy to the Whisky, from one

sound check to another to check on Michael's British invasion bands that he represents. Jimi is nowhere to be found. It's getting later and the clubs will open soon. The fans and groupies are already waiting in line or walking the boulevard or chatting in small groups, alternately bored and smoking and alert to every car trolling by. As we approach the Whisky a Go Go, a black limo rolls up to the curb. The tinted rear window slowly lowers.

"Michael! Welcome to LA. Who's the bird?"

It is my first glimpse of Jimi Hendrix, one of the world's most famous rock stars. With a huge smile and wave he disappears behind the slowly rising window before Michael can reply. Then the car rolls a few more yards down the street and the back door pops open. Jimi leans halfway out the door and touches the elbow of a beautiful blonde who is standing on the sidewalk wearing a white leather miniskirt, halter top, and boots. He whispers to her, and she disappears with him into the back seat. This attracts a flock of pretty, scantily dressed girls waving and screaming "Me too!" The car makes a quick, unsafe U-turn and drives off.

"Damn Jimi," says Michael, half in irritation and half in relief. We head back to the Beverly Hills Hotel and find Hendrix strolling through the lobby, dressed in a purple velvet suit, holding hands with the blonde, surrounded by a motley entourage of beaded, fringed, longhaired revelers in denim and velvet and bell-bottoms with inserts—a psychedelic montage of color, tie-dye, florals, and feathers. Jimi sees Michael and walks over, a little sheepish. He takes my hand when introduced and gives it a mock courtly kiss, then flashes me a heart-stopping smile and wink.

"Wasting your time with management," he says, mischievously.

I smile. I've learned that there is a hierarchy of desirability in the minds of celebrities and fans. Topping the list of desired companions are the lead singers, followed by band members, then road crew, techs, sound guys, lighting and effects. Bottom

of the ladder is management—the guys in the suits. I'm with a "guy in a suit."

Michael is all business. "Jimi, we have to talk." Jimi follows him without protest and they disappear into some private space. Left on my own, I return to Michael's room to get a sweater and read for a while. I discover that I must have left my book on the plane because I can't find it anywhere. It is the latest Dick Francis, a real page-turner. There isn't anything in the room to read, so I wander into some of the other rooms. Some are empty, some occupied. No one shows any interest in a stranger walking around.

On all of the dressers are rows of pill vials alongside over-flowing ashtrays, bottles of booze, soda, girlie magazines, rolling papers, feather boas, and a couple of paperbacks. The curtains are invariably closed. There are so many pills, uppers and downers, and lots of penicillin.

"Take what you want," a sleepy voice says from a pile of bed-clothes. I pick up a small book to take back to the room with me. It looks like a romance novel—not my favorite—but at least it is something to read. Back in Michael's room I open the curtains and windows, close the door, and settle in the chair with the best light. I immediately realize this is no romance novel. I had no idea porn came disguised in this way. I'm preparing to return the book when Michael walks in the door and sees the book in my hand.

"You into that stuff?" he asks.

Offended, I say, "Of course I'm not into it. I thought it was a novel."

"Right," he says.

I throw the book in the trash and ask him why everybody has penicillin and porn. He shrugs.

"There is so much of it," he says. "It's everywhere. Drugs, alcohol—sex, too. It gets boring. If you're with the tour, girls throw themselves at you. Sex is available always and everywhere,

beautiful girls that'll do anything to get close to fame. It gets old, believe it or not, and so the porn is to help get it up. The antibiotics are for VD. Everybody has it or gets it. The drugs and alcohol are to make you think you're having a great time."

I'm floored. Who would have thought that all these hip particrs are experiencing an epidemic of ennui?

"How'd it go with Jimi?" I ask.

"Not good," he says bitterly. "Right now my job is to keep him alive for the Hollywood Bowl show."

Hendrix's history of alcoholic drinking and drug abuse weighs heavily on Michael's mind, and the next morning Michael wakes in a panic.

"I've got to check on Jimi," he says, running out of the room. I jump up and follow him down the hallway, down the elevator, and out to the bungalows. Nobody is in the first bungalow. Michael slams open the second bungalow door. There are people on the floor and couches, crashed out, unconscious, naked or half naked, solo and in various combinations. No one acknowledges our presence. There is vomit on one of the sofas, spilled booze, needles, candy, sticky stuff, pills, and cigarette butts burned into the tables and carpet. It looks like something out of a Hieronymus Bosch painting and smells like the Ninth Circle of Hell.

Michael hesitates before opening the bedroom door. Then everything seems to happen in a slow-motion blur. Michael leaps into the middle of the bed. A blonde is passed out in the bed next to Jimi. Ignoring her, Michael grabs Jimi and shakes him.

"Jimi, goddamn it, speak to me! Wake up, you fucking idiot. Talk to me! C'mon, Jimi! C'mon, open your eyes, you fucker!"

"I'll call an ambulance!" I say.

"No ambulance! Go get Billy," he shouts, referring to one of the handlers. When I return with Billy, Michael won't let me in the bungalow. I wait outside.

"Jimi is fine," reports Michael after an interminable wait. "No big deal, just a little hungover."

That night we go to see one of Michael's British bands at the Whisky a Go Go. Noel Redding, bass player for the Jimi Hendrix Experience, and Mitch Mitchell, Jimi's drummer, are sitting in with the band. Both are English, unlike Jimi. Jimi is originally from Seattle, but his breakthrough had happened in England. After the show Noel comes to our booth and glides into the seat next to mine. He's beguiling and flirtatious and tries to talk me into going out for a drink. I'm flattered and maybe a bit tempted, but I'm loyal to Michael, who is sitting right there.

"It's awright, luv," Noel says, "'e's management. They don't 'ave human feelings like the rest of us."

I last three days with Michael before leaving that manic traveling celebrity sex circus and drug marathon. I'm afraid that the siren call of music and celebrity will suck me into a life too compelling to resist and too exciting to manage. Michael calls whenever he is in town, but eventually we lose touch.

The day after I get home from Beverly Hills, I'm back to work at the Folk Music Center when Leonard walks in. He wants to renew our relationship and invites me to the Hollywood Bowl to see Jimi Hendrix. He doesn't know where I'd been the last few days and I feel no obligation to tell him.

"Let's just go somewhere quiet," I say.

We go out to dinner and over an appetizer of chips and salsa he apologizes for the harsh breakup, begs my forgiveness, and asserts his desire to mend our relationship. I never expected to hear these words from him. After the assassinations and riots and the wild storm that is the Experience tour, Leonard seems like a safe harbor. We pick up where we left off, and soon the breakup is all but forgotten.

CHAPTER 12

DEMON RUM

One moonless autumn night Leonard and I take a stroll. The Santa Ana winds are kicking up little dust devils, and the air is charged with static electricity. We walk hand in hand, comfortable saying nothing for long stretches. Suddenly Leonard grabs a signpost with both hands and in one swift move swings himself up into a human flag, ignoring the sparks that crackle from his fingertips to the metal.

"Hey," he says, as he holds this challenging pose, "wanna get married?" There is something irresistible about this lighthearted tour de force. I know in that moment that he is the one.

Am I seduced by his charm? Perhaps. Am I in love? Absolutely. Leonard has a lot going for him. On the practical side, he is gainfully employed and has a college degree. He's also funny, charming, articulate, good-looking, and single. And he loves me.

The wedding is to be held at my parents' house on Saturday evening, January 25, 1969. My mother is overjoyed to plan and prepare for this event. Sue and Joanne hadn't given her the chance

to plan a real wedding, and now she's in her glory. She designs the invitations and cooks all the food, cake included.

We have been looking for a house to rent in central Claremont so that Leonard can walk to work at the University Center, but we encounter disappointment after disappointment. No one will rent to us. Week after week we peruse the local paper, but when we show up to see the place, all we hear is "Sorry, already been rented."

The real estate agents are no help. The ones with the most listings in town openly admit they would never rent or sell to Negroes or mixed-race couples because property values would plummet. Leonard checks with the housing offices at the colleges. Standard policy is to rent to new faculty or administrators until they are settled and can afford to buy, which sounds perfect for us. Leonard is a newly minted administrator for the Claremont University Consortium, and the colleges have several vacant houses in central Claremont. But none are available to us. We watch them fill up with white couples, our frustration surging. When we complain, we are offered a house in the East Barrio where the colleges have been buying up houses one after another, destroying the integrity of the tight-knit Chicano neighborhood that has been there for generations. We walk out. The neighborhood is not the problem. It is the insult of open, institutionalized racism. The prejudice we encounter only makes us more determined to find a place on our own terms.

With the wedding imminent, my parents suggest we live in the family cabin on Mount Baldy until something turns up closer to town. We would save a little money and it is only a twenty-minute drive down the mountain to work. We move in the day before the wedding, carrying boxes as quickly as we can up the hillside stairs to the cabin porch as the overcast sky threatens more than just drizzle. We hurriedly lug everything indoors and are unpacking when the rain starts in earnest, quickly turning into a downpour. By evening, the storm sounds like a freight train rumbling by.

When the electricity goes out we decide it is time to make a dash down the mountain. We step outside with the intention of sprinting to the car, but our flashlights quickly reveal that the usually tame stream that runs by the cabin had turned into a raging river, obliterating the road and stairs. The force of the water coursing down the arroyo pounds boulders against the canyon walls like giant bowling balls careening off the bumpers and heading straight for the village of Mount Baldy.

We go back inside the cabin to call my parents only to discover the phone is out. I manage to light a fire in the pot-bellied stove with newspaper and kindling and heat some canned soup. It is a long, terrifying night. It's too dark to see what's happening outside but we feel the house quiver and quake whenever a particularly large boulder slams into the hillside. Unable to sleep, we wonder if we'll be washed down the canyon to our deaths. I come from a land of ocean hurricanes and arctic wind-driven blizzards sweeping down the White Mountains of New Hampshire, but I've never seen anything like the cataclysm this storm has released.

One of the cabin's quaint and distinguishing features is a huge tree that's grown up through the center of it. I tell Leonard, "We could lash ourselves to the tree to keep from being washed away." I can't remember where I'd read this survival tip, but it seems like a good idea as a last resort. Leonard, born and raised in the city of Los Angeles, a place where weather is rarely a factor, ignores my idea and smokes a joint. In a dim circle of candlelight I escape into my own drug of choice: an Agatha Christie mystery.

When morning comes we assess the situation. Bear Canyon and Mount Baldy Road, the only way in or out, are both washed out. But by the afternoon the rain lets up and we are able to hike over the hill and down to Mt. Baldy Lodge. Two helicopters arrive to fly out emergency cases; one is to take a woman with a late-term, high-risk pregnancy to the hospital, and the other is a military

helicopter sent by General Westmoreland, commander of the US forces in Vietnam, for his daughter Katherine.

We tell the head ranger that it is our wedding day.

"That's no emergency," he scoffs. "Go to your cabin and stay put."

We go back. We stay put.

Back at home, my family worries when we don't show up. After many attempts, my mother finally reaches the fire department.

"That cabin's still standing," the chief tells her. "If they stayed put, they're probably alive." This puts my mother's mind at ease. She knows her daughter is smart enough not to step out into a raging storm.

Stuck in the cold cabin, lit only by candles, I thank my father for his industrious wood chopping that provides us with enough fuel to warm ourselves and heat up more canned soup. Our wedding day passes with us huddled around a small fire, willing the storm to abate, and nursing our disappointment over our ruined wedding.

The next day the water subsides. The air is clear and cold, and the sun is shining in a bright blue sky as if it were all a bad joke. Relieved, we hike through Mount Baldy Village, or what is left of it, and discover the town is gone—flattened, in pieces. Whatever feelings of concern we have about our missed wedding ceremony are quickly replaced with distress for all that others have lost. The few houses that are still standing are filled with boulders. Cars and pickup trucks are flung about like Matchbox toys, overturned and filled with mud and rocks. Debris is strewn about everywhere. Under one ruined car I spot a muddy, bedraggled cat that flees when I approach it.

We trudge about five miles down the mountain, where we come upon a road crew. A tractor driver gives us a ride to the Claremont city line, and from there we walk another couple of miles to my parents' house. Cold, exhausted, and hungry, we're glad

to be safe and finally warm. One side of the living room is filled with flowers designating the altar. The cake my mother hadn't let anyone touch stands proudly on the table. The guests had arrived the day before, eaten the wedding dinner, commiserated with our parents, left their gifts, and headed home when we didn't show up. In no time at all sandwiches and hot coffee arrive on the table while we expound—between mouthfuls of egg salad on rye—on surviving the flood of '69.

My mother calls everyone to let them know we are alive and invites them back for the ceremony. My parents are practical people. There is no need to make a fuss about a wedding that is a day later than planned. Ernie Howard, the Unitarian minister; my mother-in-law; my sisters; and a few friends return to the house. I shower, put on my white lace mini-wedding dress—modern, of course—and join Leonard in the living room, where we are married. Dan Fox, the attorney who helped Ben Vines, plays a joyful "Hava Nagila" on the fiddle while my mother serves chicken and dumplings and tells the story of her honeymoon on Lake Umbagog and the hurricane they had survived.

"You have a wonderful wedding story to tell," chirps my mother. "Most weddings are dull." People offer toasts with wishes for a long and happy married life. And so we begin our lives as husband and wife.

The first time I see Leonard falling-down drunk is our wedding night. We have reservations for a three-day honeymoon in a hotel on the beach in Santa Monica, and after everyone has a piece of cake we get ready to head to the hotel. At my parents' house, Leonard is the happiest I have ever seen him. He's gregarious and affectionate, freely socializing and making jokes. He even coaxes his mother, Tommie, out of the bathroom she'd locked herself in

for most of the ceremony. Leonard's mother had wanted a church wedding, but Leonard had left the church years before and adamantly refused. She would brook no argument and pressured him to change his mind right up until the moment of our vows, at which point she made off for the bathroom. My family takes the rain-checked wedding in stride; their view is everyone is safe and happy and no one is hurt or dead. What more could you want? Leonard is joyful as well, and he enjoys a few more champagne toasts before grabbing a bottle for our honeymoon as we leave the party.

It is late January, and the sky turns dark early. Leonard's driving is erratic, and he bounces across the freeway's dividing lines, unable to stay in his own lane. I try to convince him to pull over and let me drive but he won't go for it. Instead of driving all the way to Santa Monica, he exits somewhere east of Hollywood, pulls into a raunchy motel, and gets a room. I wait in shocked immobility in the car while he gets the key. As soon as we are in the room, he passes out. When did he get so drunk? How did he get so drunk? I search his duffle bag and find an unopened bottle of Jim Beam. I check his jacket pockets and find a silver flask engraved with our wedding date—it must have been a secret present—with only fumes left to tell the story. I sit by the window the whole night, looking through grimy curtains at the blinking neon sign advertising the liquor store next door. I find cold comfort in the realization that he hadn't passed out at sixty-five miles an hour on the freeway.

The next morning, I get in the driver's seat before he can.

"Let's go home," I say.

"That was some wedding wasn't it, Fox?" He seems pleased with himself. Neither of us mentions the honeymoon after that, but it lingers in my mind.

During the ensuing weeks I see no signs of his drinking and relax my guard. I begin to think I'm overreacting to one drunken

incident. We accept the college rental in the East Barrio and set up our new household. When Baldy Road is clear I drive up the mountain to get our belongings. On the return trip, I notice the poor cat I saw hiding under the same car wreck on the side of the road. I pull over, get on my hands and knees, and coax out the skeletal feline. He's so dirty and matted I can hardly tell his color, which turns out to be white. No one claims him, and I finally bring him home, clean him up, and name him Fido. Once he's had enough to eat he becomes a huge and dignified presence. Whenever Leonard is away on recruiting trips Fido is my loyal friend and companion.

With the exception of Leonard's strange midnight breakup speech, we had never discussed having children, and so of course we also hadn't ever talked about how to raise them—what we'd name them, where they would go to school, or any other important parenting matter. I'm not sure I want kids, and I know I don't want them any time soon, but five weeks after the wedding my period is late.

"I'm pregnant," I tell my physician, Dr. Griggs.

"You have an IUD in place," he says. "There's no way you're pregnant. Go home and relax. You'll get your period."

I leave the doctor's office angry, embarrassed, and weepy. Regardless of what my patronizing doctor said, I know I'm pregnant. When I get home I tell Leonard my doctor had accused me of having a "hysterical pregnancy," which is true only in the sense that I'm feeling hysterical. Unfortunately, Leonard is no help—he agrees with the doctor.

But they don't matter. I know my body. My period is never late.

One week later I'm throwing up. I go back to Dr. Griggs.

"Well, I'll be," he says when the test comes back positive. "You certainly are pregnant." *Surprise, surprise,* I think. "I have to remove

the IUD, otherwise there can be serious health consequences. Taking out the IUD means you will probably miscarry within the next two months. I am so sorry, but we have no other choice. Call me when you spot or start bleeding."

Unraveled, I go home and cry and throw up and cry some more. And throw up some more. This isn't morning sickness—this is all-day sickness. I throw up at the smell of coffee and cigarettes—Leonard's smell—and I throw up at the smell of meat cooking, the refrigerator, my kitchen, and the incense in the gift shop where I'm working part-time. Up comes the Coca-Cola, root beer, 7Up, ginger ale, soda crackers, and dry toast, all meant to help settle my stomach. I crave pizza, so give it a try, only to heave it. I crave In-N-Out Burgers, eat one, and lose it. In time I discover the only things I can hold down are out-of-season strawberries and fresh steamed Alaska king crab dipped in melted butter.

At the end of three months I weigh ninety-five pounds but I'm still pregnant. Soon I feel a tickle in my abdomen. The baby has an indomitable will to live.

The baby is due on Halloween and arrives three days early. After eighteen hours of labor and no medication I deliver a healthy, wrinkly, scrawny, six-and-a-half-pound boy with oversized feet. Benjamin Charles enthusiastically sets about the business of being a baby, leaving me no choice but to learn to be his mom. Breastfeeding is discouraged, but I do it anyway, without difficulty. I walk him in his pram each day and "air" him on the porch in all kinds of weather, per the advice of his great-grandmother, my nana.

Leonard is very good at his job. He increases the number of students of color at the colleges and lends his voice to the formation of a Black Studies Center. His success is noted by Pitzer College's administration, which is trying to boost its affirmative action headcount. In the summer of 1970 Leonard accepts Pitzer's

job offer of assistant director of admissions, a major step up the academic ladder in terms of salary and status.

On August 29, 1970, one month after Leonard starts his new job, the Chicano Moratorium, a daylong antiwar demonstration, is held in East Los Angeles. Like all people of color, Chicanos are being drafted for the Vietnam War and dying in it, disproportionally. The Moratorium is a multigenerational event with food, music, speeches, and a performance by El Teatro Campesino, a Latino theater group that is the cultural arm of the farm workers movement. I try to convince Leonard to go but he is afraid. He says it is crazy to go and even crazier to think about bringing the baby.

"These days they beat the shit out of white people at protests," he says. "They fucking shoot them. What do you think they're going to do to a bunch of Chicanos?"

I can't argue with him. Three months earlier, at an antiwar protest at Kent State, the National Guard had shot four students dead. Still, it doesn't feel right to sit at home; I want to be there to take part and support the cause.

"Fox," Leonard softens a bit, "by marrying each other we made a choice to put ourselves out there every day. But we don't have to put our lives on the line."

I don't go, but a few Folk Music Center employees do. David Millard comes back and tells us that he stood on the hood of a car and watched the police in full riot gear surround the perimeter of the park. Without provocation they shot tear gas into the peaceful crowd, then waded in, batons swinging, indiscriminately bashing the heads and bodies of every man, woman, and child in their path. We watch the violence unfold on the television, listening in shock and outrage to the local sheriff's self-serving lies. Several people are killed, including Ruben Salazar, reporter for the *Los Angeles Times.*

Later there are vigils and protests and marches across the nation, but there is still no end to the war in sight.

Leonard and I want Ben to go to Sycamore Elementary School because of its progressive, child-centered approach to education. So we begin house hunting again, looking for a home near the school. One day we get a call from a young realtor, Gordon Curtis, who is willing to break Claremont's color barrier. He finds us a small, affordable house on Eleventh Street. We are elated.

With Leonard's new position we manage the 156-dollar monthly mortgage bill. We furnish the house by going to yard sales, estate sales, junk and antique stores. We discover that for next to nothing you can find arts and crafts–style desks, tables, and chairs made from solid quarter-sawn golden oak. We make a comfortable home and have friends and family over for meals. I notice that Leonard starts having a glass or two of wine with dinner to be social, but he seems to handle it well and I'm not worried. We plan our second baby. Since we have one kid, we figure we might as well go ahead and have another and be done with it. Joel David is born in February of 1972, two years and four months after Ben. Leonard gets a promotion to director of financial aid.

Our lives are taking shape. The needs of a husband and two babies keep me busy, but I still go out one night a week to teach guitar at the Garner House, a beautiful old Spanish-style grove house shaded by ancient sycamore trees in the middle of Claremont's Memorial Park. Leonard doesn't like me going out at night and teaching; he says he's worried about my safety—but I do it anyway. We are content, and my life feels full.

One day I'm home with baby Joel and toddler Ben when my mother calls to tell me that Grandpa had a stroke and died. He'd been out on an errand buying office supplies for the store—where

he still worked all day, every day—and was driving on a busy street when it hit him. He managed to pull off the street into a parking lot. He died instantly, according to bystanders and the first responders.

I sit down at my kitchen table, shocked and bereft. *Just like Grandpa*, I think, hugging my babies close to me—*even dying he would pull off the street to avoid harming anyone else*. We all miss him terribly and I make time to bring the family over as often as I can to spend time with Nana. She insists that we are all too skinny and doubles down on feeding us to allay her loneliness and grief.

As she clears the table after dinner she shakes her head. "Ach!" she says. "I'm taking more off the table than I put on."

No one has the heart to remove Grandpa's sweater from the back of the office chair at the Folk Music Center where he hung it every day for years, and it stays there, a flag of remembrance, for months to come.

Leonard is a brilliant administrator. He can, with great diplomacy and humor, take control of a meeting and get to the bottom of the issue with charm and tact. He's a natural leader. Everything is going well for him.

Robert Atwell, president of Pitzer College, and Dr. Edgar "Pete" Reckard, chaplain for the five colleges, both see Leonard's potential. They want to groom him to be one of the first Black college presidents of a non-Black college, they tell him, and Leonard is flattered and honored. We are thrilled at this opportunity but not surprised.

"You're an eloquent son-of-a-bitch," says the director of admissions, Robert Duvall.

The graduate school is offering a new administrative degree program and Leonard is the perfect candidate. Leonard hands in his application, and they rave about his essay. The interview is a

resounding success. The members of the administration congratulate themselves on finding the perfect (Black) candidate. The only other thing he needs to do is take the GRE.

"It's no big deal," President Atwell and Dr. Reckard reassure Leonard. "It's just a formality." He believes them.

I had assisted Leonard with some of his homework in his last year at the University of La Verne. I was puzzled how he could expound on Durkheim's influence on the civil rights movement but be confounded when asked to produce it on a test. His sociology professor recognized that he had the knowledge but did poorly on tests. He called it "test-taking anxiety."

But I'm worried. "I know these people, these Faculty Club types," I say. "They expect you to do okay on the GRE, because they do just fine on these kinds of tests. That's who and what they are. But the tests aren't designed to be fair. They discriminate against people of color. You should protest taking it."

Leonard blows up at me, saying I am trying to undermine his self-confidence.

"They said it's just a formality! Why would they lie?" he yells.

"They're not lying." I try again. "They don't get it. They think the test is a test of your intelligence. They won't accept that it's a test of our apartheid educational system. They already know you're a leader. Refuse to take it on the grounds that it discriminates against Black and brown people, and it'll reinforce your leadership. If you take the test, you'll risk their thinking you aren't smart enough."

He takes the test. He fails the test.

Dr. Reckard and President Atwell drop him from the program.

"It's a white man's test," says my father. "Fight it. It's a discriminatory tool of the dominant culture. It's a fight worth fighting, and if anybody can win this fight, it's you. You've more than proven you're qualified. You can and you will prevail."

"No. They don't want me," Leonard says, and cracks open a fifth of Southern Comfort.

We are three years and two kids into married life when Leonard begins slipping away from me for good. Drinking a couple of glasses of wine or a few beers with friends at social gatherings now often triggers a binge. After most occasions he'll pick up a bottle at the liquor store and drink it out of the brown paper bag until he passes out. He's still functioning at work, so no one knows. Except me. And I can't admit to anyone, or myself, how bad it is getting at home.

Leonard's ability to talk circles around me doesn't help our deteriorating relationship. His moods are mercurial, but his verbal sparring is sharper than ever. His outbursts of temper can be triggered by anything—a song I'm humming, a call from my sister, a wrong number, scattered toys, misplaced sunglasses—erupting out of thin air like a sucker punch and devolving into ad hominem tirades against me. He always has to have the last word.

I'm no saint, either. What else can I do? I rail against him for his drinking, smoking, and neglect of the children. I yell and cry and urge, desperate to get through the haze of alcohol and drugs to the man I once knew. But his episodes continue to increase in frequency and intensity, and I give up reasoning with or challenging him. I know it is no use. I watch his eyes turn flat.

I spend night after night with him as he fights me without boundaries or limits. When I grow stoic, he takes my silence as a rebuke. Ordinary efforts at self-defense are an affront that only narrows his attack and hones the vitriol. When he sobers up he offers eloquent apologies and pleas for forgiveness, but they are soon belied by the attacks that come the moment he starts drinking again.

When Joel is three months old, I leave Leonard. Holding the hand of our toddler, babe in arms, I go to my parents' house for

refuge. My mother is not pleased. She admonishes me to go back to my husband, to think about the children. She says they need two parents.

I turn to Tommie, Leonard's mother, who reacts differently. She had already guessed he was drinking and says she'll put a stop to it. I am skeptical but relieved to let someone else try.

"The beer and wine is okay for Len," she says, "but not the hard stuff."

Tommie and I go back to the house, and Tommie stays with us for a few days, haranguing him about his drinking and watching him like a hawk. I learn the extent of Leonard's drinking problem, which stretches back to high school days. Tommie spends much of her time at our house scrubbing the kitchen and washing every dish by hand after it comes out of the dishwasher. She is dogmatic about right and wrong. A secretary to an admiral in the U.S. Navy, she believes the Vietnam War is right and all those Asians and communists are wrong. She resents the war resisters; they are also wrong. She adheres to her conservative Christian doctrine on all things except when it comes to gambling. She loves to gamble but keeps her habit under tight control. Once a month she takes a tour bus to Las Vegas. She takes one hundred dollars and spends not one penny more, win or lose, and believes Leonard should have the same self-control over alcohol.

For a time, it gets better. Leonard drinks less; we fight less. We start to believe we can make things work. But the foundation had fractured; even when he isn't drinking, I don't trust him.

After Joel is born, I get another IUD. What are the odds of lightning striking the same place twice, right? Apparently high. A year and a half after Joel is born, I'm pregnant.

I have options. In January of 1973 the United States Supreme Court issues a 7-to-2 decision in the case *Roe v. Wade*, striking down many federal and state anti-abortion laws and protecting a woman's right to choose to have an abortion. Before *Roe v. Wade*, medically safe abortions are mostly unavailable. Women who wanted to end an unwanted pregnancy turned to unsafe, illegal abortion providers, often resulting in infertility or deadly infections. Leonard is adamantly opposed to abortion, a result of his conservative Christian upbringing. I march for women's rights and am pro-choice. I believe in family planning and birth control. I support the women's liberation movement from within my un-liberated life. But I am torn.

I want to have the baby and Peter Matthew is born in April of 1974. He's a happy, easy baby, but having three kids turns out to be too much pressure on our already fragile marriage. Actually, two kids is too much pressure—three is untenable. Leonard starts binge drinking again, and one night he passes out on the front lawn late after stumbling out of his car. I find him early in the morning and leave him there, covered with dew, glistening with tiny rainbows in the dawn's sunbeams.

Leonard's enthusiasm for life makes a brief comeback when he applies for a new job in 1974. He excels as director of financial aid, making sure the grants and loans go where they are most needed, but he's bored. He wants a more active role working with students. He applies for the dean of students position, and the student body makes it clear they want him. Even though we know chances are slim that he'll get that post without a master's degree, we still hope.

President Atwell must be thinking along the same lines and realizes there could be a stink if someone else gets the job. So he creates a new position just for Leonard: dean of student activities. No master's degree required, and Leonard can make a real difference in this new role. Leonard is excited and has dozens of

ideas. He has a vision for a student center that becomes the Grove House, a place "where students can relax, play guitars, hold meetings, small dances, and poetry readings, and have a retreat from the pressures of studies," as he writes in his promotional material. Leonard can sell inspiration and the vision becomes a reality.

Unfortunately he doesn't have experience with a project this massive, and he struggles to keep it on track. Funds have to be raised, and negotiations with contractors and builders have to take place, or the project will fail. Other professors and administrators are better at this—and better at taking credit. Leonard leaves his imprint at Pitzer. But he doesn't feel appreciated, and the victory lacks luster.

Living the life of a stay-at-home mom and wife of a popular college administrator is not something I'm especially good at. I chafe at the daily grind of housekeeping, shopping, laundry, diapers, childcare, play groups, as well as fall guy and scapegoat for Leonard's increasingly capricious mood swings.

I return to my life's anchor and start working at the Folk Music Center again, even though the cost of the babysitter takes most of my earnings. I discover a repair shop that is overwhelmed and I'm eager to learn how to fix guitars. Working at the store again means being around guitar players, and it isn't long before I form a band called Alfonso Houston and the Houstonettes with two employees, David Millard and Geraldine Forbes. We enjoy the rehearsing as much as the scant gigs we play.

At this time there seems to be a moment of hope for Leonard's and my marriage. Leonard stops drinking. I give him a Super 8 camera for his birthday, and we take the kids on splendid outings, which he films. Leonard becomes captivated by reggae music. He's moved by the spiritual and political messages of Jimmy Cliff

and Bob Marley and wants to explore the precursors of reggae, such as ska, talk-overs, and rock steady. I want to believe this new passion represents something meaningful. For a moment I think my husband is back, but it turns out it is only the candle burning brighter before going out. I have seen this behavior before. Leonard is besotted by Rastafarian culture and begins to grow his hair into a mass of dreadlocks. His speech changes, and he says things like "irie" and "yeah, mon." He smokes tons of weed.

In 1975 Bob Marley plays the Roxy Theatre in West Hollywood. It is a sold-out show, but Leonard pulls some strings and gets us tickets. I think he may have convinced them he is press because he has a Super 8 movie camera. Our table has a great view of the stage, but Leonard is rarely in his seat. He's busy moving around the theater, filming the show from every angle.

I hardly notice that Leonard isn't nearby. Marley's dreads and denim jacket, the trademark black T-shirt, his voice, his energy, the power of his lyrics and melody, the one-drop rhythm are all so fresh and new. I'm enthralled. It is an unparalleled musical experience from the moment "One Good Thing about Music" fills the room to the fading out of "Get Up, Stand Up." If there is ever such a thing as a perfect show, that night, I witnessed it.

CHAPTER 13

SINGLE MOM

I discover a pattern to Leonard's drinking. When he is feeling up, he drinks. When he is feeling down, he drinks. The time in between the two begins to disappear. Without telling Leonard, I go to a marriage and family counselor for advice. She advises me that couples counseling is useless if one partner is drinking excessively.

"The drinking has to be addressed before therapy can be effective."

At my first Al-Anon meeting I learn that we are all alike. Regardless of race, culture, class, or background, the wives, husbands, mothers, fathers, siblings, and children of alcoholics have remarkably similar stories. In part this is because active alcoholics are all alike: To protect their addiction they become skilled at lying. They bask in self-pity, blaming others for their problems and manipulating the people that love them, creating a toxic mix that warps every relationship. Only my mother knows I'm sneaking out to meetings because she watches the kids as I learn how to empower myself while living with an alcoholic.

With Al-Anon's help I take control of my life and the kids' lives. I stop reacting heatedly or defensively to Leonard's tirades, and I stop questioning or challenging his drinking. I even stay calm the night he grabs me and shakes me after finding my hidden Al-Anon booklets.

It doesn't stop there. His mood plummets fast, and he leaves the house in a fury, then comes back after midnight, drunk and still fuming. He yanks me out of bed and slaps my face, again and again, and then punches me in the chest, back, and shoulders. I try to get away, but he hits me one last time and knocks the wind out of me. I hold on to the doorframe to keep from going down but I can't breathe. As I gasp for air, he retreats to the living room and blacks out on a chair.

I stay still and quiet as the mouse I feel like I've become. When his breathing evens out and I'm sure he's asleep, I silently get the kids out of bed and flee to my parents' house. The adrenaline coursing through my bloodstream lets me ignore the pain all over my body, which will soon make even the smallest move excruciating.

The moment my father sees me he starts crying. I have never seen my father cry and the sight stuns me. My mother is distraught, too, but insists I can't leave Leonard. She says I owe my children at least ten years of marriage and I have to go back and make things right. I feel a flash of anger toward her, but before I can respond, my father, still crying, hands me a wad of cash and tells me to get a lawyer.

Instead of staying with my mother I drop the boys off with my sister and drive myself to the emergency room. The x-ray shows massive bruising and two dislocated ribs, one cracked. None of the doctors asks me what happened. They treat my injuries and leave me alone on a curtained bed, waiting to be discharged. I sit there with nothing to do but worry.

It hurts to breathe. It hurts to move. It hurts to think. How will I pick up the baby? How will I walk the kids to school or shop or cook or do laundry?

My mind soon turns to my mother. Does she really believe she is putting my children's needs first when she says I have to stay with Leonard? Has she considered her own child's needs? I wonder why she cares more about the marriage than my well-being. Would my divorce be an embarrassment to her? Would it mean I'm a failure?

I sit on the emergency room bed for what feels like hours when a small, plump nurse with a kind, worn face and salt-and-pepper hair pulled back in a bun slips through the curtains. She sits on my bed and takes my hands in hers.

"Who did this to you, baby?" she asks, her voice soft and gentle.

"My husband."

She nods. "Don't go back to him, baby, no matter what he says," she tells me. She is kind but firm. "He'll kill you—if not the next time, the time after that. Promise me you won't go back."

I promise her I won't.

I keep my promise and divorce Leonard. As soon as I'm able I take the cash my father gave me, walk into an attorney's office, and put it on his desk.

"I want a divorce."

The lawyer takes one look at my bruises and wastes no time getting a court order. Leonard has twenty-four hours to leave our home.

Two days later, I return to the house. The empty music shelves are the first thing I see: Every album in our huge collection is gone, except one, Bob Dylan's *Blood on the Tracks*. Leave it to Leonard to make this dramatic gesture.

In 1976 domestic violence is largely ignored. There is little recourse for its victims. It is accepted, much as cigarette smoking is accepted, even though both can and do kill. It cuts across all classes, races, and religions. It is a secret malevolence happening to friends, neighbors, coworkers, and the moms whose kids are in playgroups in the nicest neighborhoods.

But change is coming. Even as I live my nightmare of abuse and witness Leonard's decline into severe alcoholism, the dramatic cultural shifts of the 1960s and 1970s are sweeping through families all around me like a tsunami. The women's movement, birth control pills, *Roe v. Wade*, Title IX—these and other milestones are a tidal wave of change that enable women to break free of their petty despots and leave soul-crushing and often violent marriages. It is not an easy road. District attorneys fail to enforce child support rulings, sending many women to join the ranks of the working poor. Counting pennies, raising children, juggling babysitters, daycare, housework, and jobs is difficult and draining, but we are *free* from the fear and anxiety of sleeping with the enemy.

Judge Paul Egly gives me full custody of the children. Leonard is awarded visitation rights on alternate weekends and every Wednesday, a typical ruling. The judge also orders Leonard to pay me five hundred dollars a month: three hundred in child support and two hundred in alimony. Egly does not make Leonard pay for my attorney fees, so my attorney agrees to a trade: one divorce in exchange for a guitar. He wants a good guitar and he knows the name Martin but has left the choice of which one is suitable up to me. I select a Martin D-35, with the three-piece rosewood back, Sitka spruce top, ebony fingerboard and bridge. It has a fabulous action, booming bass, and balanced treble and midrange.

Leonard pays child support for the first four months, sending a check that had been crumpled, stepped on, and otherwise defiled to show his resentment. After that the payments stop. I call and

demand the money, but he refuses to pay. The law doesn't make him. So he doesn't.

I go to work full-time at the Folk Music Center. It makes sense; I can't work anywhere else and still take time off for my kids without being punished or fired. My boss is my father, and when all three boys get chicken pox, I'm able to stay home with them. When Ben has an asthma attack and I have to run to the hospital in the middle of the night with Joel and Peter to put him on a Bird ventilator, I'm able to stay home and keep an eye on him the next morning. If I make the mistake of volunteering to chaperone a school field trip, I can get away from work for a day, the only penalty being a headache from a day spent at the zoo with thirty children.

But the best thing about the Folk Music Center is you never know who will walk in the door. It might be a lonely soul needing human contact or an expert in something like dog training, water geology, socio-economics, or trees—and of course, some aspect of the universal language of music. It isn't unusual for a person to walk in and put on a spontaneous mini concert using one of our instruments: a hurdy-gurdy, Veracruz harp, bagpipes, oud, duduk, or berimbau. One day a couple from the Morongo reservation comes in and teaches my father about Native American flutes, or "love flutes."

My father applies for and then receives a tax-exempt status as "a nonprofit educational institution" for the Folk Music Center Museum. Throughout the years he has been repairing and restoring all manner of instruments from around the world, and we've all gathered new insights into the world's cultures and musical traditions. This tax-exempt standing gives us the opportunity to maintain a permanent gallery of musical instruments and artifacts. In addition to the already robust offerings of the music store itself, we now provide weekly field trips for children (and adults) of all

ages, musical instrument loans to schools and museums, and a yearly Claremont Folk Festival, a project that is undertaken with great affection by my mother and her volunteer army of folk enthusiasts.

The Folk Music Center doesn't repair traditional band instruments, and my father decides it's time we service our rentals ourselves and not have to send them out. I volunteer. I'm always game to try something new. He sends me to an expert, Jimmy, the repairman for Ruffing's Music in Pomona. A flute, trumpet, clarinet, or sax that has been played a lot, especially by a kid, then put away in its case for who knows how long, typically attracts mildew and mold. The metal oxidizes and turns green with corrosion. It is gross. Jimmy takes them apart and throws the metal parts in a vat of cyanide, which cleans them in no time. I discover this requires a special permit. I just can't see having a vat of cyanide at the Folk Music Center with my kids running around. It isn't for me. We continue to do some of the simpler band instrument repairs, but if an instrument needs cyanide, we send it to Jimmy.

Through a musical accessories salesman that visited the store I become acquainted with a guitar and violin repairman in Glendale. Jack Willock had worked at the Gibson factory for many years. Jack takes me under his wing and for two years I drive out once a week and apprentice with him.

Jack is a widower and veteran of World War II. He has a strong work ethic, a strictly regimented schedule, and a full head of red hair of which he is very proud. It seems he is still living in the 1940s. The décor of his house is exactly the same as the day he lost his wife. He drives a vintage car with a bumper sticker that reads MY KARMA RAN OVER YOUR DOGMA. His tools are prewar, patched and repaired dozens of times over the decades. He puts a small pat of butter in his coffee instead of cream. He leaves money around the shop to test my honesty. But for all his eccentricities,

he is a patient and thorough teacher. After two years he presents me with a hand-lettered certificate proclaiming that I'm a full-fledged repairman. He says he has nothing else to teach me and congratulates me on my accomplishments.

The Folk Music Center is a full-time job, but the five dollars an hour my father pays me means money is always tight. My three boys require the costly help of babysitters, who sometimes are my saving grace and sometimes my undoing. When they do the job well, life is good. But sometimes they show up late, or show up on time but have to leave early, or phone me while I'm at work to say they don't feel well, or leave my kids in the house and go next door to get stoned with the neighbor's teenagers.

So I'm beholden to my mother for her support. She criticized me for leaving Leonard, and she doesn't like my parenting style—she often contradicts, undermines, or outright ignores my parenting policies—but I'm grateful for the help she willingly offers. And once Ben, Joel, and Peter are all in elementary school, they come to the Folk Music Center almost every day after school, saving me the price of babysitting.

As the oldest, Ben has the most freedom to roam. When he's eight years old I agree to give him one dollar after school to buy something to eat at the bakery or the pizzeria nearby. Sometimes, though, I'm too busy or too broke to give him his dollar. On those days, my parents or someone else at the store is generally happy to give him his dollar for the day. Pretty soon, Ben figures out that if he is discreet, he can get away with going to each of us for a dollar. Everyone is happy to reach in their pocket or purse and give the charming, polite little Ben a dollar. I don't know how long his racketeering lasts, but I do know he isn't happy when I catch him and put a stop to it.

Even with the job and children, I'm still able to make time for playing music and accept an invitation to play bass for a *norteño* band—a combination of German polka and the corridos, or story ballads, of Northern Mexico. The gigs are in Los Angeles and it is not a long-term project. However, there is a problem: I don't play bass. I buy a Guild Starfire semi-hollow bass and cram to learn some rudimentary techniques. We are called Conjunto Medio—"the half-and-half band"—because two of us are white and two of us are Latino. We stay together just long enough for me to feel barely proficient on the bass.

We rehearse at my house two nights a week, saving me the cost of a babysitter. As soon as the kids are in bed we start playing, and once the rehearsal is underway, Ben, Joel, and Peter, believing themselves to be invisible, slip out of bed, pillows and blankets in tow, and settle themselves in the middle of the floor, where they fall asleep to the give and take of the rehearsal.

Clabe Hangan, who had come to my rescue in 1967 by giving me the chance to take over his guitar classes, hears that I've learned to play bass and invites me to join him and Joe Rael in their group Music Americana. In 1978 we are an affirmative action photo opportunity playing middle school and juvenile detention center assemblies all over Southern California. I round out the group by representing half of the world's population: women. The music we play is a blast and our tour fulfills my desire to teach. We tell the history of America in song, starting with Native American mouth bow and frame drum and working our way through the history of slavery with "Gray Goose," the Industrial Revolution with "Peg and Awl," and the Civil War with "Two Brothers." Sometimes for fun we end the show with the chorus of "Stayin' Alive."

Anyone who's ever been in a band knows it's not easy to keep one together. Joe and Clabe are always squabbling with each other

over everything from tuning guitars to decisions about coffee and donuts. I don't like being in the middle, especially considering that I have three squabbling children at home. But that's not my problem. What's more and more difficult for me is traveling and rehearsing while keeping up with my children's schedules and my job at the Folk Music Center. Recognizing that it isn't fair to Clabe and Joe to be half committed, I bow out of the project.

Word of what the Folk Music Center offers continues to spread. One loyal customer and friend is the consummate musician David Lindley, whom we have known since the days of the folk music coffeehouse the Cat's Pajamas. In 1966 David cofounded the highly influential band Kaleidoscope—along with Chris Darrow—that paved the way for psychedelic rock. David is a master instrumentalist; he plays precisely, with never one note too few or too many. He buys his first Weissenborn guitar at the Folk Music Center. It is David's slide guitar that completes the sound of rock legend Jackson Browne. David's second slide guitar—also from the Folk Music Center and made by Kona—is the instrument he played on the Grammy Award–winning album *Trio* by Dolly Parton, Linda Ronstadt, and Emmylou Harris.

On David's recommendation, we are getting drop-in visits from his fellow folk-rock celebrities looking for the perfect instrument. The influential blues singer and song stylist Taj Mahal comes to the Folk Music Center with a powerful energy and joyful good humor and leaves with a funky old resonator guitar that sounds like an orchestra in his hands. Jackson Browne brings his avid musical enthusiasm and treats us to samples of his outstanding talent on a 1947 Martin 000-28. Some famous musicians show up already soured and entitled by their star status, believing they are entitled to our subservience. One of these is Joni Mitchell, who,

when she doesn't get the guitar she wants for free, deliberately and condescendingly drops her cigarette butt on the floor of the shop and casually grinds it out with the toe of her boot.

I admire Joni Mitchell for her musicianship and songwriting, but her entitled behavior in the Folk Music Center is shameful. It's hard when heroes behave badly. We're left with the thankless task of separating the flawed behavior of a person from their art and contribution to society. Celebrity, I learn, distorts the perspective of everyone it touches, resulting in a world where we expect talented musicians to be cultural priests, gurus, or philosophers, roles for which they are no more qualified than plumbers or engineers.

Meanwhile I'd been playing bass long enough to feel reasonably confident when Guy Carawan comes to the Folk Music Center asking for me. He's scheduled to play a small concert in the Grove House at Pitzer College and wants me to play bass to back him up.

I'm honored. Guy and his wife, Candie, are longtime friends of my parents, and they visit every time they are in Southern California. Guy was such an inspiration to me with his selfless dedication to the civil rights movement back in 1964, and now to have the chance to play bass for him is a privilege and I know it will be a lot of fun. I can't wait.

The Guy I have known over the years is a big, lumbering, good-natured man. He wears loose shirts tied with shoelaces, and his manner is boyish and clumsy, giving the impression that he is tripping over his own large feet even when he isn't moving.

Guy agrees to rehearse at my house so I won't have to find a babysitter. I know most of the songs on his set list, but not necessarily his versions, so I'm ready to practice when he arrives. The kids are in bed when I hear a knock on the door. I open the door and see his big body filling up the doorway.

"Where's your guitar?" I ask, inviting him in.

He chuckles, then without a word takes two steps forward, grabs me, picks me up off my feet, and attempts a huge sloppy kiss on the mouth, but I duck my head away just in time and he lands the smooch between my cheekbone and ear. His body odor is asphyxiating and I struggle to get out of his grip. He finds it amusing. I'm getting scared.

"Put me down!" I command, and he plops me on the couch. I squirm out of his grasp and push away from him. "What the hell do you think you're doing?" I splutter, although I have a pretty good idea and my fear turns to anger.

"What?" He shrugs, seeming completely clueless.

"Get out! Just get out!"

He slinks out the door. Guy is not a violent person. He could easily have overpowered me. He is genuinely shocked at my reaction.

Guy comes in the store the next day. I see him coming and quietly slip out the back door. When I am sure he's gone, I go back inside.

"Call Guy," says my mother, after I return. "He wants to talk to you about rehearsing."

I tell her what happened. "I'd rather not talk to him, Ma."

"Oh come on, I'm sure it was just a misunderstanding."

A misunderstanding? I challenge her. "Ma, that's BS."

She ignores me.

What infuriates me the most about this "misunderstanding" is that he had used music to break a trust. Music is something we both love so much, and I feel like he'd used it to lure me into a trap. Had he found this caveman technique to be successful in the past? I find it hard to believe.

For several years all I hear from Leonard are maudlin, rambling, drunken phone calls in the middle of the night. Al-Anon taught

me that these calls are standard operating procedure for active alcoholics. Apparently it's common for an alcoholic to get drunk, feel sorry for himself, and call his ex-wife to blather and rage. Leonard's favorite call is to let the musicians Hall and Oats speak for him by playing the song "Rich Girl" into the phone. It isn't worth explaining that I'm not a rich girl. When Leonard is on a binge I leave the phone off the hook.

Leonard rarely sees the kids, alternately phoning to angrily declare he'll see them when they turn eighteen, or dejectedly bemoaning that they are better off without him. Either way he manages to bail on the role of being a father. His absence is a relief for me, because when he does make promises to the kids for a visit, he neglects to show up. Other times he arrives to pick them up reeking of alcohol, which means I won't let them in the car with him. The boys don't understand the dangers of drinking and driving and resent me depriving them of their dad. It's easy for the absentee parent to take on a chimera of perfection when he is barely present.

The boys are going through their elementary school years at a time when progressive thinkers promote unisex toys and ideas like giving boys dolls and girls trucks. This seems reasonable to me intellectually, but in reality it has no place in my home. All three of my sons disparage the unisex toys I bring home for them. They are hopelessly enamored with sports, Pac-Man, guns—not allowed in our house and therefore homemade—dirt bikes, skateboards, superheroes, fart jokes, and comic books. Any and every dispute among them turns to fisticuffs within seconds, requiring me to untangle them and scold all equally because there is simply no getting to the bottom of who actually started *it*. All activities other than fighting are accompanied by, "Look at me! Mom, look at me! Now look at me, Mom!" as one of my sons attempts a daring feat that, I swear, will turn my hair gray before its time.

I was raised in a house full of girls. Our spare time was spent reading or fussing with our hair, and in a dispute, our weapons of choice were sarcasm and infallible memories for past slights. This background did not prepare me for raising boys. Maybe nothing would have prepared me for raising three boys.

I have no choice but to become a different person. I go to soccer games and track meets and shop for dirt bikes, skateboards, and gym socks. I accept Spider-Man, Superman, Batman, and the Hulk as worthy of my attention, reading material, and conversation. However, despite knowing they were created by a Jew, these superheroes are never my literature or cinema of choice.

When it comes to my boys' schooling, my family experience confronting authority comes in handy. I've seen some progress in cross-cultural understanding, but teachers and principals, unused to children of color, still do and say bigoted things. When Joel is in second grade, a case of head lice is detected in his class. A note goes home with all the kids in the school and they are examined and treated as necessary. When another infestation breaks out, Joel's teacher takes me aside.

"We think Joel is bringing the lice into the school in his curly hair," she says, explaining what shampoo I should use on his scalp.

I tell her that he has been examined and declared lice-free.

"It's hard to see the nits in all that curly hair," she insists. "Check all your kids."

The culprit turns out to be a pale, blond-haired boy. The teacher apologizes, and so do the parents of the boy who has the lice.

"I saw some bugs in his hair," says his dad, "but I didn't think kids from homes like ours could get lice."

I bring this bit of classist, racist stereotyping to the attention of the school superintendent, who issues educational materials on the matter to all the Claremont schools.

In a couple of years Ben is in middle school and Joel and Peter are in upper elementary. As they become a bit more independent I glimpse the possibility of expanding my life beyond "working mom." One day, a customer named Johnny brings in a Barcus Berry electric violin for repair.

When I'm done fixing it he asks me to come play bass in his country-western band, the EZ Band. I jump at the opportunity—this is just what I need to add some creativity to my life. I buy a Fender Mustang bass—the last bass designed by Leo Fender himself—which is the perfect instrument for this band. Johnny and I trade off vocal leads and harmonies, and I swap instruments on a couple of songs with Danny, the band's guitar player. Country-western music is all the rage in the late 1970s and early 1980s, and we work a lot, mostly in bars.

Danny is an outstanding rockabilly guitarist, but he has a serious cocaine habit. One night his mother comes to the bar to see us play. Danny is so high that as soon as he sees her he bolts out the back door and doesn't come back. I go looking for him during a break and find him in the men's room. I peel him off the sink he is clinging to and make him come out to see his mother. A vein in his neck is throbbing so hard I think his head is about to explode. His mother doesn't seem to notice and gives him a hug and a kiss on the cheek. She tells him "to break a leg," and we join the rest of the band on stage.

The EZ Band is hired for a regular gig at a bar in Riverside, Friday and Saturday nights, three sets, the first set starting at nine o'clock. It's a lot of work but we take it. Every Friday and Saturday night, I rush home from work, get dinner for the kids, put them to bed, wait for the sitter, and make a dash for the venue. The guys set up for me to save time. After the show, we take turns staying until the end of the night, when the bartender finishes totaling the sales and gives us our cut. The first time it is my turn

I'm sitting at the bar after the show, worn out and edgy, watching the bartender count and recount the till, when a small, extremely drunk man wearing a large cowboy hat sits on the barstool next to mine, putting me in mind of the expression "all hat, no cattle." He tells me a dirty joke about Little Red Riding Hood, laughs at his own joke, puts his head down on the bar, and starts snoring. For a minute I think about going back to school.

A half a year into our residency at this bar, the EZ Band is scouted. We had heard a rumor from the club owner that there was an A&R person in the area looking for country bands. He meets with us and pays for us to record a demo of three of our best songs and then offers us a well-paid, long-term gig at a casino in Las Vegas. The guys in the band are deliriously excited—this is the big break many musicians wait for—but I'm faced with a tough decision. I promised to stick with this band, but how can I uproot my boys and move to Las Vegas? Vegas is known for only one thing: hedonism. Do they even have elementary schools? If I agree to go, what kind of a life will that be for my children, who already experienced the trauma of divorce? How can I tear them away from their home, their grandparents, cousins, friends, and school?

I say no, and the deal falls apart. The casino doesn't want the band without "the chick." I feel terribly guilty, but it is the right decision, and not only for my family. Danny is a great player, but his ferocious coke habit threatens to undermine us, too. I don't say this, though. In the world of music there is an unspoken tolerance of unusual and self-destructive behavior. People in the arts pride themselves on being accepting of the many musicians who use drugs and alcohol. And anyway, I'm the one who is letting the band down, and they hate me for it. I can't really blame them.

After the EZ Band breaks up, I take some time off from performing. As joyful as it is for me, it's stressful to balance playing

with prioritizing my children's needs. Life is better when the kids are happy, and I give myself over to my family.

I keep my performing and rehearsing local and casual after the EZ Band. On most Friday evenings I play with a conglomerate of locals called Chuck Grove and the Citrus Pickers at Nick's Café Trevi, which is conveniently located around the corner from the Folk Music Center, singing old-timey, string band, bluegrass, and western-swing music. The kids often accompany me to Nick's, playing tag or staging *Star Wars* battles with friends on the café's lawn.

I also join forces with a local duo, Larry and Leif, which becomes Larry, Leif, and Ellen. Our trio is hired to play every Saturday evening at the main restaurant in town, Warren's Restaurant. We sing whatever we like: John Prine, The Kendalls, Elvis, George Jones, Kenny Rogers, Dolly Parton—yes, we play "Islands in the Stream," modulations and all—the Everly Brothers, Taj Mahal, Bob Dylan, Rodney Crowell, Willie Nelson, and some songs Larry wrote. It is freeing not to be beholden to the strictures of playing within a single genre, as most bands must if they want to work.

For two years, we pack the Saturday night gig at Warren's. Our show is early enough for me to bring the kids, and the poor things learn all the words to all the songs whether they want to or not. One night during a break I'm sitting at a table with the kids and the band when I find myself wondering if it's time to move on. Maybe a different band—or some entirely new project.

I don't leave the band, but I do something new. I apply to Pitzer College for a bachelor's degree in the New Resources Program for returning students over thirty. Now I have a day job, a band, three school-age kids, guitar classes to teach, classes to attend, and homework.

I also go on dates. Some of the divorced mothers I know choose not to date until their kids are grown and out of the house—contemporary psychologists suggest that bringing a man around could be traumatic for their children. I certainly hope I'm not traumatizing my kids, but I appreciate male companionship. I'm definitely not looking for a husband, though. I'm financially and emotionally self-sufficient and have no intention of remarrying. Once was bad enough.

I meet Jan at a gig with Larry and Leif. Leif says he wants me to meet a friend of his, and I know what he means right away. I laugh.

"I don't talk to guys at gigs, Leif, you know that. Especially not a friend of yours." I make it sound like I'm teasing, but he knows I mean it. Most of Leif's friends are stoners.

"This guy is different. I think you'll like him."

I sit at Jan Verdries's table during a break. Leif was right, he is different. He's Dutch, and well educated, with advanced degrees in neo-Freudian psychology and didactics from the University of Applied Sciences in Rotterdam. He's talkative and interesting—once I get used to his thick accent. He's divorced with three kids of his own, two boys, Sander and Eric, and a girl, Esther. We go on a date and very soon are exclusive.

The first time he asks me to marry him we are at Chuck E. Cheese with our combined six kids. Chuck E. Cheese, with its awful pizza, loud games, and overstimulated children, is my idea of hell on earth. I'm miserable. The kids are demanding tokens to play games, pizza, soda, and more tokens. They are all screaming and running around with mobs of other kids. In the middle of this nightmare Jan says: "Will you marry me?"

Talk about timing. I ask him if he has lost his mind.

"I'll take that as a no."

End of conversation.

But Jan is unfazed, and over the ensuing months he proposes to me three more times in similarly unsuitable conditions, and I

finally say yes. I actually like that he didn't fashion a romantic scene with candles and flowers; with Jan, everything is real. We get married in October of 1984 and honeymoon in Holland, where I meet his parents, aunts, uncles, and cousins. This is the first time I've been to Europe, and I'm overjoyed at the opportunity. We go to castles, museums and *rommelmarkts*, or flea markets, in Amsterdam, Rotterdam, The Hague, and Utrecht. We take the train to Paris and stay in Montmartre, eat éclairs in our favorite *pâtisserie*, watch the tiny sailboats in Luxembourg Gardens, and go to the top of the Eiffel Tower.

When we return home we set up house, and I'm in for something of a shock. I have been single for eight and a half years, and being married again is not an easy transition. Jan moves into my house, which has been my territory for years. As a single parent, I'm used to making all the decisions, for better or worse, and it's difficult for me to learn to share these responsibilities. His kids are easy. They fit right into the household and get along well with mine. They listen to me and don't seem to mind when I'm the disciplinarian, scolding, nagging and treating them like my own.

Jan is also remarkably easygoing, and he never takes anything personally, which is fortunate, because my kids resent this male interloper and let him know. They blame everything bad on him. He's an easy target: Absentminded and overly focused on some book or project, he forgets to close the refrigerator and puts the ice cream in the cupboard. With an oblivious husband, three teenagers, and three preteens in our home at any given time I think to myself: *This is why people have jobs. To get away from their families.* Eventually, we find our new roles in the extended family unit and go about our daily routines.

It is important to spend time at home with children when they are babies and toddlers if possible. As time passes, though, I learn that being home with teenagers is just as important. If there is

something stupid or dangerous to try, they'll give it a go. Jan and I deal with broken curfews, bad grades, lost report cards, messy rooms, unfinished homework, confrontations, back talk, teacher conferences, more teacher conferences, calls from the disciplinary principal, fighting at school, lying, sneaking out, and experimenting with drugs. If it is off-limits, one of our boneheaded boys will try it. But as luck will have it, all six kids get along. Competition is at a minimum. They look out for one another and stand up for each other. Jan and I wonder, *Could we possibly have done something right?*

Between starting school, working at the store full-time, being in a band, and having a husband and six kids, something has to give to keep the Harper/Verdries train on the track. I give up my band and I resign from the store. Quitting the band isn't easy but I'm ready to stop anyway. Quitting the store is excruciatingly painful. My father just hired a new repairman, so I expect it to be a good time for me to move on, and I assume my parents will understand my desire to further my education and be home with my boundary-testing children more. But they are angry and dead set against my leaving. My mother goes so far as to recruit my sisters to talk me out of it. Soon none of us are speaking to each other. My actions are seen as a betrayal, and my parents excommunicate me from the family for more than a year.

I escape from the pain of this separation by diving into a heavy load of schoolwork. I finish three years of requirements in two years, taking seven courses in one semester. My 4.0 grade point average is tarnished by one B. I'm indignant about the grade, and consider taking it up with my adviser, but Jan laughs and says it's a good sign for me to get a B. It means I'm *loosening up.*

Maybe he's right, I think. I accept the B and move on.

I complete my BA at Pitzer at age forty, the same year Ben graduates from high school. Ben goes to work at the Folk Music Center, following in my footsteps by training with Jack Willock and becoming an expert at repairing and restoring high-end guitars.

With Ben independent, Joel and Peter in high school, and my schoolwork complete, I'm faced with a new decision. I have to find a job.

I WALK INTO
THE RISING SUN

I set up an appointment with my adviser to talk about next steps. He surprises me by inviting the interim president of the college and a representative from Claremont Graduate University to the meeting. It crosses my mind that it's a setup. In fact it is, but it's a good setup. I enroll in the Teacher Education Internship Program and begin right away. I take the necessary methods classes three evenings a week for six weeks while I do my student teaching and pass the necessary tests. I'm placed in a classroom that September for a year's internship teaching at full salary. It's the same program from which my father had graduated. I'm assigned to a bilingual second-grade classroom in the Pomona Unified School District.

In 1987 the student body in the Pomona schools is mostly Latino. My class is labeled "English Immersion," but as the only English speaker in a group of thirty-two native Spanish-speaking seven-year-olds, I'm the one immersed—and not only in the Spanish language. In 1986 Proposition 63 had made English the official language of California, a thinly disguised attack on undocumented immigrants and virtually unenforceable. In my new work I have to navigate

this and other language policy issues, as well as a stressful world of immigration politics.

The California economy is always hungry for cheap labor, which is attracting increasing numbers of undocumented immigrants. In the 1960s we marched alongside Cesar Chavez and Dolores Huerta, we sang, we boycotted grapes and lettuce to support the United Farm Workers Union to empower the hardest-working people in the country paid pitiful wages to work in deplorable conditions so that we can have gallons of good cheap wine and markets full of fresh food. And our immigration policies are still a disgrace. California's affluent lifestyles are built on the backs of cheap undocumented labor. The schools reflect the political pressure and battle lines are drawn over language policy leaving a dearth of support for teachers trying to provide materials and resources for their multi-language, multicultural classrooms.

For the first time in decades music is not part of my busy professional life, and I crave it. I bring my guitar to the classroom and we sing first thing every morning in English and Spanish. We sing seasonal songs, holiday songs, family songs, and activity songs. For Black History Month I teach them songs from the civil rights movement.

One day I return from my lunch break to find the school secretary in my classroom, looking worried. "Mr. Rodriguez is outside with your students," she says. "They are all being punished. Hurry up and get out there!"

Rodriguez is the school principal. This doesn't sound good.

It's not.

Outside I find my entire class lined up against the "discipline" wall.

"I'll take over," I say, and I usher them back to the classroom, wondering what on earth happened.

"This is not acceptable!" Rodriguez calls after me, cryptically. "See me immediately after school."

Seeming pleased with themselves and showing no signs of remorse, the students explain that a new rule had shortened their fifteen-minute cafeteria lunchtime to ten minutes. Many of them—the girls mostly—come to school with elaborate homemade lunches and like to linger, share, and chat over their meal. When the bell rang for dismissal they didn't leave. The principal was summoned, and a couple of brave girls started singing the old civil rights movement anthem I taught them, "We Shall Not Be Moved." The whole class joined in, singing first in English, then in Spanish: *"No, no, no nos moveran."*

"We had a sit-in, just like you taught us!"

Can you blame me for feeling proud?

I meet with Mr. Rodriguez that afternoon, and he is reasonable. "Between us, I'm impressed with the lesson. But the rules have to be followed."

The next day, I tell them they had a right to stand up for something they believed in. I tell them that speaking up about injustice is only partially about standing by their beliefs; it's also about making change.

"Did you get what you wanted?" I ask.

They had not. The lunch period didn't change, and they still believe it should. My new lesson for them is to persevere. I give them a writing assignment: "Explain why your lunch break is important to you and why you should have your five minutes back." They organize their thoughts and ideas into a petition to the principal. Everyone in the class signs it, including me, and we present it to Mr. Rodriguez.

He gives my class permission to stay longer in the lunchroom. The rest of the school has to follow the new rule. My class has

learned the value of advocating for their rights. I hope the lesson will stay with them as they grow into adulthood.

I teach in Pomona for six years, during which time I dedicate hours every day to developing lesson plans for the English-language learners. A few of my kids don't speak Spanish either and I have to scramble to find speakers of Nahuatl or other indigenous languages for parent-teacher conferences. It's hard work, and some days I'm completely worn out by the schools' failure to support low-income families with bilingual children. The status quo favors wealthy and white Californians and reproduces the same discriminatory results again and again. My frustration mounts and I apply to the PhD program at Claremont Graduate University in the hope that I can make a difference by earning a degree that will allow me to train other teachers to better address issues of economic and racial disparity. I'm accepted and immediately lay out a plan for my dissertation.

I don't want to fall into the all-too-common PhD predicament of completing coursework and stalling out on the dissertation, so I dig into it right away. The title of my dissertation is "Teaching with the Enemy: An Archival and Narrative Analysis of McCarthyism in the Public Schools." I had heard about how one small local teacher's union, Union Local 430, brought significant positive changes to the Los Angeles schools during the repressive 1950s, and I want to know how they did it. I also want to find out how the Los Angeles School Board was able to fire the leadership of Local 430 and bust the union.

I spend months in the depths of the Los Angeles Unified School District basement paging through a decade of school board meeting minutes and finally bring the dirty political crusade to light: I learn that in the 1950s, the Los Angeles School Board worked

in tandem with the California Senate Fact-Finding Committee on Un-American Activities—the state version of Congress's HUAC—to destroy one small, socially active union: Local 430. In the stuffy, dusty archives I learn that teachers in the Los Angeles Unified School District can thank Union Local 430 for much that we all have come to take for granted: integrated schools and unions, a multicultural curriculum, free lunch and breakfast programs for underprivileged children, limitations on class size, the end of substitute teacher exploitation, a living wage, pensions, a good health plan, and tenure.

Local 430 fought for all these rights and was a thorn in the side of the powerful people who were accustomed to being in charge. To bring down the union they used the typical dirty tricks of McCarthyism: fear and intimidation, labeling people as communists and socialists, demanding that people name names, and attacking those who were most vulnerable by threatening their careers and standing in the community. Three hundred and four teachers were named and investigated. Not one of them was charged with subversion. But using a law passed in the dark of night, the leaders of Local 430 who refused to answer the committee's questions were fired for insubordination.

Writing the dissertation is my therapy for the harm caused to me, my family, and the rest of the United States of America by the McCarthyite war declared on humanitarians, altruists, and any individual or group who challenged the profit motive of corporate capitalism. In the end, my dissertation is nominated for the 1996 Dissertation of the Year Award. When it doesn't win, I'm told it's because it is "too political."

At my commencement ceremony the doctoral students get to wear a beret with a gold tassel rather than the standard

mortarboard. In a ceremonial rite of passage from the twelfth century known as "hooding," a hood is looped over our heads, the soft velvet resting on our throats and draping down our backs—in my case it drapes nearly down to my knees—over a heavy purple satin gown with the three black velvet doctoral chevrons appliqued on the bell sleeves. We are congratulated on our accomplishment and handed our diploma. As soon as we leave the stage the ushers hand us each a bottle of ice-cold water to prevent anyone fainting from the unrelenting one-hundred-plus-degree heat wave that suffocates the Pomona Valley that year. My kids and step kids, husband, and many of my friends watch me cross the stage at graduation.

Ben, who is rapidly making a name for himself in the music industry with two albums out on Virgin Records—*Welcome to the Cruel World* and *Fight for Your Mind*—recently married JoAnna Giuliani and presents me with my first grandchild, a boy named Charles Joseph, or CJ. Joel graduated from Pitzer College the year before, and Peter's graduation from Pitzer is the same weekend as mine. I'm thrilled to pieces to have everybody together for this celebration. It makes me happy to see the pride on my parents' faces, having long since forgiven my transgression of leaving the store. To celebrate, I throw a huge party at my house. It is a joyous time. I have a beautiful family, a new grandchild, and a PhD. I'm forty-nine years old.

I accept a tenure-track professorship at Cal State University San Bernardino (CSUSB) teaching reading and language acquisition in the Teacher Education department. CSUSB is situated on four hundred parched acres swept barren by the devil winds that constantly course through the mountain passes. From my office window I look out over yellowed, desiccated foothills at the ominous strike-slip scar of the San Andreas Fault. Like every Cal State University built in or after the 1960s, this campus has

no cozy, intimate spaces for conversation or study or cultivating revolution. It is wide-open stretches of paved walkway to accommodate the National Guard, should there ever be campus unrest again. The campus unrest I face is mostly academic bickering and intradepartmental feuds, but the legislative and political mood on education in the country is swinging to the right. Creativity is being cast aside, bilingual education denied, and the battle lines of conservatives versus liberals have been drawn. The department is in disarray.

Sometimes I look out my window and wonder what it would be like if teachers had control of their own profession and could do what they do best: teach.

Two years later, my father has a stroke. The existence of the Folk Music Center is in jeopardy, and I prevail upon Ben to buy it. None of us wants this cultural treasure to disappear and my parents aren't able to keep it going anymore without help. Ben and his grandfather come to a satisfactory agreement and the sale is made. The arrangement allows my father to remain working.

It's now 1998, and all three of my sons are out on their own. Ben's career is soaring. He's touring constantly, playing stadiums with his band the Innocent Criminals. His records are going gold. Joel is working as a counselor at Boys Republic, a school for troubled adolescents. Peter is studying for his master's degree in art at NYU. I'm in awe of how well they are all doing. I wish I could say that Leonard was a part of my sons' lives, but that is not how it has played out. He skipped their high school and college graduations and is absent for the birth of our first grandchild. He can't hold down a steady job anymore. His mother makes excuses for him, claiming that his health is failing, which indeed it is. His drinking is still incessant, and it's clear that no situation is too dire to cause

Leonard to give it up: not losing his wife, not losing his kids, not losing his home, not losing his job, and not losing his health.

Leonard finishes drinking himself to death on July 4, 1998, his mother's birthday. He's fifty-five years old. He dies alone in his apartment, surrounded by countless empty Wild Turkey bottles. His mother finds him and soon after calls me, sharing very little of the details. I hang up the phone, pause to gather my thoughts, and wonder if every empty bottle represents a regret denied, a moral inventory not taken, an amend not made. I call my three sons to break the news to them.

Ben is on tour in Europe, but he cancels his shows and comes home. I page Joel, who is headed to the beach with friends, and he turns around and drives straight home.

Peter catches a flight out of JFK and comes home, too. Over the years each of them had tried to connect with their father, certain that the strength of their love would convince him to stop drinking. Each of them faced the insurmountable opponent of Leonard's addiction. Now they mourn their father's death. I mourn Leonard's death, too. I mourn my lost girlhood, and I mourn our youthful dreams.

Later that year I'm offered a position with Antioch University in Marina del Rey helping establish and teach in their new Teacher Education department. Cal State allows me a two-year leave of absence and I think it would be a nice break from the swath of desert schools I've been working with in some of the poorest, most regressive school districts in California. At Antioch I'll be involved in the child-centered, progressive teaching philosophy for which the university is known. I accept the job.

Soon my days are consumed with the routine of classes, supervision of student teachers in the field, grading endless papers, and

driving the sixty-mile commute twice a week from Claremont to the coast. I typically get home around 11:00 p.m., just in time to go to bed. It's a grueling schedule but I keep up with it. Then, close to the end of my second summer session at Antioch, my routine is short-circuited. One morning, my first cup of coffee in hand, I listen to a voicemail from the night before from Ben. The acclaimed photographer and director Danny Clinch has been working on a documentary of Ben's career, and Ben says that he and Danny are coming to Claremont that morning with a film crew. He says I should pick a song for us to sing together.

I'm momentarily stunned. They are coming now—today? And we're going to *sing*? Ben and I have never sung together—outside the home, that is. When Ben was young, I would often be rehearsing a song or preparing a lesson and hear his high harmony floating through the house, accompanying my voice. But Ben is a rising star now, a household name. He wants to sing with me—and on film? Flustered but without time to spare I choose "Tomorrow Is a Long Time," a Bob Dylan song I have always loved. I know we could sing it well together but I'm anxious for him to like my choice.

Forty-five minutes later, Ben, Danny Clinch, and a camera crew show up with the camera rolling, taking in my small, white-stucco, Spanish-style house with the red-tiled roof and red front door—the house where Ben grew up. Danny has a knack for setting a comfortable and natural scene and asking the right question at the right time. He's well known as a photographer of legendary musicians such as Johnny Cash, Bruce Springsteen, Tom Waits, and Willie Nelson, and Ben's story is one of his first efforts at a full-length documentary. When Danny asks me about Ben's first guitar experience, it is easy to be myself and answer, even with the camera rolling. I tell a story about teaching a guitar class when I'm eight months pregnant with Ben.

"I strummed the guitar, the baby kicked, the guitar bounced. 'Keeping time,' the students joked. That was Ben's first experience with guitar."

"Did your dad ever live here?" Danny asks Ben.

"Dad was around until I was five," Ben said. "He was a raging alcoholic, and violent, so there was a lot of running. My father left me a lot but he also left me hanging on." He paused. "Some things my father said to me when I was young affected me deeply. Certain things he was able to give in spite of himself."

His answer is enigmatic, but I know what he means, and it touches me. "That is well said," I say, holding my breath and trying not to cry.

I bring out two guitars. Ben selects the New York–style Martin, a sweet-sounding parlor size I have borrowed from the Folk Music Center. I play my late 1930s Gibson L-00 that I restored myself when I still worked in the store's repair shop. It is about the same size as the Martin and has a sunburst top. It has seen a lot of miles and aged gracefully. We sit on the living room couch, where I set out the lyrics on the table in front of us. I take a breath, look at Ben, and we begin.

Once we start playing and feeling out the harmonies, I almost forget about the camera and crew. Our voices blend beautifully, and tears come to our eyes. Harmonizing together feels like being home.

A month later, Ben invites me to sing "Tomorrow Is a Long Time" with him at the Santa Barbara Bowl. I haven't performed in public for years and I've never performed in such a large venue. The Santa Barbara Bowl seats five thousand and is one of the most beautiful venues in California, set in the wooded hills above the city with a view of the ocean and harbor. I'm about to sing on the

same stage where I saw Emmylou Harris and the Hot Band, David Lindley and El Rayo-X, Peter Tosh, and of course Ben Harper and the Innocent Criminals. I feel exuberant, but this quickly passes as my nerves take over.

August 30, 2000, is a perfect, late-summer day. Rather than taking the tram up the hill from the VIP parking lot to the backstage, I walk, hoping to burn off some nervous energy. I spot several of my friends—the screenwriter Barry Morrow and his wife, Bev; some teaching colleagues and students from Antioch; my husband, Jan; Joel and Peter and Peter's wife, Lea; along with my stepson, Eric, and his wife, Nicole. I appreciate their presence, even though it would be easier to sing for an audience of strangers.

Alvin Youngblood Heart opens the show. Watching and listening to his country blues helps me forget my nerves for a while, but the jitters return when I hear the shrieks, cheers, and thunderous applause that meet Ben when he steps on stage and launches into "Burn to Shine." I listen with my daughter-in-law JoAnna, grandson CJ, CJ's little sister—my one-year-old granddaughter—Harris, and the congeries of friends, fans, and family that are always milling about backstage at Ben's shows.

As night comes, the temperature drops. I pull a gray sweatshirt over my fitted T-shirt and jeans, a concession to comfort over vanity. I pace and breathe, willing myself to relax. Above all I don't want to let Ben down. I drink a small cup of coffee. I've heard it's good for the vocal chords, though I'm not sure if this is true.

Ben sings "Steal My Kisses" to end his set, and the crowd brings him back with a surge of applause, whistles, and stomping feet. He glances around backstage to locate me, and we catch each other's eye before he steps back on stage, solo with his guitar. He plays one song, then another. I stand side-stage, quietly singing along. Ben's song ends. My knees shake as Ben introduces me. I walk on stage, avoiding all the cables that snake and coil around

and cross the path to my chair. The crowd roars. They are on their feet. Someone yells over the din, "Hey, Ben, your mom is hot!"

"Settle down," says Ben to my new fan. We hug and sit in the chairs that have been set side by side on a Persian carpet for us, making the stage area between the amps and the monitors feel a little bit like a living room. A tech hands me a guitar. The bowl goes dark and all I can see is Ben and the ring of people closest to the stage.

"You ready?" Ben whispers.

I nod and start the song.

In that moment I discover I'm at ease beside Ben, center stage in the circle of warm light. It dawns on me that I am more than ready. *I know how to do this.*

We finish singing and I head toward the wings. Ben and his band do an encore, and I'm hit with an intense sensation of accomplishment. It feels fantastic. My inner post-performance critic hasn't set up camp in my brain yet, telling me, as it did after every gig in my life, what I could or should have done better. Suddenly I realize I'm starving. I run to catering to see if there is any food left, and thankfully the head of catering had saved a piece of strawberry shortcake for me. As soon as the show is over I go out the backstage door looking for the friends who were in the audience. The crowd closes in around me, bombarding me with questions and accolades, shaking my hand, taking pictures, or just gawking. Ben's tour manager, Scott, pushes through and guides me back to the greenroom.

"You can't just walk out into the crowd," he says. "If you want to see someone, I'll bring them to you."

It hits me with a visceral jolt that along with the pleasure of recognition comes a new and unbidden sense of understanding and loss. Anonymity is privacy; privacy is freedom; and with recognition comes the sacrifice of freedom. Performing on such a big stage

alters my place in the world. Celebrity, even a wee, momentary case of it, casts a long shadow over the coveted spotlight.

Later that night in the greenroom Ben says, "Ma, we ought to do an album together."

"Yes, let's."

I'm in the middle of deciding to stay at Antioch or go back to CSUSB. Cal State is the practical choice because it is a tenured position. It is a difficult time in teacher education. The political pendulum of reading methodology has swung completely to the right and all the emphasis is being put on testing. The pending No Child Left Behind Act forced on educators by the George W. Bush administration creates a testing frenzy that punishes "low performing" schools. Caught in the middle, teacher education programs are expected to enforce this flawed legislation.

In January of 2001 Ben asks me to take over the Folk Music Center. This request comes out of the blue. I have a career. I'm paying off student loans. It makes no sense to even consider this proposition. But I don't say no. A small but undeniable voice in my head says this could be good for me. I can't pretend I'm not frustrated by the misguided, politically driven catastrophe I'm witnessing in teacher education. On the other hand, I have worked hard for my career. How can I just give it up?

I ask around for advice. Jan thinks I would be nuts to consider leaving my job. My friends say taking over the store is a terrible idea—the schools need me and I would lose my tenure-track position, pension, and benefits. This all sounds like practical, logical advice.

Then my mother is diagnosed with progressive supranuclear palsy (PSP), a neuromuscular degenerative disease similar to ALS. The doctors give her a five-year life expectancy. It becomes evident

how much my parents' needs are taking a toll on my role at the university. It's getting harder to help out from a distance. There are trips to the emergency room, doctors' visits, specialists, and physical therapy. Joel is living with them and does what he can, but he has a full-time job. My sister Sue comes out intermittently from Virginia to help. But my parents require a lot of care, and not just for short stretches of time. My mother's mind is strong, but her body is giving out. My father is the reverse. We hire round-the-clock care.

I'm grappling with all this when a phone call from the accountant helps clarify my thinking. The Folk Music Center is a month away from bankruptcy. It is time to decide what to do. After two strokes, my father's judgment has declined badly. We are shocked to hear how far the center has slipped, but we also know that Dad doesn't want to let go of the reins. He's the patriarch, and he can still hold his own in many conversations. But parts of his brain are not working—the math part, for one—and people around him have taken advantage. The books are a disaster, the bank accounts ravaged.

In 2001, after thirteen years working in the school system, I resign. The decision isn't easy, and I tell myself I will put five years into the Folk Music Center and then go back to the university. I feel unmoored, as if I'm drifting onto the rocky shoals of the unknown. What will the Folk Music Center become without Dot and Charles? I'm a little panicky and very uncertain. I'm starting over, reinventing myself again.

Ben and I let everyone who works at the store go. I hire my daughter-in-law Lea, Peter's wife, and the two of us put the place back together. Lea knows how to work efficiently—how to organize, how to keep the books, and how to sell. She is a marvel. My father stays on at the store, coming in every day, where he enjoys talking to customers and working on the instruments.

I take over my mother's guitar classes, and the teaching helps me adjust to putting aside my academic career. For a time, my mother holds on to her banjo class. It's the last vestige of her former life and she keeps it as long as possible. At the start of each class, I help her onto her stool and place the banjo in her hands, and she takes it from there. But this last pleasure is robbed from her by her cruel degenerative illness, and the day comes when she tells me she is done.

"Take my banjo classes," she says, her once strong voice reduced to a whisper by the disease.

"But, Ma, I'm no good at banjo."

"You're good enough."

Case closed. I add banjo classes to my roster and watch my mother fade away. Her gentle and peaceable nature becomes more so as she loses her independence. Ever the stoic, she never complains, but I see the sorrow and anguish in her eyes. One day, my mother asks me to help her end her life. My attempt to be rational lasts less than a second. I fall apart, melting into uncontrollable sobs.

"I can't, Ma," is all I can muster.

"I'm sorry," she says to me, soothing as best she can. I have failed her. Not only can't I help her, but she is consoling me.

When I tell Jan about it, he says, "This is not your responsibility. It shouldn't be on your shoulders. In Holland the state medical system would have made it possible for her to choose euthanasia if she so desired. Americans are so backward."

When I take over the Folk Music Center I quickly realize the retail music business is shifting to the Internet. We are already far behind the times and I need to strategize. The Folk Music Center survived the decline of the 1960s folk boom. It survived the arrival

of the chain store Guitar Center and its virtual takeover of the retail music business. It survived neglect and mismanagement. Could it survive eBay, Google, and Amazon?

Late in 2000 the Coen brothers produce a movie called *O Brother, Where Art Thou?*, a unique take on Homer's *The Odyssey* set in the American South during the Depression. The songwriter and record producer T. Bone Burnett's soundtrack draws on traditional music sung and played by some of America's best traditional and country musicians. The movie and its soundtrack are spectacular successes and the impetus of the folk revival of the 2000s. This revival has its own identity: roots music. It also brings a new Grammy Awards category: Americana.

I welcome anything that promotes folk music, but it is disconcerting to have a revival triggered by a Hollywood film and soundtrack. Still, I'm happy to see a national audience celebrating our musical roots. *O Brother, Where Art Thou?* influences an entire generation's perception of traditional music. The public is nostalgic for a life that was never theirs and that they had never known. They yearn for a simpler time of handmade music. With its romanticized depiction of an era portrayed as more authentic and human than the present, the Coen brothers' movie fits the bill. It offers an alternative to machine-enhanced, digital, technology-driven music.

And I can't deny that the roots music revival is good for the Folk Music Center. It means selling more guitars, banjos, mandolins, and fiddles. It means a surge in music lessons. It means keeping the doors open. And it is gratifying to see people put down their headphones, pick up a real instrument, and discover the joy of making music. Interest and sales in acoustic instruments burgeon. It seems everyone now wants to make music and not just consume it. Lessons, classes, workshops, and our concert series are thriving.

There is no avoiding the truth: My parents are rapidly deteriorating. My father is diagnosed with dementia, and following a bad fall he is moved to a nearby senior care facility to recuperate. My mother is wheelchair bound and can only communicate yes or no with a shake or nod of her head. Her caretaker and I offer to take her to visit my father, but she shakes her head no every time; she prefers to see him when he comes home. But he is bedridden with congestive heart failure as a result of multiple small strokes, which were most likely the reason for his fall. He isn't coming home. I visit him every day at lunch. His temperament is increasingly agitated, and every day he blames me for putting him in this jail, exhorts me to get him out, and rages because they give him mashed instead of baked potatoes. I beg the kitchen workers to please just pop a baking potato in the microwave for him, which they do.

Six days after he's admitted, I get a call at work. It is the only day I can't visit him at lunchtime.

"Your daddy has passed," says a voice on the phone. "I'm so sorry."

The hospice worker is kind. She tells me it is very common for older people to wait until they are alone to die and assures me I shouldn't feel guilty. She says he had had a stroke and a heart attack simultaneously, and with his very last breath, he called for his papa.

It is May 21, 2004, just three months shy of his ninetieth birthday. We hold a memorial at the Folk Music Center three days later. There is an outpouring of shared grief, joyous memories, and music. One longtime friend, Chris Moran, draws a picture and writes: "The mouth bow–strumming, limberjack-popping, tree-stump-carving, rusty-metal-welding, poetry-posting, city hall–picketing, banjo-gluing, dulcimer-nailing original Charles Chase is an honest and true gift to this earth." I post a poem my father wrote in the store window.

I walk into the rising sun
Silent promise of another day

The coming of a gift so great
It takes all day to open.

We all make a special effort to spend more time with my mother. Joel sits with her a couple of times a day before and after he goes to work. Ben comes out as often as he can when he isn't on the road. Peter, now an adjunct professor of art at Cal State University Channel Islands, tells her stories from the classroom. Sue flies west for a week every other month.

Ben, Joel, Peter, Sue, Jan, and I take my father's ashes to the cabin in the mountains he had loved so much. We scatter his ashes, letting them mingle with the mulch of oak leaves, moss, and pine needles. A mourning dove with black speckled wings perches on the telephone wire above our heads and softly coos. As we scatter the last of the ashes, the dove circles our little group and flies like an arrow into the clear blue sky.

"She took his soul to heaven," I say.

In a light, wavering soprano, Sue sings Leonard Cohen's song and we all join in:

Like a bird on a wire,
Like a drunk in a midnight choir,
I have tried, in my way, to be free.

That October, Ben invites me to Neil and Pegi Young's 2004 Bridge School Benefit to sing his song "In the Lord's Arms" with him. The concert has an extraordinary lineup: Neil Young, Paul McCartney, Tony Bennett, the Red Hot Chili Peppers, Sonic Youth, Los Lonely Boys, Tegan and Sara, Eddie Vedder, and Ben Harper, all there to help raise money to support the Bridge School, which serves children with severe physical and speech impairments. The kids and their families attend the concert for free, with many of them sitting on the stage. The kids are excited

when I come up for our song, and many want my autograph. I think there is a misunderstanding—I'm not famous, they must think I'm someone else—but it turns out I'm a different kind of celebrity. Neil tells me these kids see their parents as heroes, and here is a mom playing on stage with her kid, which makes me a hero, too.

The entertainers' greenroom trailers are parked in a circle with a central courtyard for food that includes a space for arcade-type games. I'm keeping an eye on my five-year-old grandson, CJ, who is engrossed in one of the games, when a nice-looking man in a blazer and jeans introduces himself.

"Hi," he says, extending his hand. "I'm Paul."

As if I don't know who he is. Taking his hand, I say, "I'm Ellen, pleased to meet you. And this," I say, calling my grandson away from the game, "is my grandson, CJ Harper. CJ, this is Paul McCartney."

"Hi," CJ says, politely shaking his hand.

"Good to meet you, CJ. I wish my daughter Beatrice was here. She would like to meet you."

"Yes, um, well, nice to meet you," CJ replies, glancing over his shoulder. He's eager to get back to his game, so I release him with a chuckle.

"Tough competition, right?" laughs Paul, indicating the games with a tilt of his head.

"Indeed," I agree. But I'm thinking back to when my mother told the five-year-old me how fortunate I was to meet Pete Seeger. I wonder if CJ will remember this meeting with Paul McCartney.

One year after my father dies, my mother, completely immobilized but still responsive with the use of her index finger and right eyebrow, slips into a coma. We sit vigil. The hospice nurse arrives and the caretaker tells us to go home and take a little break. She will call if there is a change.

I get the call an hour and a half later.

"Your mama has died. She went very quickly and peacefully."

It is June 11, 2005. We hold a memorial for her at the Folk Music Center ten days later, where her dear friend Ross Altman sings a song that he wrote for her.

There is always a big pot of soup on at Dot's
There is room for your bed on her floor
I never saw her turn anyone away
There is always room for one more
It must have been hard on her family
To give so much of her away
That's just who she was and I loved her because
There is no one else like her today

Grandma is a hippy
The last of her kind
She is thirty-five years
Ahead of her time
I'm glad that I met her
I'll never forget her
She's up there in heaven now
Speaking her mind.

My parents' passing represents the end of an era. Having lived through the deprivations of the Great Depression and the horror of World War II, their generation of folkies and activists tried as best they knew how to create a better world through peace, justice, egalitarianism—and music. They sincerely believed that a multicultural world of shared effort, resources, and understanding was possible. They passed the torch to my generation. We came of age during the Cold War, the threat of nuclear annihilation, and the disaster of Vietnam.

It remains to be seen what we will do with the torch we've been passed: Will we use it to enlighten generations to come or burn down the planet?

After my mother's passing my parents' house has to be sold. It's filled with sixty-seven years of musical instruments, books, art, artifacts, tchotchkes, correspondence, diaries, song files, poetry files, furnishings, tools, and a shed full of seasoned hardwoods and banjo necks. Sue and I sit with all the tokens and memories for days and try to make sense of what to do with it all. I inherit my mother's cat, an elderly calico with one blue and one green eye. I already have two dogs and one cat, and I don't really want another cat. I post a photo of her in the store window, but no one wants her. "She's too old," says Jerry O'Sullivan—recently hired, whose first event at the music store was my mother's memorial—joking that Ben Harper will have to sign the cat for anybody to take her. She lives with me until she dies of old age.

CHAPTER 15

CITY OF DREAMS

In 2007 I turn sixty. It is a milestone. Instead of adding up the years, I start counting them down. It is time to take stock of what matters and decide what I want to do with my remaining time on earth. Our family is changing and growing. I'm a grandmother several times over. Ben and JoAnna divorced and Ben is married to the actor Laura Dern and has two more children, Ellery and Jaya. Joel marries a French woman named Marielle and publishes a book of poetry, *Restless Spirit: Eyes of a Child*, and a groundbreaking, bestselling children's book called *All the Way to the Ocean* about protecting the health of the world's oceans. Peter and Lea are living in Goleta while she attends graduate school at the University of California at Santa Barbara. Peter is teaching art and sculpture classes for Cal State Channel Islands and casting bronze.

As my birthday approaches I know I have to make a plan. If I don't make a plan, plans will be made for me by my flourishing, loving, and well-meaning family. So I book two days in a room with a balcony overlooking the ocean at the Fess Parker hotel in Santa Barbara, just for me. Everyone feels sad for me, being alone

on my birthday, but they shouldn't. I'm happy. I sleep soundly and late, and order room service breakfasts of scrambled eggs, toast, fruit, yogurt, and large pots of coffee. I sit on the balcony gazing out to sea, basking in Santa Barbara's unique light and salt air, wondering what I want. Am I missing something crucial? Is there something more I'm meant to do?

The Pacific is a different sea than the one I gazed at as a child, but it has the same powerful and peaceful impact on me, and in that meditative state, it comes to me. I want to preserve the stories of the Folk Music Center. I have always been a scribbler of notes, songs, memories, short stories, and bits of conversations that catch my ear. But now, I decide, I'll buy a video camera and record other people's memories of the music store. I'll be the link between the older generation of folk musicians and music lovers and the kids and grandkids. If I don't make a record of the memories and stories, they will die with me.

I come home refreshed and raring to go. I know I have already missed collecting so many important stories from people who had passed on, and in the coming days and weeks I contact everyone I can think of from the early days of the music store. I film Clabe Hangan, Keith and Rusty McNeil, Mike Seeger, Chris Darrow, and Mike McClellan. I film dozens of interviews, recording the memories of the events and characters that populated the early Southern California folk revival. For good measure I have each person play and sing a song. I gather a historic collection representing a movement that I like to think changed the world.

A year and a half after my sixtieth birthday the Folk Music Center celebrates its fiftieth anniversary at the store. The staff protests that the space isn't big enough, but I'm not concerned. Somehow

the Folk Music Center will manage to accommodate whoever shows up. It always does.

People come from far and wide. Some have made complex plans to attend; others happen upon the event at the last moment. A photographic history lines the countertops and there is a table laden with food against the guitar wall. There is no program or agenda beyond celebration. A house band forms organically. Ben thanks everybody for coming. I invite everyone to share their thoughts, stories, and songs. Miraculously, no one rambles or hogs the mic. Messages congratulating us on fifty years arrive from all over the country. Huell Howser had filmed an entire episode on the Folk Music Center that aired on his popular public television show, *California's Gold*—with an audience of a million viewers a week—and many who had seen it find their way to the anniversary party.

Ross Altman, Angela Lloyd, John York (formerly of the Byrds), and Ruthie Buell, some of my mother's dearest pals and fellow musicians, are here. The internationally known singer and songwriter Jackson Browne sings Warren Zevon's "Carmelita" and expresses his gratitude for the Folk Music Center, adding his wish that it continue to thrive. Tom Freund and I join Ben and Jackson on Ben's song "Spanish Red Wine," and we wrap up with "Goodnight, Irene." Then we thank everyone, cut the cake, and toast fifty years of promoting, supporting, and providing live music made by and for the people.

My parents' children, grandchildren, and great-grandchildren are here. The music store crew, musicians, friends, family, community, supporters, and strangers—everyone comes and pays tribute to a venerated institution.

After the guests depart, the family and crew and our closest friends talk and reminisce. I listen as guest after guest expresses their love for the place. I am thrilled, and exhausted. After we

clean up, I feel just like the tired kid who had been sent home to drink orange juice following the grand opening of the Folk Music Center fifty years before.

In 2009 Ben is invited to perform at Pete Seeger's ninetieth birthday party and concert at Madison Square Garden. It seems extraordinary but also fitting that my son is invited to play at a tribute to this giant of American music whom I first knew as a family friend. Pete had helped my mother from time to time with her guitar and banjo classes back in Boston, and sat in our kitchen discussing banjo bridges and the blacklist with my father. He came to Claremont to visit my family and the Folk Music Center. Dot and Pete's wife, Toshi, exchanged Christmas cards for years.

Ben invites my sister Sue and me to accompany him in New York on his song "Gather Round the Stone." Sue plays guitar and I play banjo. Ben is tickled to be able to provide a full circle moment for us as a tribute to Dot and her mentor, Pete.

Our car drops us at the entrance to the stadium, where an assistant is waiting to escort us around Penn Station to an unprepossessing side door and through to the backstage labyrinth of Madison Square Garden's hallways, locker rooms, dressing rooms, production offices, greenrooms, cafeteria, and lounges. We are ushered to the Knicks greenroom—a comfortable lounge with a giant in-house flat screen showing the preparations being made on stage. Lo and behold, there on screen is Ben's guitar tech Dave, who has voluntarily jumped in to help with the cumbersome sound check. It feels like every folk singer on earth is here. I catch up with old friends—Joel Rafael, Tom Morello, Taj Mahal—and meet new ones—Steve Earle, Billy Bragg, and Bruce Cockburn. Pete, Toshi, and their family members are across the hallway in

rooms of their own, and the women performers are further down the curved hallway in their assigned area.

Ben, Sue, and I cut out of the fray to briefly rehearse the song in a quiet corner of an empty physical therapy room. A large framed poster catches my eye: NO BETTING. NO TIPPING. NO FIXING. I have no experience with professional sports and it occurs to me that incentives for unethical behavior can be hard to resist. But isn't this just the professional sports version of selling out? Selling out cuts across all forms of entertainment, whether it be athletes, musicians, writers, actors, journalists, photographers, or newscasters. We are all just small cogs in the corporate money machines. Posting signs instructing us to be ethical can't hurt.

Danny Clinch gets a great photo of me coming off stage holding my mother's banjo and shaking hands with Pete, who is just heading to the stage with his banjo. The photo hangs in a place of honor in the Folk Music Center. Pete goes out on stage and sings "Amazing Grace," which sounds all the more amazing in his aging voice, rich with the ardor and wisdom acquired over his lifetime. Ben and I are watching on the greenroom TV screen and look at each other wide-eyed as Pete adds another verse and chorus, and then another verse and chorus, and another and yet another. Where did he get the stamina to share so much of his hard-earned grace? When Pete returns from the stage, after singing what seemed like a hundred verses and choruses of "Amazing Grace," Toshi, Pete's wife of sixty-six years, comes out of their dressing room and gently but firmly reminds him not to overdo it.

With the completion of dozens of Folk Music Center history interviews, I begin another project. I gather up all the notebooks, envelopes, napkins, and scraps of paper on which I have written songs and parts of songs over the years. I polish the lyrics and

arrange the music. Then I invite several musician friends to a local recording studio, and over the course of two years—between the Folk Music Center, producing the Claremont Folk Festival, the ever-growing family, and teaching ukulele—I record my songs.

It feels terrific to be in the studio. Recording a song is like painting a picture with layers of sound, highlights, and coloration, a delicate balance of what I want to hear while giving each musician freedom to do what he or she does best.

But before I have the chance to mix and master the recordings and turn them into an album, I'm sidetracked by other adventures. My songs will have to wait.

Ben stumped for Barack Obama before the 2008 election and has been invited to the White House as a guest of the president several times. In 2013, he is invited to be one of the performers at the *Memphis Soul* show in the East Room of the White House, which is broadcast on PBS. Ben shares this remarkable experience with me, inviting me to be his guest. I would have to get a preliminary security clearance, and I wonder how far back they check. The blacklist left a permanent scar.

I pass the test, and the invitation reads, "The President and Mrs. Obama request the pleasure of your company at a performance and reception to be held at the White House on Tuesday, April 9, 2013, at six-thirty o'clock." It specifies cocktail attire.

"I'll have to go shopping," I tell Ben.

I arrive at the W hotel in Washington, DC. I'm scheduled to meet Ben and his friend Jac that evening. I discover I'm in the land of crab cakes. My favorite! I have crab cakes for lunch and crab cakes for dinner.

A visit to the White House involves a security gauntlet unlike anything I have ever experienced. In addition to the prescreening,

the town car that brings us to the White House has to be inspected by dogs and a magnetometer at the gate. I look up and see sharp-shooters on the roof. Once we are inside we walk through a metal detector, and then finally into the White House to connect with our guide. Blues musician Charlie Musselwhite, who traveled with us, has his harmonica case scrutinized. Our guide says there have been more death threats made against President Obama than all previous presidents combined.

The performers and their guests are ushered from one room to another for interviews, filming, and refreshments. Ultimately we land in a large room where we wait to meet the president and Mrs. Obama.

While we wait, Charlie Musselwhite and his wife, Henri—who looks striking in a layered outfit she designed herself—tell me their story. Charlie was in the throes of alcoholism and circling the drain when he met her.

"Stop drinking or you'll never see me again," Henri told him. Charlie stopped drinking, reclaimed his career, married Henri, and hasn't had a drop to drink since.

The singer and civil rights activist Mavis Staples admires my dress and says she would like to borrow it when she comes to California on tour. Cyndi Lauper is a delight to see but keeps to herself and warms up with vocal exercises sung through a straw. I chat with a tall, pleasant young man Ben tells me later is Justin Timberlake. A member of the Alabama Shakes arrives wearing cargo shorts and flip-flops and is sent away to get properly dressed. Hey, this is the White House. Everyone is dressed to the nines.

Before we step through the doorway to meet the Obamas, a page hands us name cards and holds out a tray for our purses, phones, and any other objects we still have on us. Finally, Ben and I are ushered into the room. The Obamas are standing side by side. Michelle, in a sleeveless dress and kitten heels, stands

nearly as tall as her husband. Another page takes our cards to the president and first lady. President Obama brushes the cards away.

"I know Ben," he says, giving Ben a hug. Ben turns to me.

"This is my mom."

I reach forward to shake the president's hand, but he says, "Moms get a hug." I get a hug and a bonus light brush of an air kiss on the cheek.

"Look at this, Michelle!" he says. "How does a big old guy like Ben have such a tiny mom?"

The first lady gives me a knowing look, rolls her eyes in the direction of her husband, and shakes her head ever so slightly. She hugs me and kisses me on the cheek. The official photo is taken, and soon we are on the other side, reunited with our belongings. Ben leaves to warm up for his performance.

Henri saves me a seat in the front row—a proud mother and a proud wife, side by side. It is an unforgettable night. The performers are marvelous, and the honor is beyond comprehension, but there is also an element of sweet revenge. Never in a million years would I have pictured myself in a private event at the White House at the behest of the president of the United States. Sitting there soaking it all in, I smile and think, *Suck on that, Joe McCarthy!*

A brief champagne reception follows the show. Our guide gives us our official boxes of White House M&Ms, and I'm handed a rose from the Rose Garden. It is a huge relief to step into the warm muggy night after hours of shivering in my St. John Knits in the subzero chill of the White House.

The day after the event Ben, Jac, and I stroll from the National Mall to the shoreline of East Potomac Park. It is an unseasonably warm spring and the cherry trees are blooming early. In the heat of the afternoon the sunlight seems pink, feels pink, and smells pink. It has taken sixty years, but the daughter and granddaughter of communists has been invited to the White House—the People's

House—because her son was raised to appreciate all kinds of folk music. Times have changed.

The Folk Music Center Museum continues to produce great festivals—always dedicated to the memory of Dorothy Chase—with an eclectic collection of musicians. We have Henry Rollins, formerly of Black Flag, doing spoken word; David Lindley; Dave Alvin of the Blasters; David Grisman Bluegrass Experience; Ben Harper and the Innocent Criminals; Taj Mahal, Jackson Browne, Yuval Ron, John McEuen, Susie Glaze, and many more. The Chase-Harper clan is growing rapidly. By 2013 there are four more grandchildren, Peter's two boys, Saul and Zev, and Joel's two boys, Enzo and Mathéo. They all live in Claremont, and I get to watch another generation growing up in the midst of all the instruments, lessons, classes, workshops, musicians, and artists. I put the boys to work as soon as they are able, sorting parts and accessories, dusting, pricing, stocking shelves, and their favorite, talking to the public.

My life is busy and full.

Then, in the summer of 2013, I get a call from Ben. "Mom, we've got ten days to record an album. Pick your best songs. I'll see you at the Machine Shop tomorrow at noon."

The next day I walk into the Machine Shop, Ben's studio in Santa Monica, to the strains of Ben playing a beautiful melody on the piano. It is "Born to Love You," a song he has just written. I sit beside him on the piano bench and find a harmony. Once again I'm struck by how well we communicate in the language of song. We go into the vocal booth together and roll. One day down, one song recorded.

The second day in the studio we are recording one of my songs, "Farmer's Daughter," a political song that starts, "My daddy is a

farmer, that makes me the farmer's daughter," and follows the demise of the family farm from the ruthless tactics of the mega-agribusiness Monsanto to the ruthless tactics of the banking industry. I play banjo in a G modal, or sawmill, tuning that I learned from Clarence Ashley at Idyllwild. Jimmy Paxson, drummer and percussionist nonpareil, adds a beat that breathes new life into the song. I go into the vocal booth with the banjo and record a scratch track—that is, a rough version of the vocals intended only to help the other instruments, such as the bass, percussion, and guitar, lay down their tracks. The plan is that I will rerecord the banjo and lead vocal after that, which is how it is usually done. But in this case Ben, the engineer Ethan Allen, and the band members—guitarist Jason Mozersky, upright bassist Jesse Ingalls, and Jimmy—all agree that we should keep the scratch version because it has the right emotional feel.

On day three we work on Ben's song "Heavyhearted World," a raw song that addresses addiction and mental illness. I'm in the booth recording my harmony vocal and get stuck on one line. I'm frustrated with myself and Ben is frustrated with me for being frustrated with myself. The pressure builds and the session begins to spiral down. He walks out of the studio, but Ethan and I continue to work on the song. When Ben returns the harmony is complete. I have changed it a little but it works, and best of all, Ben likes it.

I realize that being the producer of an album with his mother as co-artist has to be difficult. At one point we sit down and talk it through. I assure him that he is the producer and his choices will prevail. Even if I think one of my verses has Shakespearean brilliance, if he thinks otherwise, his decision will stand. We are both relieved.

When I arrive on day four, Ethan and the band are there but Ben hasn't arrived. I suggest we start working on "City of Dreams," my tribute to an earlier Southern California of citrus groves, sage, and chaparral.

Ben walks in and says, "Nice fingerpicking. Who is that?"

"It's me!" I chirp. Another song is done by the end of the day.

Ben and Jason record all the album's instrumental solos. I'm usually done recording my parts by the time these tracks are being laid down, which allows me to sit back, listen, and enjoy all the great playing. There are a lot of good takes. I'm glad I'm not in charge of choosing.

Ethan mixes the album—that is, blends the individual tracks of each song to create a version of the song that is the best it could be. This is as much of an art as songwriting, playing, or singing. He shares all his work with us and sometimes we aren't satisfied until the eighth, ninth, or tenth mix. I'm never worried. Between Ethan's superb ear for timing, pitch, and levels and Ben's producer's ear for artistic precision and emotional feel, the best is brought out in each song.

After that the album has to be mastered. Mastering is the process of transferring the final mix to its ultimate location, which is the source from which all copies will be produced. Mastering is just as important as mixing. Ben chooses Lurssen Mastering in Hollywood, which is a big deal. Gavin Lurssen is a much sought-after engineer. He mastered the soundtrack of the Coen brothers' movie *O Brother, Where Art Thou?* We sit at his side in the perfection of the mastering lab listening to his superb work. We listen to it in the lobby. We listen to it in our cars. We listen until ultimately the sound, spacing, and levels are perfect. I know this because the album sounds like it was always meant to sound.

The first track on *Ben and Ellen Harper: Childhood Home* is "A House Is a Home," by Ben. This song becomes the name of the documentary Danny Clinch makes about the creation of our album. About half of the documentary is filmed at my house, and the other half is filmed at my other home, the Folk Music Center.

Once the video is complete, the art for the front and back covers of the album is selected, the photos and lyrics for the liner notes are settled on, and the tech copy—which is all the text that says who did what where—is written out, it is time to introduce *Childhood Home* to the world.

The album's drop date is Mother's Day, 2014. We head to New York to record several songs for SiriusXM Satellite Radio, play Rockwood Music Hall, and do an interview with *Rolling Stone*. We interview with NPR's Scott Simon and do a Mother's Day special for CBS. Then we fly to England for more interviews and play the BBC's *Woman's Hour* and *Breakfast*. After that I continue on with Ben's solo tour of Europe to help promote the album.

We discover that our mother-and-son interaction is suffused with meaning for our varied audiences—more than we could have imagined. After the shows, countless people share their personal stories of filial or parental love and loss. It is all so tender, loving, and wistful that at times it's almost more than I can bear. I listen and offer whatever advice, hope, or comfort I can. If sharing music with my son gives people solace or brings them closer to peace, it is a gift beyond our expectations.

Of course, not everyone adores us. One man, part of a European production team, looks at me just as I prepare to go on stage.

"A mother performing on stage! *My* mother cooks a big dinner for me every Sunday afternoon."

I want to say, "Screw you and your mother." Instead I reply, "She cooks, I sing."

We do many interviews for radio, TV, newspapers, and magazines. Sometimes I wonder how some of these people got their job as interviewers, but most are fine. Some questions are completely unexpected, like when Chris Hayes of MSNBC's *All In with Chris Hayes* asks if we can handle some tough political questions. Ben responds by bringing up gun control.

In a completely unanticipated twist, Hayes says, "Ben, I don't understand why you would do an album with your mother. I mean, with your *mother*?"

Ben starts to answer, but Chris interrupts him. "I can barely be in the same room with my mother. How could you, with a career like yours, do an album with your mother?"

"Chris," I say, "it sounds like you're having some issues with your mother. Would you like to talk about it?"

Instead of replying to me, he turns to the camera. "We'll be right back with Ben and Ellen Harper talking about their new album, *Childhood Home*," and cuts to a commercial break.

Throughout the experience of the *Childhood Home* tour I'm asked one question again and again. "What is it like doing an album with your son?"

To me, and I believe to Ben, making music supersedes the personal past, present, and future. Ben works hard on every project and so do I. We both expect professionalism and commitment from ourselves and anyone we work with—including each other. At the same time, there is no denying the magic that occurs when Ben and I sing together, whether it's at the Santa Barbara Bowl or on tour with *Childhood Home*. Who can explain magic?

I resort to saying, "If your mother is still alive, do a project with her. It doesn't matter what. Write a story, sing a song, journal, scrapbook, learn calligraphy, paint a painting, join a class—but do it now. I wish I had done an album with my mother. I waited too long." No matter how many times I say this, I always feels a twinge of pain and a pang of guilt for what never is to be.

With the *Childhood Home* album cycle over and thoughts of the lost opportunity to record with my mother on my mind, I resolve never to let another regret pass me by—or at least to try. I return

to the studio to work on the songs I recorded after the Folk Music Center's fiftieth anniversary. I contact Ethan Allen, and we collaborate on producing an album of my songs, *Light Has a Life of Its Own,* mastered by Gavin Lurssen. The songs on my album tell stories; for example, "The Busker" looks at playing for money on the street as a job, not as begging. The song "Dragon's Chain" is written after the disaster in Fukushima Daiichi. It's a posthumous correspondence between Albert Einstein and Marie Curie in which Marie shares feelings of remorse for inadvertently unleashing the dragon's chain reaction that led to a nuclear meltdown. It sounds bleak but feels like a love song. "Hearts on the Line" is about interracial marriage.

Sometimes I think about my songs as "folk music grows up." I've left behind sentimentality. I don't have illusions about love. Singing probably isn't going to change the world and we might not overcome. But I figure if you've got something to say, say it well in five verses and a chorus and someone out there will listen.

Some things can't be said in five verses and a chorus, so I also write stories. I feel a responsibility to preserve the past so my grandchildren, and their children, will always know where they came from. Out of my old notes and scribbles emerge family stories, entwined with the stories of complicit singers, songwriters, sinners, and saints. When I share these stories with friends and family, I'm tickled by the reactions. Everyone demands more. "Send more stories."

I'm happy to oblige. At the core of it all is the Folk Music Center, now a historic site. Not the official kind—the real kind. It's both a destination and a legend. Multiple generations have made pilgrimages to the Folk Music Center to connect with the music and spirit of the place. You don't have to be a Chase or a

Harper for the Folk Music Center to feel like coming home. Our extended community has always loved the store for supporting the live, organic music of the people, and for making a home and performance space for musicians of all stripes and from all places.

We hear from people all over the country who are carrying on the traditions of Dorothy and Charles and Bess and Pete. They are teaching and playing and singing the folk songs that keep alive the voices of people past and present. When people come together to sing, be it in a band, church, temple, picket line, protest march, ukulele club, or living room—wherever voices are raised together in song—that is a folk music revival.

You don't have to be a musician to appreciate and carry on this tradition. Musicians can't keep music alive for a second without music lovers. Don't ever let anyone tell you otherwise.

A lesson I learned from my father the septuagenarian rings true to my septuagenarian ears. Being part of a friendship laced with poetry, songs, art, nature, and compassion is being part of the ultimate friendship—peace on earth.

I am the tongue
of my own bell
ringing out
the constant call
of dignity
for all

ACKNOWLEDGMENTS

I want to thank my husband, Jan Verdries, for his everlasting patience as a sounding board. I'm grateful to my son Ben for bringing the music from our small store and living rooms to the whole wide world, and to Joel for his advice on publishing, and to Peter for his dedication to teaching. Thank you to all the rest of my large, fabulous, multifaceted, extraordinary family.

I greatly appreciate Clark Noone and my cousin Norah Chase for their time, advice, and support for this project. I couldn't have done it without the Folk Music Center crew, Henry Barnes, Jerry O'Sullivan, David Millard, Marguerite Millard, and Evan Smith, who stepped up to give me time and space to write.

I want to thank Mark Tauber for having faith in the stories, Eva Avery for bringing them clarity, Laura Mazer for tying up the loose ends and appreciating the intricacies of human relations, Jen Jensen for making it all come alive, and Sam Barry for helping me be brave and share my feelings, otherwise kept carefully guarded.

Thank you Dot and Charles Chase for your sagacious vision and hard work.

—*Ellen*

ABOUT THE AUTHOR

ELLEN HARPER is a singer, songwriter, musician, teacher, and owner of the Folk Music Center in Claremont, California. In 2018 she released her first solo album, *Light Has a Light of Its Own*. Ellen and her son Ben Harper collaborated on the album *Childhood Home* and went on an international tour together in 2014. Ellen and Ben's musical journey is the subject of Danny Clinch's documentary *A House Is a Home*.

Ellen received a PhD in Education from Claremont Graduate University and taught at California State University San Bernardino. Ellen currently runs the Folk Music Center shop, concert series, folk festival, and music classes. She lives in La Verne, California, with her husband, Jan Verdries.

SAM BARRY is the author of *How to Play the Harmonica: And Other Life Lessons,* coauthor of *Write That Book Already! The Tough Love You Need to Get Published Now,* and editor and coauthor of *Hard Listening: The Greatest Rock Band of All Time (of Authors) Tells All* by the all-author band the Rock Bottom Remainders. Sam is a professional harmonica and keyboard player and has taught thousands of people how to play the harmonica and piano. He performs and records music in San Francisco and Marin County.